Discover the Adirondacks

AMC's Guide to the Best Hiking, Biking, and Paddling

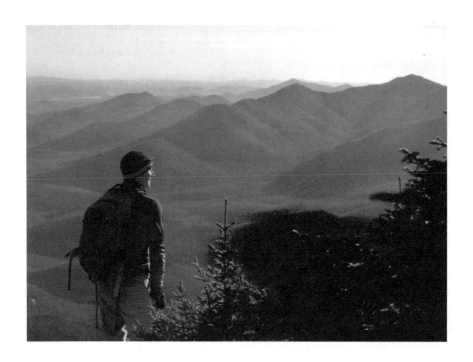

PETER W. KICK

Appalachian Mountain Club Books
Boston, Massachusetts

AMC is a nonprofit organization and sales of AMC books fund our mission of protecting the Northeast outdoors. If you appreciate our efforts and would like to become a member or make a donation to AMC, visit outdoors.org, call 800-372-1758, or contact us at Appalachian Mountain Club, 5 Joy Street, Boston, MA 02108.

outdoors.org/publications/books

Front cover photographs: (top l-r) © RubberBall / Alamy, © Blue Jean Images / Alamy, © Lisa Densmore / densmoredesigns.com; (bottom) © Caleb Kenna / calebkenna.com
Back cover photographs : (l-r) © Dave Scranton / ADKpictures.com, © Lisa Densmore, © Jupiterimages / Getty Images
Interior photographs © Peter W. Kick and Lori Lee Dickson, except on page i © Geneviève Sasseville / iStockphoto
Maps by Ken Dumas © Appalachian Mountain Club
Book design by Eric Edstam

Library of Congress Cataloging-in-Publication Data
Kick, Peter W.
 Discover the Adirondacks: AMC's guide to the best hiking, biking, and paddling / Peter W. Kick.
 p. cm.
 Includes index.
 ISBN 978-1-934028-31-5 (alk. paper)
 1. Hiking—New York (State)—Adirondack Mountains—Guidebooks. 2. Mountain biking—New York (State)—Adirondack Mountains—Guidebooks. 3. Canoeing—New York (State)—Adirondack Mountains (N.Y.)—Guidebooks. I. Title.
 GV199.42.N652A34416 2012
 796.5097475—dc23

 2011044375

The paper used in this publication meets the minimum requirements of the American National Standard for Information Sciences-Permanence of Paper for Printed Library Materials, ANSI Z39.48-1984. ∞

Outdoor recreation activities by their very nature are potentially hazardous. This book is not a substitute for good personal judgment and training in outdoor skills. Due to changes in conditions, use of the information in this book is at the sole risk of the user. The author and the Appalachian Mountain Club assume no liability for accidents happening to, or injuries sustained by, readers who engage in the activities described in this book.

Interior pages contain 30% post-consumer recycled fiber.
Cover contains 10% post-consumer recycled fiber.
Printed in the United States of America,
using vegetable-based inks.

10 9 8 7 6 5 4 3 2 1 12 13 14 15 16

MIX
Paper from
responsible sources
FSC® C005010
www.fsc.org

For Lucas Thompson, and the Sailing Society

Locator Map

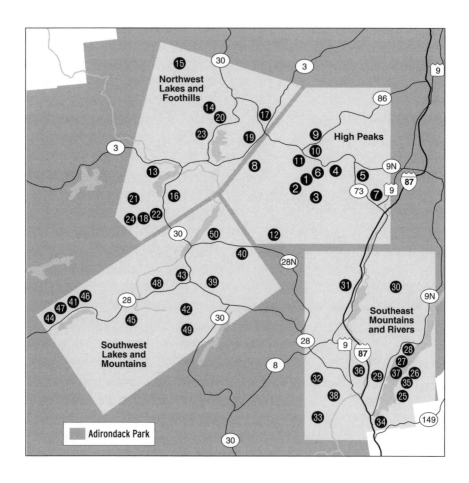

Contents

At-a-Glance Trip Planner

Trip	Page	Hiking/Biking/ Paddling	Rating	Distance and Elevation Gain
HIGH PEAKS REGION				
1 Mount Jo	3	👣	Easy	2.3 mi, 700 ft
2 Algonquin Moutain and Avalanche Lake	8	👣	Strenuous	13.0 mi, 3,500 ft
3 Mount Marcy	13	👣	Strenuous	14.8 mi, 3,300 ft
4 Cascade Mountain	18	👣	Strenuous	4.8 mi, 1,885 ft
5 Baxter Mountain	23	👣	Easy	2.0 mi, 700 ft
6 Mount Van Hoevenberg	27	👣	Moderate	4.4 mi, 850 ft
7 Giant Mountain	31	👣	Strenuous	8.0 mi, 3,375 ft
8 Ampersand Mountain	36	👣	Strenuous	5.5 mi, 1,750 ft
9 Lake Placid Loop	40	🚲	Moderate	10.5 mi, 600 ft
10 The Barkeater (BETA) Trails	44	🚲	Moderate	9.0 mi
11 Henry's Woods	48	🚲	Moderate	2.4 mi, 350 ft

Estimated time	Fee	Good for kids	Dogs allowed	X-C skiing	Snow-shoeing	Trip highlights
2.0 hrs	$	🚶‍👦	🐕		⛄⛄	Easy walk to views of the interior High Peaks
6.0–8.0 hrs	$		🐕		⛄⛄	Most interesting alpine hike in the Adirondacks
8.0–12.0 hrs	$		🐕	🎿	⛄⛄	Highest and most-climbed alpine summit in New York State
4.0–5.0 hrs			🐕		⛄⛄	The easiest of the High Peaks
1.5 hrs		🚶‍👦	🐕		⛄⛄	Kid-friendly hike with sweeping views
3.0 hrs		🚶‍👦	🐕		⛄⛄	Scenic hike through a pine plantation
6.0 hrs			🐕		⛄⛄	A steep climb leads to views of 39 peaks
4.5 hrs			🐕		⛄⛄	Old-growth forest; an open, panoramic summit
1.0–2.0 hrs						Mountain scenery and easy roads around the Olympic Village
2.0 hrs				🎿	⛄⛄	Single-track cycling in a well marked forest trail system
1.5 hrs		🚶‍👦	🐕	🎿	⛄⛄	Ride on a cinder path among scenic hills

Estimated time	Fee	Good for kids	Dogs allowed	X-C skiing	Snow-shoeing	Trip highlights
4.0 hrs		👪	🐕	🎿	⭐⭐	Easy carriage trail ride to an Adirondack Great Camp
1.5 hrs		👪	🐕		⭐⭐	The easiest hike to a fire tower in the Adirondacks
4.0 hrs		👪	🐕		⭐⭐	Excellent views of the St. Regis Wilderness Canoe Area
2.0 hrs		👪	🐕		⭐⭐	Views of the St. Lawrence Seaway from the fire tower
2.0 hrs		👪	🐕		⭐⭐	Very easy hike on a historic trail
5.0–6.0 hrs		👪	🐕	🎿	⭐⭐	Rail trail through wetlands to hard roads
4.0 hrs		👪	🐕	🎿	⭐⭐	Dirt road riding to a wilderness lake and campsites
8.0 hrs		👪	🐕			Lake and flatwater river paddling among island campgrounds
6.0 hrs		👪	🐕	🎿	⭐⭐	Isolated pond hopping in the state's only designated canoe area
4.0 hrs		👪	🐕			Scenic and sheltered river paddling to a short, scenic hike
10.0 hrs		👪	🐕			Family-friendly wilderness paddling and camping
4.0–5.0 hrs		👪	🐕			Easy and sheltered pond paddling

	Trip	Page	Hiking/Biking/ Paddling	Rating	Distance and Elevation Gain
24	Lake Lila	108		Moderate	6.5 mi (plus 3.0 miles hiking)

SOUTHEAST MOUNTAINS AND RIVERS REGION

	Trip	Page	Hiking/Biking/ Paddling	Rating	Distance and Elevation Gain
25	Buck Mountain	115		Moderate to Strenuous	4.5 mi, 1,140 ft
26	Sleeping Beauty Mountain and Bumps Pond Loop	119		Moderate	7.0 mi, 1,400 ft
27	Fifth Peak	124		Strenuous	5.0 mi, 1,540 ft
28	Five Mile Mountain	128		Moderate	7.0 mi, 1,200 ft
29	Cat and Thomas Mountains	132		Strenuous	6.5 mi, 1,600 ft
30	Pharaoh Mountain	137		Strenuous	10.0 mi, 1,700 ft
31	Severance Hill	141		Easy	2.0 mi, 750 ft
32	Crane Mountain Loop	145		Strenuous	4.5 mi, 1,360 ft
33	Hadley Mountain	149		Moderate	3.5 mi, 1,500 ft
34	Warren County Bikeway	153		Easy	9.6 mi
35	Shelving Rock Bay	157		Strenuous	10.0 mi, 1,000 ft
36	Schroon River	161		Moderate	10.0 mi, 28-ft drop
37	Lake George Islands	166		Moderate	12.0 mi
38	Hudson River	170		Moderate	14.0 mi, 40-ft drop

Estimated time	Fee	Good for kids	Dogs allowed	X-C skiing	Snow-shoeing	Trip highlights
6.0 hrs		✓	✓	✓	✓	White sand beaches and remote campsites; a short hike
4.0 hrs		✓	✓		✓	Scenic foot trail among pine and birch trees
5.0 hrs		✓	✓		✓	Gradual ascent to a long rock summit
4.0 hrs		✓	✓		✓	Cascading brooks, old-growth pine, and a grassy summit
5.0 hrs		✓	✓		✓	Secluded hike through lovely woods
4.0 hrs		✓	✓		✓	Climb two mountains separately or as a loop
6.0 hrs			✓		✓	Wilderness hiking to remote area with trout ponds
1.5 hrs		✓	✓		✓	Easy hike to ledges overlooking Lake George Wild Forest
4.0 hrs		✓			✓	Ladders, open cliffs, and a rocky beach
2.5 hrs		✓	✓		✓	Popular and scenic fire tower hike
2.0 hrs		✓		✓	✓	Wooded, paved bike path, ideal for families
2.0 hrs			✓	✓	✓	Expert single-track trails, near swimming in Lake George
4.0–5.0 hrs		✓	✓			Class I riffles and rapids in a wooded setting
6.0 hrs		✓				Scenic lake paddling to the Narrows Islands
5.0–7.0 hrs		✓	✓			Effortless paddling and a scenic introduction to moving water

Estimated time	Fee	Good for kids	Dogs allowed	X-C skiing	Snow-shoeing	Trip highlights
3.5 hrs			🐕		❄❄	Wilderness appeal and striking views
3.5 hrs		👪	🐕		❄❄	Hike to an old barn, cabin, and fire tower
2.0 hrs		👪	🐕		❄❄	Excellent views for relatively small effort
5.0 hrs			🐕		❄❄	Remote wild forest setting, 360-degree views
1.5 hrs		👪	🐕		❄❄	Scenic short climbs to caves and a pond
3.0 hrs	$	👪		⛷	❄❄	Ride a train with your bike and cycle back through Old Forge village
4.0–6.0 hrs				⛷	❄❄	Backcountry cycling in remote wild forest with free camping
4.0–5.0 hrs		👪		⛷	❄❄	Dirt road cycling in woodlands with little shared traffic
4.0 hrs		👪	🐕			Easy river paddling for beginners
6.0 hrs		👪	🐕			Lake, river, and wetland paddling for canoes and sea kayaks
5.0 hrs		👪	🐕			Quiet and remote paddling in the Canada Lakes Wilderness
15.0–20.0 hrs		👪	🐕			Scenic wild river with easy quick water

Preface

THE FIELD OF BEHAVIORAL PSYCHOLOGY HAS ADVANCED THE IDEA THAT we are all products of our environment. Perhaps nowhere else is this so visibly apparent as it is in places like the Adirondacks, where you'll quickly notice that people tend to wear their most rugged wilderness outerwear as their everyday wardrobe. Most of the 150,000 year-round residents in the Adirondacks' 100 communities live at upper elevations in remote areas, existing in a constant state of preparedness for a wide variety of constantly changing weather and travel conditions.

Most of the full-time—and some of the 70,000 seasonal—residents work in the forestry, tourism, recreation, and government industries. They can most likely tell you—and any of the 10 million visitors the Adirondacks welcome each year—the names of trees, rivers, and wild forest and wilderness areas, and recommend a good hike or fishing spot, or a few outstanding weekend paddling destinations. They use four-wheel and all-wheel-drive cars and pickup trucks. They carry bicycles, canoes, or kayaks on their vehicles throughout the season, so they can go for a short ride, or go fishing, or check their traps, or paddle home to their remote lakeside cottages after work. They make jokes about the weather and the blackflies and the tender-footed tourists.

The outdoor life is part of their normal existence, and the line separating the indoor and outdoor life is a thin one indeed. Everywhere in the Adirondacks, nature lies close at hand, and people spend their spare moments enjoying it. Most of them know the lakes and rivers as they know the main roads. Like the storied guides and backcountry mavens who came before them, they can discourse authoritatively on the subject of mountains

and waterways, popular paths, and trailless peaks. This is a harder place to live than most, they will tell you, here at the edge of creation, where the natural world offers its beauties and imposes its hazards on everyday life. It is generally colder and wetter than elsewhere, with longer winters and shorter, cooler summers—summers that you will certainly discover are well worth the wait. It is harder to find meaningful work here. It is far from downstate and the putative amenities of higher-population areas, which many Adirondackers eschew. They live by both choice and necessity in a more constant state of preparedness than most of us do. But for those who choose to live here, it is the only life there is—and the rest of us can envy them.

Many of the fortunate people who make their lives in Adirondack Park were born here, and had the outdoor lifestyle thrust upon them; others moved in from the outside to achieve it. Millions more of us make the Adirondacks a place we must, at least for now, be content to experience piecemeal, seeking out the most interesting and exciting adventure travel destinations the area has to offer in the relatively limited time we have to do so. It is the latter group for whom this book is intended.

The present is a key moment in the history of the Adirondacks, as they face the first major climactic change since the last ice age. Drastic variations in the environment have taken place over the past 30 years. Increasing temperatures have altered the habits of breeding birds, which are arriving in the park earlier in the year. Flowers are blooming earlier. Acid deposition has "killed" hundreds of upper-elevation lakes, where no fish can reproduce. Mercury contamination is on the rise. Accelerated global climate change is pushing the northern range of both migratory and indigenous species farther north. It is possible that within 100 years, the sugar maple will be replaced by southern forest species, such as the red oak and its associated types. The loss of calcium (which maple trees store in their foliage) will have cascading effects on biodiversity, as calcium is depleted in soils and becomes unattainable for the breeding birds, frogs, and snails that depend on it for reproduction. The sugar maple is also an important and sustainable forest product, providing considerable revenues from syrup production and saw timber. Warming will further affect the stability of the region, with a decrease in snowfall threatening the already-struggling skiing and snowmobiling economy.

Large blocks of indigenous forests that are bastions of biodiversity and

carbon sequestration are being threatened by agriculture, roads, dams, and disease (the larger a forest, the more resistant it is to pests). Vigorous policy initiatives, sustainable resource preservation and development, green tourism, economic incentives, development of renewable energy sources, and maintenance of existing resource protections are just a few of the things the Adirondacks need to ensure their preservation. They are a vital link in the 26-million-acre Great Northern Forest that stretches across New York, Vermont, New Hampshire, and Maine, much of which is continually threatened by development and fragmentation. The Adirondacks are a microcosm of the kinds of dramatic environmental shifts facing the entire planet this century and beyond.

This book stems from my interest in promoting and nurturing the relationship between green recreation and the inevitable awareness it generates of the vital necessity to preserve the wilderness. It's commonly recognized that an appreciation of the outdoors leads to education and conservation (we tend to protect the things we value), and, ultimately, to preservation. If we introduce our children to the outdoors with this idea foremost in our actions and intentions, and provide a guided discovery of the skills and rewards inherent in the outdoor experience, we will raise a generation who will learn the ways of wilderness. They will work to preserve a world that their own children will not simply be a product of, but will also be proud of.

Acknowledgments

I'D LIKE TO THANK KRISTOFER ALBERGA, the Department of Environmental Conservation's supervising forester of Region 5, for his sustained support and for providing state land management information. Who would have imagined that the young staff member I recruited so long ago as a voyageur guide would end up overseeing 2 million acres of Adirondack forestlands? I'd also like to thank the region's many dedicated forest rangers and summer summit stewards for their tireless service to Adirondack Park and its visitors, and for answering so many questions—lots of them my own. Thanks go to the cheerful and energetic staff members of the Adirondack Mountain Club's High Peaks Information Center, as well as to the employees of the Student Conservation Association, headquartered at Whitney Park. Thanks to my old friends Dave Cilley of St. Regis Canoe Outfitters and Rob Frenette of Raquette River Outfitters. Thanks to Pat Randolph, for companionship in the field as well as for providing a home away from home. Thanks also go to Lori Lee Dickson, who contributed to the interior photos and field observations of this book, and to Ryan Kick and Josh Winn for tagging along with me for three rainy days on the Raquette River. For their support and generosity, I would also like to thank Christina and Dan Papes. Thanks go to paddling guide Kathy Scott for her thoughts on destinations, and to AMC members Richard Breton and Russell Faller for reviewing the manuscript.

My gratitude extends to the staff members of Appalachian Mountain Club Books who gave this book life in its physical form: Publisher Heather Stephenson, Editor Kimberly Duncan-Mooney, and Production Manager Athena Lakri.

Stewardship and Conservation

Protect the Resource!

With so many people enjoying the Adirondacks, everyone needs to learn and adhere to Leave No Trace principles. These principles were developed and are updated regularly by the Leave No Trace Center for Outdoor Ethics to promote and inspire responsible outdoor recreation. How we use this spectacular place now determines what the Adirondacks will be like in the future. Whether you are hiking, biking, or paddling, follow these principles:

Plan Ahead and Prepare

Plan a trip that you know everyone in your group can finish. Be prepared for unexpected events by having extra food, water, and clothing. Paddlers need to be cognizant of stream currents and prevailing winds. Bicyclists need to know how to change a flat tire. Hikers need to understand the dangers of exposure to the weather. Keep your group size to ten or fewer (group-size restrictions for trips in this book are listed in the main text), and split into smaller groups if necessary. Try to avoid travel in wet and muddy conditions. Also confirm that you are going to be recreating in areas where it is legal to do so.

Travel on Durable Surfaces

When hiking, try to stay on trails and rocks. Stay in the center of the trail, even when it is wet and muddy. Use your boots! Trails are hardened sites

where use should be concentrated. Avoid contributing to the widening of trails and their erosion. When biking, always stay on the trail.

Dispose of Waste Properly

Pack out *all* that you bring in—including any food you might drop while eating. Urinate at least 200 yards from any water source and pack out your used toilet paper. To dispose of solid human waste in the outdoors where toilets are not available, dig an individual "cat hole" at least 200 yards from a trail or water source. Organic topsoil is preferable to sandy mineral soil. Dig a hole 6 to 8 inches deep and about 6 inches in diameter. After use, mix some soil into the cat hole with a stick and cover it with the remainder of the soil. Disguise the hole by covering it with leaves or other brush. Pack out your toilet paper in a plastic bag. Be especially careful not to pollute near water.

Leave What You Find

Leave all natural and historical items as you find them for future visitors to enjoy. Do not disturb items, and contact local historical groups to learn about artifacts. Before picking any wild edibles, consider that you might negatively affect an important food source for wildlife.

Minimize Campfire Impacts

Campfires are no longer permitted in the Adirondack eastern High Peaks. It is possible that these regulations could apply to other areas in the future. Campfires contribute to defoliation, scarification, and potentially to forest fires. Where fires are permitted in designated campsites, a campfire ring is provided. Keep fires small and under control, and make sure they are extinguished completely before you break camp.

Respect Wildlife

Remain reasonably quiet while in Adirondack Park's open spaces, and give animals enough space so that they feel secure. When you are watching wildlife, if you notice animals changing their behavior, you are most likely too close. Avoid nesting or calving sites and never attempt to feed wildlife. For low-impact wildlife-watching tips, visit Watchable Wildlife's website, watchablewildlife.org.

Be Considerate of Other Visitors
Refrain from using cell phones and radios. When hiking or cycling, take rests on the side of the trail so that other hikers do not have to walk around you. On the water, remember that sound carries a long way. Purchase tents and boats in natural colors. Dogs are allowed on most trails in the Adirondacks, but must be kept in sight and under voice control at all times. In some areas, they must be leashed.

AMC is a national provider of the Leave No Trace Master Educator course. AMC offers this five-day course, designed especially for outdoor professionals and land managers, as well as the shorter two-day Leave No Trace Trainer course at locations throughout the Northeast.

For Leave No Trace information and materials, contact the Leave No Trace Center for Outdoor Ethics, P.O. Box 997, Boulder, CO 80306. Phone: 800-332-4100 or 302-442-8222; fax: 303-442-8217; web: lnt.org. For a schedule of AMC Leave No Trace courses see outdoors.org/education/lnt.

Adirondack Mountain Club

The Adirondack Mountain Club (ADK) is a nonprofit organization dedicated to the protection and responsible recreational use of the New York State Forest Preserve, and other parks, wild lands, and waters of the region. The organization is committed to recreation, environmental advocacy, informational publications, and trail stewardship. In addition to operating two lodges and a wilderness campground in the Adirondack Park, ADK maintains many of the trails described in this book. For more information about the organization, visit adk.org.

Introduction to the Adirondacks

...these lands should be preserved; and for posterity set aside...
—Verplanck Colvin, 1883

NEW YORK STATE'S ADIRONDACK PARK IS THE LARGEST DESIGNATED park in the contiguous United States, a 6-million-acre landmass slightly larger than the state of New Hampshire. The park encompasses the largest designated wilderness areas east of the Mississippi River, including both public and private lands, with 2.5 million acres (40 percent) belonging to the state in the form of forest preserve lands. (New York State's remaining designated forest preserve lands are in the Catskills.) Adirondack Park is larger than Yellowstone, Yosemite, Glacier, Grand Canyon, and Great Smoky Mountain national parks combined. It contains 85 percent of the Northeast's wilderness, and only .01 percent of its concrete. It has 46 peaks over 4,000 feet; in contrast, the entire neighboring state of Vermont has eight.

Occupying 20 percent of the state's total land, the Adirondack Mountains are the principal highlands region in eastern New York. The range is bordered by the lowlands of Lake Champlain and Lake George to the east and the Tug Hill plateau in the west. The St. Lawrence River forms the natural northern boundary, with the Mohawk and Black rivers to the south and west, the headwaters of which the Adirondacks supply. The Adirondacks are often grouped with the Appalachian mountain chain, though geologically they are the most southern extension of the Canadian Shield. This is the same billion-year-old rock that covers most of eastern Canada and Greenland, and is among the oldest surface rock on the planet.

The Adirondacks' rugged scenic appeal—the open peaks and extensive spruce-fir forests—and ecological diversity, which differs markedly from the

rest of the state's, are due to the fact that they represent the southernmost extension of tundra and boreal forest in the United States. This in part accounts for their tremendous appeal to hikers, who are able to see hundreds of other peaks and landmarks from these higher, unobstructed summits.

These scenic and natural attractions inspired early environmentalists to raise the call to protect the Adirondacks. The earliest legislation was intended to protect the state's water supply for the purposes of commerce. Unregulated logging had reached destructive levels by the early 1800s, but it would take another 50 years for geologists, writers, and surveyors—the first visitors to gain a comprehensive grasp of the Adirondacks as a beautiful and vitally important human resource—to call for protective measures. In 1837, Ebenezer Emmons, while conducting a natural history survey for the state, named Mount Marcy (after the governor and proponent of the survey, William Learned Marcy) and proposed to name the mountain range the Adirondacks, after "...a well-known tribe of Indians who once hunted here...." The name was derived from the Mohawk word *ratirontaks*, a defamatory term the Mohawk applied to their Algonquin neighbors to the north, with whom they competed for hunting territory. The word is taken to mean "they who eat trees," or "bark eaters," in reference to the fact that during times of scarcity, hunters would chew the sweet bark and buds of trees for nourishment.

These early visitors would not be the only people to answer the wilderness call of the Adirondacks—many more would follow. However, their prophetic influence would result in a continuum of land acquisitions and protections leading to the formation of the forest preserve. Verplanck Colvin, a state land surveyor, was instrumental in developing the idea for a state park when he proclaimed in his 1883 survey that "...these forests should be preserved; and for posterity set aside, this Adirondack region, as a park for New York...".

Colvin's advice led directly to the 1885 law that stated, "All the lands now owned or which may hereafter be acquired, constituting the Forest Preserve as now fixed by law, shall be forever kept as wild forestlands. They shall not be leased, sold or exchanged, or be taken by any corporation, public or private, nor shall the timber thereon be sold, removed, or destroyed." At the same time, the state's first forest commission was created and the first parcels of forest preserve in the Adirondacks and the Catskills were designated. Visitors to the Adirondacks will hear frequent references to the

"forever wild" clause of the state's constitution, for it represents the only such protection (by amendment) granted to public lands in the United States.

Adirondack Park was established in 1892, its boundaries defined on early maps with a blue line. Thus, being "inside the blue line" is today a commonly used reference to being inside the park itself.

With 8,000 square miles of mountains and an estimated 2,000 miles of foot trails, hikers can find a lifetime of opportunities for exploration here.

Climate

The Adirondack climate requires careful preparation for any type of outdoor recreation. The overall climate is highly changeable because of the range's high average elevation and its proximity to the Atlantic Ocean, Lake Ontario, and Lake Champlain. The Adirondacks are among the highest mountains in eastern North America (Mount Marcy is 5,344 feet), and the plateau's average lake and trailhead elevation is around 1,500 feet. The predominant environmental influences on the range are the prevailing southwest winds, which circulate northward from the Gulf of Mexico and bring large volumes of warm air to the region. Cold, dry air originating in the northern interior of the continent and the Hudson Bay area often brings long periods of stable, high pressure. Air from the Atlantic Ocean flows west and inland, bringing the same cool, damp, and cloudy air that affects the White Mountains, and that can spell trouble for the unprepared.

The pleasant southwesterly winds are the reason for the mild and frequently humid conditions that characterize the Adirondacks' moderate summer temperatures, and that temper the spring and fall conditions. Summer days are generally cool, with temperatures in the 70s. June and August can bring freezing temperatures at night, which has given rise to the familiar jest that Adirondack weather may be summed up as "eleven months of winter and one month of poor sledding." However, these temperatures represent the extremes in weather change, and visitors will generally find Adirondack weather to be very similar to conditions found in most upper-elevation areas of the eastern United States. There is no annual wet or dry season, although drought is not uncommon and can create fire hazard conditions in the forest preserve (see page 63 for more information about forest fires in the Adirondacks). The average annual rainfall is 50 inches.

Winters are typically very cold (although the year-round temperature has risen steadily over the past 30 years), with the lowest recorded temperature

being minus-52 degrees in Old Forge in February 1934. There are on average 40 days of subzero temperatures a year. Annual snowfall can be as much as 175 inches. Hikers traveling at upper elevations, especially above treeline, and at the extremes of the seasons will experience temperatures up to 15 degrees colder than those at the trailhead. With wind chill, those temperatures will feel even colder.

Maps

This book's maps are meant to complement maps of greater detail, which are listed in the chapter headings. Curiosity and the benefits of being well informed afield will motivate you to find a variety of excellent maps. The most recent USGS topographic maps covering each destination are included in the outing's heading, but be aware that hiking trails are not always shown on USGS maps, and when they are, they are not always accurate. Many trails have been relocated over the years and USGS maps cannot be updated regularly enough to ensure accurate information. Some of the other maps listed in the trips will lead you to the trailhead, but may not have sufficient trail detail, in which case you will need supplemental maps— all of which are suggested.

As for other state park and regional park maps, there are many to choose from. Keep in mind that this book's maps are not designed for land navigation, and that wherever you enter the wilds, you should carry a map and compass and know how to use them. For road navigation, carry a regional road map. An excellent all-around resource is the DeLorme *Atlas & Gazetteer* for New York State, which provides comprehensive topographic map coverage for the entire state, with enough detail to find trailheads and other amenities. Once you get to the trailhead, you'll need a dedicated trail map.

Lodging and Camping

Adirondack Park offers a wide variety of lodgings, with hotels and motels in the major towns and villages as well as bed-and-breakfasts in the more touristy locations. The Adirondack Mountain Club (ADK) maintains Adirondak Loj, an historical lodge on Heart Lake, which is situated very close to the interior High Peaks trail system, 8 miles south of Lake Placid. The club also maintains a wilderness campground on Heart Lake, with lean-tos and canvas cabins. ADK operates Johns Brook Lodge, Grace Camp, and Camp Peggy O'Brien in the backcountry of John's Brook Valley, 3.5 miles

from any road. Members of ADK receive discounts at the lodges as well as various membership benefits. The Appalachian Mountain Club does not have an Adirondack chapter, although it does conduct activities within Adirondack Park.

Recreational visitors will be pleased to find a wide assortment of state campgrounds in the park, many of which make ideal staging areas for the activities described in this book. (These are pointed out in the text.) Seasonal opening dates for state campgrounds vary, but on average begin on May 20 and close from early September to mid-October. Day-use fees range from $6 and up, with overnight tenting fees averaging $18 to $28. Campers who are not New York State residents are charged an additional $5 fee per night at all facilities. State campgrounds are frequently situated in very attractive and wild settings, and because they tend to be destinations for long-term summer vacationers, they often fill to capacity in July and August. Reservations are advised, and can be made in advance through Reserve America.

Of course, you can take your chances and arrive at the campground without reserving ahead of time and usually be given a site, but there's no guarantee, especially at the height of the season from mid-July to the end of August. If you wish to have a particular site, all facilities offer site-specific reservations. The maximum continuous stay at any state campground is 14 nights.

State campgrounds offer varying levels of access and amenities, depending on their location and design. Some have auto access only, many have both auto and boat access, and some (such as the Lake George Islands and Indian Lake Islands) have boat access only. Some sites within the campgrounds can be reached only on foot. Check ahead of time for available amenities, such as boat launches, trailer launches and RV hookups, and the location of other nearby launches and facilities. While most state campsites provide amenities for people with disabilities, such as campsite and shower accessibility, this is not always the case and should be established ahead of time.

Green Recreation—Camping for Free

With the price of campsite use, fuel, and food on the rise, one of the great attractions of practicing green (non-motorized, self-powered, environmentally friendly) recreation is the savings and enjoyment you and your family will realize by camping in the wild, free of charge. Opportunities to camp for free abound in the Adirondacks, and where applicable or advisable, are

described in each trip. In the rare instance that you cannot find a designated campsite, it is legal to camp anywhere in the state forest preserve as long as you stay at least 150 feet from a trail, road, or water source (unless otherwise specified), and you camp below specified elevations (see the Rules and Guidelines section below).

Hundreds of free, designated campsites are throughout the park, with a limited number accessible by car. These are also pointed out in the text when they lie in proximity to suggested outings. With few exceptions, nearly every trip described in this book provides an opportunity for camping in the wild. Whether it is a backpacking or day-hiking trip where the opportunity to camp is always near at hand; a canoe trip, where camping is either part of the experience or a suggested option; or a cycling trip, where camping is not as feasible but is still a possibility, you will continually be invited to camp out, free of charge, and you should arrive prepared to do so. This will extend your recreation kitty and enable you to spend an even longer time in the Adirondacks. (See Appendix B for more information.)

Rules and Guidelines for the Use of Public Lands Managed by the New York State Department of Environmental Conservation:

- Camping is prohibited within 150 feet of any road, trail, spring, stream, pond, or other body of water, except at areas designated by a "camp here" disk.
- Groups of ten or more persons or stays of more than three days in one place require a permit from the New York State Forest Ranger responsible for the area.
- Lean-tos are available in many areas on a first-come, first-served basis. Lean-tos cannot be used exclusively and must be shared with other campers.
- Use pit privies provided near popular camping areas and trailheads. If none is available, dispose of human waste by digging a cat hole 6 to 8 inches deep at least 150 feet from water or campsites. Cover it with leaves and soil.
- Do not use soap to wash yourself, clothing, or dishes within 150 feet of water.
- Drinking and cooking water should be boiled for five minutes, treated with purifying tablets, or run through a filtration device to prevent giardia infection.

- Fires should be built in existing fire pits or fireplaces, if provided. Use only dead and down wood for fires. Cutting standing trees is prohibited. Extinguish all fires with water and stir the ashes until they are cold to the touch. Do not build fires in areas marked by a "No Fires" disk. Camp stoves are safer, more efficient, and cleaner.
- Carry out what you carry in. Practice Leave No Trace camping.
- Keep your pet under control. Restrain it on a leash when others approach. Collect droppings and bury them away from water, trails, and campsites. Keep your pet away from drinking water sources.
- Observe and enjoy wildlife and plants but leave them undisturbed.
- Removing plants, rocks, fossils, or artifacts from state land without a permit is illegal.
- The storage of personal property on state land is prohibited.
- Carry an approved personal flotation device for each person aboard all watercraft.
- Except in an emergency or between December 15 and April 30, camping is prohibited above an elevation of 4,000 feet in the Adirondacks.
- At all times, only emergency fires are permitted above 4,000 feet in the Adirondacks.

Emergencies

In case of emergency, call Regions 5 and 6 emergency dispatch at 518-891-0235, available 24 hours a day. You can also call a New York State forest ranger or the state police. See Appendix A.

Hunting Season

Hunting is allowed in Adirondack Park. Because of the difficulty involved in moving big-game animals, hikers cannot expect to see many hunters on the interior trails of the High Peaks. Hunting parties are more common on easier terrain, and will be encountered using boats and hunting from camps on lakes and rivers. Participants in any outdoor activity conducted during hunting season—including pets—should wear some article of blaze-orange apparel.

Big-game seasons in the Adirondacks are usually as follows, but are subject to change locally and from year to year:

- *Early Bear Season:* Opens the Saturday after the second Monday in September and continues for four weeks

- *Archery Season (deer and bear):* Opens September 27 and continues to the opening of the regular big game season
- *Muzzle-loading Season (deer and bear):* Opens seven days prior to the opening of regular season
- *Regular Season:* Opens the next-to-last Saturday in October and continues through the first Sunday in December

Choosing Your Trip

The 50 hiking, biking, and paddling trips in this book provide a variety of outdoor experiences and most can easily be turned into overnights. Once you have determined the interest of your group (scenery, camping, exercise, wildlife viewing), select a trip that you feel falls well within the interest and ability level of everyone involved. Consider the distance and elevations you are willing and able to undertake, balanced against your time constraints. Use the At-a-Glance Trip Planner that follows the table of contents. This will give you information about the difficulty, length, and highlights of each trip. Please read the entire trip description before setting out—important details such as equipment recommendations, trail characteristics, and various bits of advice are embedded in the text. Err on the side of caution with all of the trips, but be especially careful with longer, more difficult outings when budgeting your time. Allow plenty of daylight for longer trips, and have an alternative, easier trip planned if you can't adhere to your original objective.

Consider bringing your own children or those of friends on appropriate trips. Frequent, unstructured outdoor play can increase children's health, school performance, self-esteem, and feelings of connection to nature. Kids who feel connected to nature today are likely to be tomorrow's conservation leaders. The Appalachian Mountain Club is committed to helping kids build strong connections to the outdoor world, including its protection. When you bring young people outdoors, you should teach them to take care of the natural resources around them.

Trip Planning and Outdoor Safety

Hiking in the Adirondacks

You will come to know the land and to develop a sense of love and reverence for all that it embraces.

—Barbara McMartin

Outdoor recreation in the Adirondacks increased dramatically during the early 1900s. The state responded quickly, building campsites, trails, boat launches, fire towers, lean-tos, and supporting infrastructure, a trend that has resulted in today's 2,000 miles of designated and marked trails (the largest designated trail matrix in the country). There are 46 peaks over 4,000 feet—known as "The 46 Adirondack High Peaks"—nine of them with alpine summits, and a hundred peaks over 3,500 feet. Many hikers aspire to join the Adirondack Forty-Sixers (adk46r.org), admission to which is granted when one has climbed all 46 High Peaks (20 of them do not have trails, but all have summit signs). Joining in a guided hike led by one of the knowledgeable 46ers is an ideal way to discover the vast Adirondack backcountry. The Adirondack Mountain Club (adk.org) is another; this nonprofit, member-supported club is headquartered in Lake George. The club's various chapters conduct year-round hiking and other outings in the Adirondacks. The Appalachian Mountain Club's New York State chapters also lead trips here.

The Adirondack backcountry is a vast and storied wilderness, one of open summits, dense boreal and hardwood forests, deep ravines, extensive bogs and wetlands, cascading brooks, and waterfalls. Wildlife habitats are diverse, supporting a wide range of mammals, breeding birds, migratory birds, and plant life. Eagles, ospreys, bobcat, and lynx are common, as well as white-tailed deer and coyotes. Once in a while a moose will be spotted. Debate exists over whether to reintroduce timber wolves, which many people claim have reestablished themselves in the park in small numbers. Black bears are frequent visitors to some of the more intensively used areas of the park, even in remote wilderness campsites—and the Department of Environmental Conservation mandates the use of bear-resistant canisters in the eastern High Peaks region. Using normal precautions and common sense, hikers have no reason to avoid such places for fear of experiencing bear problems.

Because of the size of Adirondack Park and the remoteness of the trails that penetrate its wilderness and wild forest areas, trips into the backcountry can often require as much as 15 miles or more of hiking. Trails are rugged and rocky, requiring durable footwear, preferably with lugged soles. Sudden weather changes require that you carry suitable waterproof outerwear. Distance and difficulty are compounded by elevation changes, which are often significant, especially in the High Peaks region. A hiker unfamiliar with the park easily can be overwhelmed by the seemingly unlimited destinations and the trail connections and combinations required to reach them, so carrying a good map is essential. Contrastingly, many of the trails in the park discussed in this book are among the easiest and most accessible, with a scenic and wild appeal that is similar to that of the most difficult and rugged of the High Peaks.

Because of the immense landmass of the Adirondacks, no single book deals comprehensively with all of the hiking trails. For that reason, this publication covers routes that are considered to be among the most interesting, scenic, accessible, or otherwise desirable for a variety of reasons. These are trails that will provide an overview to the park and its many facets, while at the same time offering a satisfying wilderness experience, in proximity, where possible, to excellent state campgrounds that can be used as staging areas.

Hiking Times and Trail Ratings
Many of the routes in this book will require considerable effort, and each will demand planning and preparation. Once you are familiar with the vari-

ous regions and highlights of the park, you will have become an informed backcountry user, and will enjoy devising trips of your own into areas that are not included here.

With the exception of a few highly recommended overnight backpacking trips, the hikes in this book can be done in a single day or less, allowing you to travel light and fairly quickly, leaving time to enjoy base camp activities in addition to your hikes. The hiking times provided for each trip are based on a person of average fitness carrying a lightweight daypack (under 10 pounds in summer; under 20 pounds in winter) and traveling without children. Weather, elevation, and the number and fitness level of companions, especially children, will affect your hiking times and require different levels of planning and preparedness. Over the kinds of varied terrain encountered in the Adirondacks, average day-hikers will usually travel at around 2 MPH. With steep terrain, and with a heavier pack, this speed drops significantly.

Distances in each hike's heading are for the entire round-trip. Mileage has been derived electronically, from topographic maps, so in the majority of cases it is slightly different from what you'll see on state trail signs, the numbers of which were most likely calculated before the advent of electronic maps. As a general rule of thumb, never place complete faith in state trail signs.

Elevation gains have also been calculated electronically, and so they are cumulative. These numbers reflect the entire elevation gain of a hike (not simply the summit or destination elevation minus the trailhead elevation). With a little experience, you will be able to determine the effort required to comfortably manage distance and elevation gains with less guesswork. For example, a 5-mile hike with 1,000 feet or less of cumulative elevation gain may feel comfortable to you for a given afternoon's outing, but the same-distance hike with 2,000 feet of gain represents twice as much aerobic effort (assuming that walking on level ground is not aerobic exercise). Using the book's system of rating trips as easy, moderate, or strenuous, such extra elevation would turn a moderate hike into a strenuous one. Accordingly, in very general terms, it is the elevation gain more than the distance that determines the difficulty of a hike.

Easy trails are those that follow gentle terrain or are limited to short, sometimes steep pitches that can be managed by families with kids of any age, provided they can walk for themselves and will follow directions. Many of the trails in the book lie in close proximity to rushing rivers, steep or vertical

drops and other natural potential hazards, so parents of small children should determine the suitability of a particular hike only after carefully reading the text. Moderate hikes will generally have more distance and/or elevation gain, requiring a greater degree of physical effort and preparedness. Children with hiking experience, energy, and enthusiasm, who are able to carry their share of provisions, will feel at home on such trails. The trails listed as strenuous in this book require extended periods of aerobic effort because of substantial elevation gain and linear distance, and in many cases involve scaling ladders, ascending steep slopes, or scrambling, sometimes using all fours. Difficulty will be greater when trails are snow-covered or during periods of rain or ice, when additional time, effort, and caution will be required.

Biking in the Adirondacks

Of all the roads you travel, make sure one of them is dirt.

—Anonymous

Bicycling of all kinds is an increasingly popular activity in the Adirondacks. Touring cyclists have enjoyed the park's scenic roads for decades, while more recent improvements in designated bikeways, as well as motorists' increasing awareness and acceptance of bicycles, have led to improved highway cycling conditions. More and more, cycling is being considered a viable alternative to vehicular travel, a form of green recreation and eco-commuting that improves health and reduces greenhouse gases.

Because of undefined state land-use policies, which until fairly recently meant a lack of designated all-terrain bicycling (ATB) trails, the off-road, fat-tire crowd has gained traction throughout the park only in the past decade or so. Part of the problem was that all-terrain bikes, and the enthusiastic riders who embraced them, were moving a great deal faster than any policy-making group could react. But eventually the policies were updated, and today, hundreds of miles of interesting back-road and off-road trails are designated for use by hybrid and mountain-biking enthusiasts, who enjoy the serenity of the forests without the interruptions or hazards inherent in sharing the road with vehicular traffic.

Land-use planners and seasoned ATB riders are quick to point out that the Adirondack high-peak area is characterized by "self-limiting" terrain, which acts to reduce the useable mileage of off-road cycling trails. Added to this is the fact that no bikes are allowed in the designated wilderness areas

of the state's forest preserve, and correspondingly, there is limited access to the sensitive High Peaks region and related upper-elevation areas. However, a great deal of mileage awaits the off-road cyclist in the extensive wild forest areas.

The bike routes in this book are geared toward off-road cyclists, since this sort of cycling is generally considered a safer, more family-oriented pursuit than highway riding. A few routes do share the road with vehicles, but these are in areas (such as the Moose River Plains) where the roads themselves require slow going or receive little traffic to begin with.

Before the advent of paved roads, the Adirondacks were logged, mined, penetrated by railroads and stages, and explored by means of rough paths, wagon roads, portage routes, skid roads, and, later, fire roads that reached into remote locations. Many of these routes became hiking trails, and some ultimately became bike trails. Reacting to the sudden increase in mountain bikers, towns and counties eagerly cooperated by designating their existing multi-use trails as cycling trails. As a result, bikers share paths that have been used as all-terrain vehicle (ATV) trails, snowmobile trails, cross-country ski trails, and equestrian trails.

The best examples of such trails lie in the southwestern areas of the park, around Old Forge and Inlet, where the seeds of ATB advocacy in Adirondack Park began in the mid-1990s. Races, rallies, and events were organized. Many people realized that cycling was a form of recreation in which the Adirondack blackfly might be successfully outrun—and the immortal Black Fly Challenge was born. The race is an annual event, open to anybody. It is as much an introduction to sanctioned bike racing as it is a fun family outing. This 40-miler runs between Indian Lake and Inlet, crossing the Moose River Plains, one of the largest blocks of wild forest in the Adirondacks. Ride fast enough, and you'll stay ahead of the flies. Slow down too much, and maybe they'll get you!

The bike outings in this book are not based as much on fitness as on sightseeing and relaxed touring. Times are estimated for riders of average fitness and basic skills. There are no overly steep inclines, few trails requiring advanced technique, and limited single-track trails. Accompanying small children or pulling tagalongs, which are appropriate for only a few of these rides, such as the paved Warren County Bikeway, will add time to any ride. (Take precautions to protect infants in bicycle trailers from bugs and sunburn.)

Cycling in the park offers tremendous opportunities for exploration and bikepacking overnights, and these locations are mentioned in the book

where they exist. Keep your bike tuned and well lubricated, and it will be a quiet means of approaching wildlife, just like a properly handled canoe, or silent footfalls on the soft earth of a forest footpath.

Canoeing in the Adirondacks

Wild rivers are the museums of the natural world.
—Paul Jamieson, *Adirondack Canoe Waters: North Flow*

Retreating glaciers left a mind-numbing 30,000 miles of brooks and streams, 6,000 miles of rivers, and nearly 3,000 lakes and ponds across the ice-gouged Adirondack plateau. These waters dissect and drain the uplands, flowing north to the St. Lawrence River and Lake Champlain (the North Flow), and south into the Mohawk and Hudson rivers (the South Flow). Using this intricate, connected system of rivers, lakes, and ponds, it is possible to paddle a small boat for a hundred miles across the Adirondacks. The Mohawk took advantage of these waterways when they ventured into the area seasonally to hunt, fish, and forage. For long-range travel and trade to the north, they used Lake Champlain; however, the interior forest route provided shelter from headwinds and enabled easier travel than the windy and often tempestuous lake.

By the middle of the nineteenth century, the Adirondacks had become the premier destination in the country for recreational boat travel. The preferred crafts were the canoe and the Adirondack guide boat, an indigenous design. These small, fast, lightweight rowing boats (typically steered by a stern paddler) have a large carrying capacity and were the favored craft of guides, hunters, and anglers. As the monied leisure classes moved into the area, they established summer camps and hostelries along the banks of the larger lakes and rivers, when small boats were the only means of travel.

Early guides and adventurers knew the waterways as well as we know the roads of today. Indeed, until the late nineteenth century, roads didn't exist here—only footpaths connecting the interior "highway" matrix of lakes and rivers. Access to the area was established originally by rail and steamboat. As civilization came to the Adirondacks, the larger lakes had fleets of steamboats that freighted passengers and materials from railhead to railhead. Early writers and developers did much to popularize the area, promoting it as a utopian paradise with infinite quantities of fish and game, the numbers of which have been systematically depleted. But the Adirondacks were difficult

to live in or farm or otherwise develop, and the area resisted the kind of settlement that many speculators envisaged. The rivers would run free and logging would be halted as the state took over the lands. And the waterways remain, much as they have from the end of the ice age.

By 1850, canoeing as a form of recreation was beginning. In the 1880s, Nessmuk (the pen name of George Washington Sears) made three summer trips through the Adirondacks in the *Wee Lassie* and the *Sairy Gamp*, tiny cedar canoes built by J. Henry Rushton of Canton, New York. Rushton canoes were of such high quality that they inevitably became family heirlooms. Many are on display today in the Adirondack Museum in Blue Mountain Lake. Nessmuk was a small man, weighing not much more than 100 pounds, and his boat plus his gear for a month's cruise weighed in at less than 30 pounds. (His ability to hunt and fish allowed him to travel light.) His accounts were among the most tantalizing ever written about the Adirondacks, and popularized the area's canoeable waters while giving rise to the concept of lightweight camping. Rushton's small paddle and sailing canoes quickly became the staple craft for interior forest travel in the North Woods. Many of Rushton's designs are copied today, some still built of cedar strips, but others of more durable Kevlar and carbon fiber. These little boats are known for their low weight (typically 10 to 20 pounds) and ease of handling, and anglers use them to get to remote ponds. They are ideal for teaching children the art of solo paddling. You'll see these boats throughout the Adirondacks.

Many long-distance canoe routes in the park do not require the kind of portaging that early guides readily undertook to reach the backcountry. It is certainly true that the existence of a carry is often the reason for a certain area's appeal—as it tends to eliminate the number of visitors—but portaging will always be a way of life in the Adirondacks. And, while I have taken measures to include routes that limit the most difficult ones (the longest portage in the book is 1.3 mile, at Raquette Falls on the Raquette River), they cannot all be avoided.

Island camping, pond hopping, and river tripping opportunities exist throughout the Adirondacks, and the best of them are included here. Eventually, you will want to graduate to moving water. One such outing is included here. There are Class I and II rapids on the Schroon River, but these rapids, which vary according to the season, can be avoided by carrying. Some portages are required to access the St. Regis canoe area, but these are short and relatively flat. With the exception of the Schroon River, none of the trips is sensitive to normally fluctuating water levels to the point that they

are not navigable. The best thing about canoeing in the Adirondacks is that, nearly without exception, the opportunity to camp in the forest preserve is always close at hand, and in most cases is free. The distances in the trips' headings are line-of-sight–based and assume that you will be following the shore most of the time. Conditions will sometimes mandate a change in your route, for example, when one shore is preferable to another for protection from the wind. Times are estimated based on the average paddler's ability and accommodate a short stop for lunch. If you are carrying excessive weight, have kids along, or are paddling tandem at expedition weight, your times will increase. Also, skills such as the J stroke will improve your traveling efficiency and enjoyment of the sport (visit outdoors.org/recreation/paddling for paddling tips).

While you will invariably see many classic canoes and designs of varying vintage, shape, and size everywhere in the park, the most common canoes in use on Adirondack waterways are traditional production tandem tripping and touring boats in the 16- to 18-foot range. Because of the size of most lakes and rivers, which give rise to varied and often challenging conditions, kayakers use sea kayaks or larger-volume touring outfits. In the backwoods, lightweight boats are preferred for their ease of carrying. All of the trips in this book can be undertaken with standard touring canoes or kayaks. A boat that will serve you well on a small pond, however, may be a liability on a large lake. Of course, every boat has limitations, and it is not so much the type of craft you use, but rather good judgment and preparation, that are key to comfortable, safe travel in the wilderness.

Packing

The items in your pack will vary depending on the type of trip you are taking, in addition to the time of day and the weather. However, you should always have the following:

✓ Water: Two or more quarts per person depending on the weather and length of the trip.

✓ Food: Even for a short, one-hour trip, bring high-energy snacks like nuts, dried fruit, or snack bars. Pack a lunch for longer trips.

✓ Map and compass

✓ Extra clothing (at least a windbreaker)

✓ Flashlight

✓ Sunscreen

✓ First-aid kit

✓ Pocketknife

Section 1

High Peaks Region

THE HIGH PEAKS REGION IS THE HIKING HUB OF THE ADIRONDACKS.
Located in the northeastern quadrant of Adirondack Park within Essex and
Franklin counties, this upper-elevation landmass encompasses the villages
of Lake Placid, Saranac Lake, Keene Valley, Keene, and Newcomb. The area
is roughly bounded by NY 28N and NY 2 in the south, US 9 in the east, and
NY 3 and NY 30 to the north and west, and is nearly bisected by NY 86 and
NY 73.

Rocky, open summits; dense boreal and hardwood forests; alpine lakes;
meadows; wetlands; bogs; and many miles of streams characterize this area.
Forty-six peaks rise above 4,000 feet, and all but 20 have marked trails
to their summits.

Like the rest of Adirondack Park, the High Peaks region contains a
combination of private and public lands. Public lands are classified, for
management purposes, as wilderness (foot travel only, and limited or no
structures); wild forest (more intensive use); and primitive (may contain
structures, roads, and private parcels). While several smaller designated
wilderness areas exist in the region, 33 of the High Peaks are located within
the eastern and western High Peaks Wilderness Area zones, which also
include several wild forest and primitive areas.

The main attraction of the High Peaks area is the wilderness experience
it provides. Secluded trails lead to the park's highest summits and largest
tracts of state forest preserve lands, enabling hikers to undertake short
day outings or long multiday and overnight hikes in loops or as end-to-
end journeys. Cyclists can enjoy road biking with alpine scenery or miles of
single-track off-roading.

None of the High Peaks described in this book requires technical skills,

although several are considered strenuous. All are marked with state trail disks and signage. Most have very steep sections. High Peaks destinations require that more attention be paid to the risk of a long fall.

Unfortunately, high levels of public use have caused serious negative impacts in this area, particularly in the upper-elevation alpine zones, and hikers should be careful not to contribute to these. A few special regulations in addition to the usual state forest preserve regulations apply in the High Peaks zones:

- Pets must be leashed in most areas (on marked trails, at campsites and lean-tos, above 4,000 feet, in public areas). Proof of current rabies inoculation is required for dogs.
- Camping groups are limited to eight in the High Peaks' wilderness areas.
- Day-hiking groups are limited to fifteen.
- Skis or snowshoes must be worn or carried when snow depth exceeds 8 inches. Crampons may be necessary when the trail is icy.
- Fires are not allowed anywhere or for any purpose in the eastern High Peaks.
- A bear-resistant canister must be used in the eastern High Peaks from April 1 through November 30.

TRIP 1
MOUNT JO

Rating: Easy
Distance: 2.3 miles
Elevation Gain: 700 feet
Estimated Time: 2.0 hours
Maps: USGS North Elba 7.5; USGS Keene Valley 7.5x15; National
Geographic Adirondack Park: *Lake Placid/High Peaks*; Adirondack
Maps, Inc.: *The Adirondacks High Peaks Region*

**An easy climb along a signed interpretive trail, from Heart
Lake and the Adirondak Loj and campground complex, leads
to spectacular views of the High Peaks Wilderness Area and
Mount Marcy.**

Directions

From Exit 30 of the Adirondack Northway (I-87), turn left off the exit ramp
and take NY 73 west toward Lake Placid. Go through Keene Valley at 10.5
miles, pass the Mount Van Hoevenberg Olympic Recreation Center at 23
miles, and in North Elba bear left onto Adirondak Loj Road at 26.0 miles.

From the Lake Placid traffic light at the intersection of NY 86 and NY 73
in the village, go 3.4 miles south on NY 73 to Adirondak Loj Road. Turn
right here.

Go south on Adirondak Loj Road, where you'll see a sign for the High
Peaks Wilderness Area. Follow the road south 4.6 miles to Adirondak Loj.
(Note the turnout at 3.6 miles on the left. This is South Meadows Road,
where free primitive camping is allowed.) At the Adirondak Loj parking
kiosk, pay the daily parking fee. Park in the designated parking area next
to the High Peaks Information Center. *GPS coordinates:* 44° 10.959′ N, 73°
57.977′ W.

Trip Description

Mount Jo (2,876 feet) is perhaps the most approachable and well-loved little
peak in the Adirondacks, the centerpiece of what has been called the area's
"finest square mile." It is the geologic mascot of the Adirondack Mountain

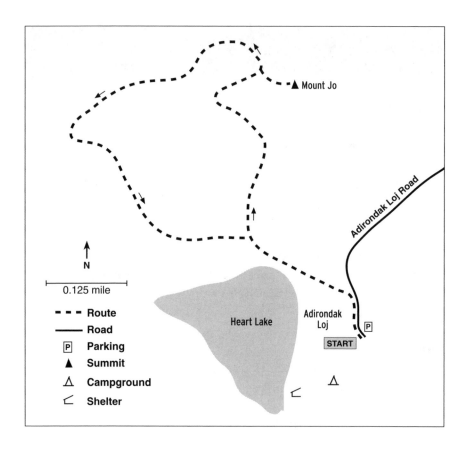

Club, named for Josephine Scofield, fiancée of Henry Van Hoevenberg (see page 7), founder and builder of the first Adirondack Lodge (which would later be called "Adirondak Loj").

Not only is Mount Jo as cordial and attractive as a mountain can be, it also sits at the nerve center of the Adirondack High Peaks—ADK's Adirondak Loj property (the Heart Lake Program Center) on Heart Lake. The trailhead is only a stone's throw from the parking area at the High Peaks Information Center, ADK's information clearinghouse for the High Peaks Wilderness Area where you can purchase maps, snacks, and a selection of day-hiking gear. The staff is knowledgeable about the High Peaks trails and can help you with route planning while providing up-to-date trail conditions.

Park your car and visit the High Peaks Information Center at the head of the visitor parking lot. Request the interpretive brochure *Reading the Landscape of Mount Jo,* which you can borrow or purchase for only 25 cents.

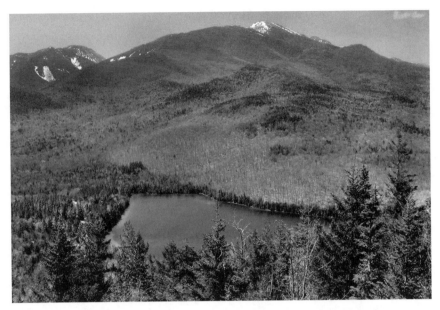

Marcy, Colden, and Algonquin rise to the south over Heart Lake in the High Peaks Wilderness Area.

This brochure describes the interpretive stations along the trail. Go back to the parking kiosk and walk diagonally across the road 200 feet to the visible Indian Pass/Mount Jo trailhead sign (red markers). The next section of trail is probably the best-maintained in the Adirondacks. The trail is gravel-covered, self-guiding, and well marked. At a T intersection, bear right. Pass the little nature center on the left. Mount Jo Trail bears right, leaving Indian Pass Trail at the point where an observation platform over Heart Lake can be seen to the left.

Within fifteen minutes of level walking from the parking area, you will come upon the trailhead kiosk and register. Soon you will reach a T. This is a loop hike. Short Trail, which rises steeply, goes right. Long Trail, to the left, is longer but provides a gentler rise in elevation. Go right on Short Trail, where the eight interpretive stations begin. The trail is briefly steep, ascending on rocks amid ledges and boulders, rising 600 feet in the next 0.4 mile. At Station 1, you'll see a pine stump remaining from the 1903 forest fire that burned the original Adirondak Loj and many of the surrounding peaks (including Mount Jo), leaving their summits bare. Fast-growing pioneer species (aspen and birch) took over, and spruce-fir (or second growth) took

over afterward. Additional stations describe forest succession, geology, fauna and flora, the function of groundwater in creating mosses and lichens, and the various techniques of trail maintenance, such as the stone steps and water bars you'll see on Mount Jo Trail. You become surrounded by boreal forest as you rise to ridge elevation, where you will bear right at a T (this is Long Trail, your return route) on leveling terrain, crossing a pair of puncheons over wet ground on the approach to the scenic westerly summit. From these open rocks, continue east a bit, where a step up onto a ledge brings you to the easterly summit with better views.

Your interpretive handout will come in handy for identifying the expansive landscape before you. The centerpiece of this sweeping view is Mount Marcy (5,344 feet, the Adirondacks' highest), with Mount Colden, Avalanche Pass, and Algonquin Mountain (5,114 feet, second highest) in the MacIntyre Range. Easily identified at the end of the down-sloping western shoulder of Algonquin is Indian Pass, with Wallface and its sheer easterly face rising above it. In the foreground above Heart Lake, it is easy to visualize the shape of a whale, with Wright Peak as its head, and the tail (shown on the interpretive guide) to the northeast (Whale's Tail Mountain). Street Mountain (with MacNaughton to the south of it) lies on the line of demarcation between the western and eastern High Peaks. You'll be able to identify many ranges and separate peaks, among them the Sentinel Range, Cascade, Porter, Big Slide, Boundary, Gray Peak, and Santanoni. Phelps Mountain stands close by in the southeast.

Retracing your steps over the rooty trail, bear right off Short Trail and descend on Long Trail, which sweeps around the western side of the mountain, passing Rock Garden Trail where it turns east again to join Short Trail. Long Trail is not as well maintained or marked as Short Trail. Watch the marking here as Long Trail follows a rocky streambed before leaving it to the left (east). Trail markers are white (ADK) as well as red through this section. The slow and easy descent will bring you back to the junction with Short Trail, where you began. On your way back to the parking lot and the High Peaks Information Center, follow the trail signs toward the Loj and take a quick peek inside at the rustic common room and fireplace. Have a look at Heart Lake and stroll through the campsite area on a circuitous route back to your vehicle.

The Legend of Henry and Josephine

If the Adirondacks ever had a first gentleman and lady, they would be Henry Van Hoevenberg (1849–1918; known affectionately as Mr. Van) and Josephine "Jane" Schofield, his paramour and putative fiancée. Henry and Josephine, both avid trampers, met on a hiking trip to Upper Ausable Lake in 1877, and quickly fell in love. When it came to pass that they wanted to choose a place for happy ever-aftering, they climbed Mount Marcy to survey the vast lands below. They settled on the area around a small heart-shaped lake (Clear Lake) that would later be named Heart Lake in honor of Henry's bride-to-be. Here, at the lake's edge, they planned to build their home and a guest lodge for wilderness vacationers and friends. The nearby mountain, then Mount Bear, was later renamed Mount Jo, also to honor Josephine. Henry was fond of calling this 640-acre parcel the "finest square mile" in the Adirondacks. A more auspicious beginning for a lifelong love could hardly be imagined.

But Josephine would never see the home and lodge they planned. She died in 1877 in what has since been described as an "accident" at Niagara Falls. A deeper inquiry into the circumstances surrounding Josephine's death suggests that it may not have been an accident: Many have speculated that Van Hoevenberg's family did not approve of the marriage, though there is little or no basis for this claim. Sandra Weber, author of The *Finest Square Mile: Heart Lake and Mount Jo* (Purple Mountain Press, 1998) points out that circumstantial evidence suggests the purported accident was most likely a suicide. It turns out that Josephine (who was suffering from tuberculosis) met Henry when she was already engaged to a Toronto man whom her father was pressuring her to wed. Unable to reconcile her situation, she may have chosen to end her life.

Heartbroken, Henry went on to complete the Adirondack Lodge, with construction beginning in 1878. He worked tirelessly with the Adirondack Camp and Trail Club, creating hiking trails that led from the lodge to the many High Peaks. Though the original lodge burned in 1903, the property is now owned by the Adirondack Mountain Club, which operates the rebuilt—and renamed—Adirondak Loj. Here, the memory—and some say the spirits—of the star-crossed Henry and Jo still resides.

TRIP 2
ALGONQUIN MOUNTAIN AND AVALANCHE LAKE $ 🐕 📍

Rating: Strenuous
Distance: 13.0 miles
Elevation Gain: 3,500 feet
Estimated Time: 6.0 to 8.0 hours
Maps: USGS North Elba 7.5; Keene Valley 7.5x15; National
Geographic Adirondack Park: *Lake Placid/High Peaks*; Adirondack
Maps, Inc.: *The Adirondacks High Peaks Region*

One of the most spectacularly scenic alpine treks in the east, this loop hike provides many opportunities for overnight camping.

Directions
See Trip 1 for directions to the High Peaks Information Center.
GPS coordinates: 44° 10.959′ N, 73° 57.977′ W.

Trip Description
Algonquin Peak (5,114 feet) is the centerpiece mountain of the MacIntyre Range. The hike described here takes you considerably farther than Algonquin's summit. The route climbs Algonquin using the first stretch of Van Hoevenberg Trail to Algonquin Peak Trail, then leads you back to Marcy Dam and Adirondak Loj in a loop formed by dropping down the south side of Algonquin through the remarkably dramatic backcountry of Avalanche Lake and into the otherworldly cliff and talus zone of Avalanche Pass.

Algonquin requires the same thorough level of preparation as the hike to Mount Marcy, so take a minute to review page 13. The two hikes are very similar in character, even though a hike to Algonquin's summit from Heart Lake and back is a shorter round-trip day hike by nearly 7 miles. Be prepared for any eventuality, and turn around on Algonquin's summit to retrace your steps back to Adirondak Loj if your party lacks the energy or enthusiasm to continue with the next rigorous section of the hike. This second section is mostly downhill, but is also steep, rugged, and, in some places, makes for a very slow-going pace over large boulders.

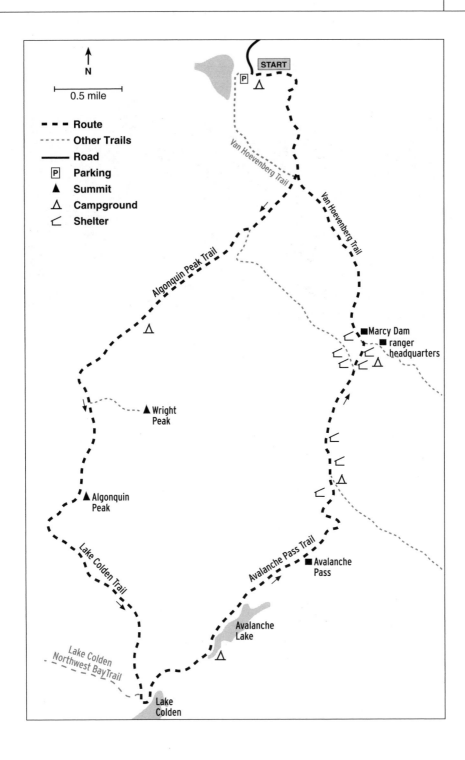

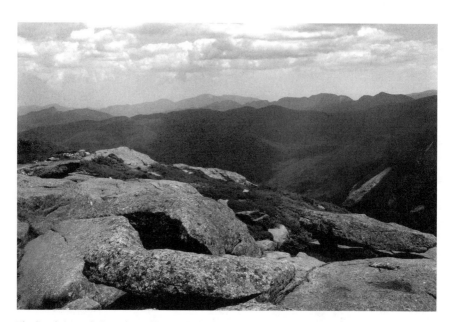

The hard-earned views from Algonquin Mountain are among the best in the Adirondacks.

From the parking lot, walk east to the trailhead kiosk and sign in. Follow the blue trail markers of Van Hoevenberg Trail and signage toward Mount Marcy and Algonquin. Walk through a maturing red pine forest before crossing Algonquin Brook and bear right at the end of the boardwalk. Within a mile of the Loj parking area, you will arrive at a Y intersection. Bear right toward Algonquin, following yellow markers. The trail begins to ascend here. At 1.4 miles, pass the Whale's Tail Notch ski trail on your left.

Cross a stream at 2.0 miles, then cross MacIntyre Brook at 2.5 miles, where a designated campsite is to the left of the trail in the vicinity of a small waterfall. A few low ledges follow. Ahead, a sign appears on a tree warning of the sudden weather changes that can occur at this elevation. Climbing another ledge, the trail turns toward the southeast. As you turn into the south at this point, you get the first glimpse of Algonquin.

Now you begin to walk along a pitched bedrock surface as you enter the alpine zone. At 4,030 feet, the trail to Wright Peak departs to the left. Most aspiring 46ers (see page xxxi) will bag Wright on the same day they climb Algonquin. A long, steep slab, smooth and angled enough to be hazardous when wet, follows. Stay low to the rock and use all fours when necessary.

The intensity of the pitch remains the same as the incline changes from slab to boulders to ledgy terrain, relaxing only at the point where the trail becomes tunneled in by spruce-fir scrub. Soon you come upon the open dome and see the summit ahead. Views of the surrounding country open up dramatically from this point. Cairns and yellow paint blazes identify the route.

At the summit, facing southeast, Colden is across the abyss of Avalanche Pass, right in front of you, with Marcy behind it. Moving north, Basin, Saddleback, Gothics, and Armstrong are prominent. Giant is obvious with its open slides. You can see Big Slide and the slide on its south side, and Hurricane with its fire tower in the far northeast. The Cascade Range, the Sentinels, and Whiteface follow, as you look to the left. You see the Saranac Lakes Wild Forest, and, moving west, the Sawteeth, the Sewards, and the Santanoni Mountains.

You will see the mat-forming heath Lapland rosebay in bloom by early summer, with its pretty lavender blooms. It is among the first of the alpine flowers to bloom in the High Peaks. You may also find alpine bilberry with its whitish-pink, bell-shaped flowers, along with various sedges and lichens. The soil here is very thin (from 2 to 12 inches) and highly sensitive to impact and erosion. Use care where you step and stay outside of the defined revegetation areas.

Head west off the summit toward Iroquois Peak, descending by the cairned route to join Lake Colden Trail at 0.3 mile. The trail to Boundary and Iroquois goes right. Mount Colden, with its dramatic bare slides and the deep cleft known as the Trap Dyke, sits immediately to the east. Go left, and descend the next rugged 1,900 feet over a distance of 1.6 miles, following a wide, flat, bedrock streambed where the trail goes in and out of the woods. The trail is well marked, but you will have to keep an eye on it. Continue to the intersection with the blue-marked Lake Colden Northwest Shore Trail. Turn left and continue to the yellow-marked Avalanche Pass Trail (0.2 mile). Go left toward Avalanche Lake (0.3 mile), passing a designated campsite on the right. Walk along the lake's western side over a system of hanging catwalks that are bolted to the cliffs just above lake level. The next 0.5 mile goes slowly, owing to the fabulous scenery and to the large boulders that require cautious footing. The trail leads around the northeast edge of Avalanche Lake, and you are treated to a fine view of the steep gulch created by Avalanche Mountain and Mount Colden to the southwest.

The trail rises easily into Avalanche Pass now. At the next trail intersection,

the right-hand turn leads to Lake Arnold and Feldspar Brook. Continue left following the yellow markers, heading toward Marcy Dam. Immediately to the left of this junction is an unmarked side trail leading to Avalanche Camp lean-to. Additional lean-tos and designated campsites appear in the next mile to Marcy Dam, and several more are in its immediate vicinity. From Marcy Dam, join Van Hoevenberg Trail, which heads north over easy, nearly flat terrain back to the intersection with Algonquin Peak Trail. Bear right, retracing your steps back to Adirondak Loj.

TRIP 3
MOUNT MARCY

Rating: Strenuous
Distance: 14.8 miles
Elevation Gain: 3,300 feet
Estimated Time: 8.0 to 12.0 hours
Maps: USGS Mount Marcy 7.5 and 7.5x15; National Geographic
 Adirondack Park: *Lake Placid/High Peaks*; Adirondack Maps, Inc.:
 The Adirondacks High Peaks Region

**The most-climbed alpine summit in New York State offers a
360-degree view across the eastern and western High Peaks
wilderness and the Champlain Valley.**

Directions
See Trip 1 for directions to the High Peaks Information Center. *GPS coordi-
nates:* 44° 10.959' N, 73° 57.977' W.

Trip Description
Van Hoevenberg Trail is the most popular trail to the summit of Mount
Marcy (5,344 feet), the state's highest mountain. The trail was originally
conceived by Henry Van Hoevenberg, builder of the first Adirondack Lodge
(see page 7) and tireless promoter of tramping and trail building in the High
Peaks region. Today it is the shortest, most direct route to Marcy's summit,
which attracts up to 40,000 visitors annually.

When you arrive at the Adirondak Loj parking area, go first to the High
Peaks Information Center (HPIC) and check the weather report at the front
desk. Talk to the staff, tell them your plans, and ask for their input about the
trail's conditions, which can change considerably throughout the seasons and
vary drastically at different elevations. Exit the HPIC, head to the trailhead
at the end of the parking lot, and sign the register.

Get onto the trail and bear right at the fork, following blue markers. Walk
through a red pine woods, and cross Algonquin Brook on the boardwalk. The
Mount Marcy ski trail weaves through the main trail here and there, so watch
for markers and signage. The trail leads along the side of a hill rising away

from the brook. At the first big intersection (with Algonquin Peak Trail), bear left toward Marcy Dam. This is easy terrain, as the trail is intensively used and very well maintained. The trail rises as you approach the dam. Marcy Brook is on your left. At 2.2 miles cross the dam, which provides striking views of Algonquin and Mount Colden. Several designated campsites and lean-tos are in the area around Marcy Dam and upstream along Marcy Brook (off-route), and these are generally full on summer weekends. An interior ranger outpost is located here as well, but it is not staffed at all times.

Continue following blue markers and begin to ascend along the south side of Phelps Brook. Cross the brook on the rustic high-water bridge, and the trail becomes rockier as you ascend. The trail to Phelps Mountain departs to the left. Stay to the right, following blue markers. Bear right where you encounter the ski trail again, and continue uphill, crossing a bridge over Phelps Brook at 3.4 miles. On the other side of the brook, the ski trail comes in on the left. At this point a cairned and signed trail to Table Top Mountain goes left. Bear right continuing toward Indian Falls (signed). As the trail levels out, you will get your first glimpse of Mount Marcy, rising in the south. At 4.4 miles, don't fail to take the short side trail to Indian Falls, where views of Algonquin, Iroquois, Colden, and Wright Peak dominate the western skyline.

Back on the main trail, walk 0.1 mile and go left at the junction where Lake Arnold Crossover Trail goes right. Again, follow the blue markers. The trail rises easily now over varying terrain, at one point following an open ridge with excellent views of Marcy. At 6.2 miles leave Hopkins Trail to your left. Van Hoevenberg Trail drops into a wet area and the spruce-fir growth thickens dramatically. Ascending, leave Phelps Trail to your left in a small open area at 6.8 miles. Ascend, crossing a long puncheon over a sphagnum bog in full view of the summit. As you gain altitude on Van Hoevenberg Trail, follow the cairns and yellow paint blazes, taking care to avoid the fragile alpine vegetation by staying on the rock surfaces. Make sure to use a leash if you are hiking with a dog.

Marcy has two distinct "summits," but the true summit is the second one, lying a few hundred feet farther west at 7.4 miles. You've arrived.

Try your hand at map and compass orientation or recruit the skills of a summit steward to help in the identification of the 44 High Peaks that can be seen from this summit. Beginning with Skylight and Haystack, go left through the Great Range, with Gothics in the center (between you and

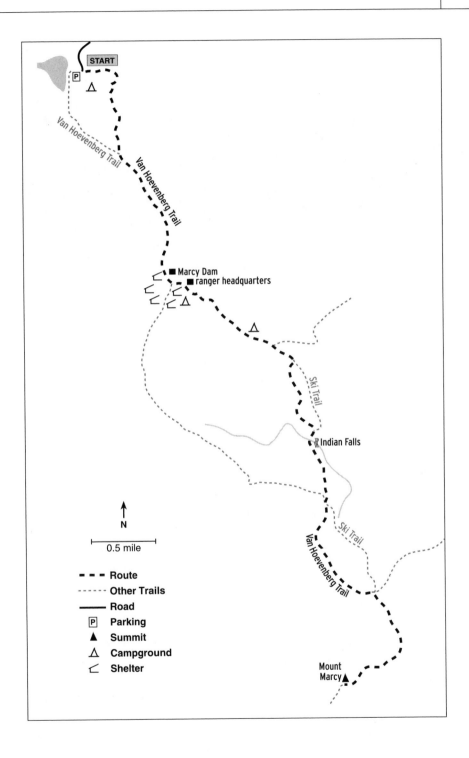

START

Van Hoevenberg Trail

Van Hoevenberg Trail

Marcy Dam
ranger headquarters

Ski Trail

Indian Falls

Ski Trail

Van Hoevenberg Trail

N

0.5 mile

- - - Route
----- Other Trails
——— Road
P Parking
▲ Summit
△ Campground
⊏ Shelter

Mount
Marcy▲

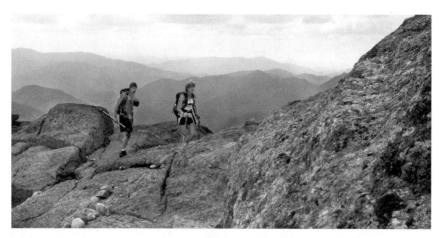

Two hikers cross the exposed rock of Mount Marcy's summit.

Giant). Sweep across the north over the Hurricane and Jay Mountain primitive areas, the Sentinel and McKenzie Mountain wilderness areas, the Saranac Lakes Wild Forest, and across the western High Peaks wilderness. Continuing counterclockwise, the Sawteeth, Seward, and Santanoni mountains follow. Algonquin, Wright, Colden, and Boundary (north and south) are nearest to the west. Marcy Swamp, the Boreas Ponds, and Elk Lake lie to the southwest. The Dix wilderness rises beyond them to the east.

Beneath your feet, the many small white flowers of mountain sandwort, a pioneer alpine species, appear in the summit crevices here and there. Heaths, such as the boreal shrub Labrador tea, flower from June to August in the upper elevations, where acidic soils are found. You'll recognize Labrador tea by its terminal clusters of white flowers and its fragrant leaves. Don't be alarmed at the appearance of the wasplike alpine flies, which help to pollinate these plants: They don't sting, but they do bite. You will likely be subject to blackflies on high-mountain summits in the summer unless a brisk wind is blowing, so bring insect repellent.

The peak you are standing on was originally called Tahawus ("Cloud-Splitter"). Ebenezer Emmons (1799–1863; credited with first recorded ascent of Mount Marcy) renamed it for William Learned Marcy, a United States senator from New York who also held the office of governor for three terms and who appointed Emmons to the first Geological Survey of the State of New York in 1836. Emmons went on to become a prominent geologist, assuming the lead role in introducing the public to the Adirondacks.

After enjoying the view, return the way you came, allowing plenty of time to walk out in the daylight.

The Alpine Zone

The Adirondacks are composed of the single largest mass of anorthosite, an igneous rock, in the United States. At more than a billion years old (one-quarter of the estimated age of Earth), Mount Marcy's anorthosite is among the planet's oldest surface rock. When the Wisconsin Ice Sheet retreated 10,000 years ago, it left in its wake bare summits and heaps of glacial till. In the thousands of years that followed, soils formed and fragile plants grew. These same plant species still grow on the High Peaks today. Because the High Peaks are very steep, the climate is cold for much of the year, the winds are often very strong above treeline, the growing season is short, and soils are poor and thin, the surviving vegetation is fragile—too fragile to withstand even minor disturbances.

The Adirondacks have 35 species of alpine plants. Rare plants such as diapensia, bearberry willow, Lapland rosebay, alpine azalea, deer's-hair sedge, Boott's rattlesnake root, and other species cling tenaciously to life in the alpine zone. There are roughly 85 acres of alpine tundra in the 215,000-acre Adirondack High Peaks Wilderness Area, and of those, only an estimated 42 acres contain stable vegetation. These areas with their fragile plant communities (as well as subalpine species that grow at upper elevations) have remained largely unchanged since the ice age. Yet they have become critically imperiled by habitat destruction caused by the estimated 200,000 hikers that visit the High Peaks each year.

Several steps have been taken to help protect the High Peaks alpine zone. The first of these began in the 1990s with the efforts of botanist E.H. Ketchledge, who led the summit revegetation and protection efforts that hikers will see in progress today on the summits. These efforts led to the creation of the High Peaks Summit Steward Program. Paid summit stewards are present on Algonquin Mountain and Mount Marcy throughout the summer to help educate hikers about the fragile nature of the alpine plant community. The stewards climb to their posts on the summits as many as five days each week and conduct educational programs elsewhere in the High Peaks area.

For their part, all hikers should remember to walk only on the trail and solid rock surfaces, leave plants in place, avoid walking on soils where plants can grow, keep dogs leashed above timberline (dogs must be leashed at all times in the High Peaks), and share the summit steward message with others.

TRIP 4
CASCADE MOUNTAIN

Rating: Strenuous
Distance: 4.8 miles
Elevation Gain: 1,885 feet
Estimated Time: 4.0–5.0 hours
Maps: USGS Keene Valley 7.5 and 7.5x15; National Geographic
Adirondack Park: *Lake Placid/High Peaks*; Adirondack Maps, Inc.:
The Adirondacks High Peaks Region

**The easiest and most frequently climbed High Peak in
the eastern Adirondacks, Cascade rewards hikers with a
spectacular 360-degree view of 30 High Peaks.**

Directions
From the intersection of NY 86 and NY 73 in Lake Placid, travel east on NY
73 for 8.4 miles (or travel 4.2 miles east on NY 73 from Adirondak Loj Road
and 6.8 miles west on NY 73 from Keene). Park in one of the three road-
side turnouts in the next 0.3 mile on the road's south side, the middle and
smallest one being at the fairly obscure trailhead itself. Parking is limited to
fifteen to twenty cars. Follow the signed dirt path behind the guardrail to the
right of a line of riprap. *GPS coordinates:* 44° 13.136' N, 73° 53. 253' W.

Trip Description
Cascade Mountain (4,098 feet) ranks 36th in the descending order of the
Adirondack High Peaks (see page xxxi). Experienced hikers will be quick
to point out that Cascade is the easiest of the 4,000-foot peaks to ascend,
requiring the least elevation gain and the shortest distance. However, less
experienced hikers should note that Cascade's legitimate status as the
easiest of the High Peaks should not be misinterpreted to mean that it is an
easy hike. A 1,885-foot elevation gain in just over 2 miles is not an easy hike
by most people's standards. This is a high and exposed mountain, so your
preparations should be the same as they would be for any other High Peak.
The trail is fairly steep in places and the summit is bald and therefore subject
to high winds and rapid weather change.

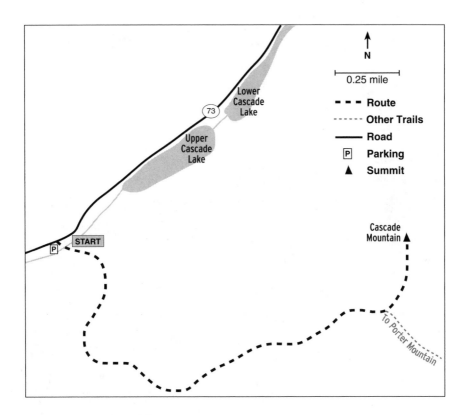

The trailhead is located in rugged, high-walled Cascade Pass, the gulch that lies between Pitchoff Mountain on the valley's north side and the southerly Cascade Range. Cascade Mountain is named for the falls that plunge straight down the narrow defile between the Cascade Lakes. In the late nineteenth century, the Cascade House hotel was located between the two lakes. Like many mountain trails, those in the vicinity of the hotel are believed to have been created from old logging roads and footpaths that led to frequented lakes and summits. When NY 73 was being improved in preparation for the heavy traffic it now carries, a large stone fell from the northerly cliff face and was pushed to the side. A local artist later engraved it as a memorial to the old stage route that the road replaced. The stone stands just downhill from the Cascade and Pitchoff parking areas behind a section of guardrail.

Follow the red markers into the woods and sign in at the trail register. The trail descends slightly at first, and heads through a dense northern hardwood forest. It soon rises consistently, but never too steeply, over stone

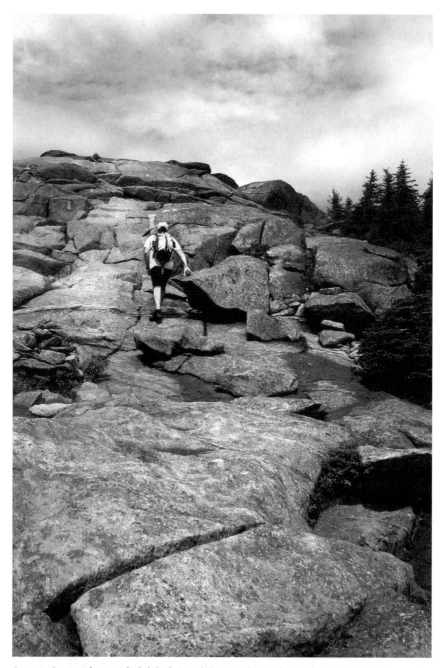

A steep rise over low-angled slabs brings hikers to the treeless summit of Cascade Mountain.

steps and water bars as it follows along the mountain's southwest ridge. The climbing is relaxed for the first mile or so, and then steadily gains in elevation. Rising to 3,000 feet and passing around to the south side of an unseen knoll, the trail yields its first reprieve around a muddy swale at 3,060 feet. The trail ascends again to the east–northeast, continuing over low ledges and boulders.

At 1.8 miles, you will arrive at an open outcropping facing west, from which you can see Lake Placid, the ski jumps, and, in the southern part of the western High Peaks, Wallface and Indian Pass over to Algonquin and Mount Marcy in the south–southwest.

The trail relaxes above the outcropping, and at 2.1 miles you will pass the trail to Porter Mountain, which departs to your right. Hikers who aspire to become 46ers (see page xxxi) can easily include Porter in a same-day ascent of Cascade.

Bright stars of bunchberry and the mottled petals of trout lilies greet the hiker here in the earlier stages of summer, but the most noticeable vegetation is tree moss (*Usnea barbata*), a fungus better known as old-man's beard, or beard lichen, which is prolific at upper elevations. It is similar in appearance to Spanish moss. Edible (though bitter tasting) and high in vitamin C, *Usnea* is an herbal antimicrobial that has been used for 1,000 years as a poultice for surface wounds and infections, and eaten as treatment for digestive disorders. It is believed to have some toxicity at higher concentrations, but the degree to which this is true has not been established.

Just as you're crossing a flat, open area and wondering where the summit is, an enormous expanse of low-angled, open rock appears to your left. The trail rises again, following yellow paint blazes and low cairns over several ledges as you ascend the last few hundred feet to the summit. This expansive, open dome was burned off in the same forest fire that destroyed Adirondack Lodge in the dry summer of 1903 (see page 63). Efforts to restabilize the existing vegetation are evident and ongoing. Avoid the protected areas as you climb around on the summit.

Looking toward Lake Placid, you see the ski jumps. The body of water in front of you is Round Lake, and Mud Pond is to the left. Over the low top of Scotts Cobble you see Lake Placid (the lake) in three sections, as it is partially blocked by Mount Whitney and Cobble Hill. The little mountain north of Lake Placid is Eagle Eyrie; Whiteface is unmistakable in the north; you can see Mirror Lake in Lake Placid village; the McKenzie Mountains rise behind

Lake Placid. North of Whiteface is Ester. Turning north, you will see the triple-crowned summit of Pitchoff immediately to the north in the Sentinel Range wilderness (which divides the Ausable River into its east and west branches). Back to the west, at the western end of boggy South Meadow, you see Mount Jo, as well as the bobsleigh run on neighboring Mount Van Hoevenberg. Nearest to the south of you are Big Slide Mountain (named for the slide on its southerly slopes) and the Brothers, as well as the rugged array of peaks comprising the Great Range.

From the summit, return to the parking area the way you came.

TRIP 5
BAXTER MOUNTAIN

Rating: Easy
Distance: 2.0 miles
Elevation Gain: 700 feet
Estimated Time: 1.5 hours
Maps: USGS Keene Valley 7.5 and 7.5x15; National Geographic
Adirondack Park: *Lake Placid/High Peaks*; Adirondack Maps, Inc.:
The Adirondacks High Peaks Region

An easy and wonderfully scenic hike leads to sweeping views across Keene Valley and the eastern High Peaks.

Directions

From Exit 30 of the Adirondack Northway (I-87), go 13.3 miles and turn right onto NY 9N south. Find the Baxter Mountain trailhead on the right after 2.0 miles, immediately past Hurricane Road. Parking (room for three or four cars) is on the pull-off area on the road's shoulder. *GPS coordinates: 44° 13.258′ N, 73° 44.975′ W.*

Trip Description

Hikers who would like to minimize their time on the trail and maximize their exposure to High Peaks scenery should head for Baxter Mountain (2,440 feet). Those who know this endearing little peak consider it to offer the best views in the Adirondacks when weighed against the amount of effort expended. Like many peaks with similar attributes, Baxter's popularity has proven to have a downside: The trail had become so badly eroded that it had to be restored at considerable expense with the combined effort of public and private trail groups. When the trail's existing layout could no longer sustain intensive use, it was rebuilt and rerouted to accommodate a greater carrying capacity.

Today the trail is stable and beautifully maintained by the Adirondack Mountain Club's Algonquin Chapter. It's not unusual to see grandparents and children with puppies meandering side by side up this cordial trail, which switches back easily up a steady grade, gaining 700 feet in elevation from the

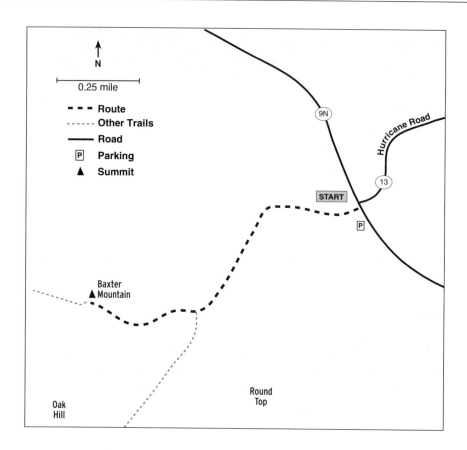

trailhead. Most of the elevation gain is earned near the summit, however, where the trail steepens enough to require some brief aerobic exercise.

There are three approaches to Baxter, and the one described here is both the shortest and the most popular one. The brevity of this hike is, after all, what is so appealing, but a loop can be made using Beede Road on Upham Trail, which you'll see at the turnaround point of this hike. The loop requires a total of 4.5 miles returning from Beede Road and Beede Farm. (Be advised that Upham Trail may not be well marked or maintained at this time.)

From the trailhead parking area, the trail leads southwest into the woods following blue markers. This section of the trail is an easement over private property, on which no camping, hunting, or fishing is permitted. Walk through a pinewoods and under a power line. A northern hardwood forest of birch, beech, and maple follows, and then hemlock woods take over, followed

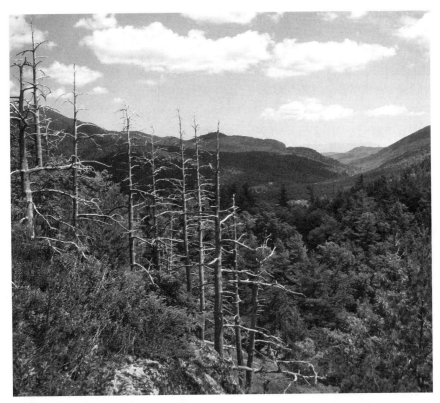

Baxter Mountain offers a shaded hike that climbs to cliffs with fine views.

by sugar maples. The trail is shaded for most of its length, until it approaches the summit by way of a few long switchbacks. The footway is wide and clear of stones and roots. Rain bars and foot puncheons have been placed here and there to check erosion.

In the first 0.3 mile, the trail rises only 130 feet. By 0.6 mile, it has risen 475 feet. At 0.7 mile, the trail junction to Beede Road is to the left (red markers). Baxter Trail continues to the right with the blue markers, as the forest cover changes to red oak and white pine with some red pine here and there. The trail steepens as it turns west, following the edge of Baxter's spectacular south-facing cliffs over a series of bare rock pitches. Avoid the herd trail you will see to the left, remaining on the more resilient surface of the designated trail. Blueberries abound in the open, sunny areas of the ridge.

Here, the first views appear. Hurricane and its fire tower is obvious far to the left. Giant, rising in the southeast, shows only its shoulder—not its scarred face. Dix is the most prominent peak in the center of the view-shed, with Noonmark rising in front of it. Keene Valley seems scooped out of the earth below. The eastern High Peaks follow, with the Great Range mountains—especially the unmistakable peaks around Gothics and Mount Marcy—prominently in view.

Return to the trail and follow it into a tunneled-in balsam woods. The trail descends slightly and rises again, more steeply than before to gain a wider, broader lookout. Porter and Cascade are visible to the right now, as more of the western valley opens up. Walk along the ridge to the west end, where a little group of red pines offers one last look over Keene Valley. Upham Trail to Beede Road drops down to the right of a rock outcropping at this point.

Turn around and hike out the way you came.

TRIP 6
MOUNT VAN HOEVENBERG

Rating: Moderate
Distance: 4.4 miles
Elevation Gain: 850 feet
Estimated Time: 3.0 hours
Maps: USGS North Elba 7.5; USGS Keene Valley 7.5x15; National
 Geographic Adirondack Park: *Lake Placid/High Peaks*; Adirondack
 Maps, Inc.: *The Adirondacks High Peaks Region*

**An easy, flat approach through a red pine plantation and
around a beaver pond is followed by the steep ascent of a
mountain, with spectacular views of the High Peaks rising
above South Meadow.**

Directions
See Trip 1 for directions to Adirondak Loj Road, where you'll see a sign for
the High Peaks Wilderness Area. Follow Adirondak Loj Road south for 3.6
miles to South Meadows Road (not signed) and park in the small area (room
for four cars) on the left. You'll see trailhead signs posted across the road
from the parking area. During dry months, you can drive down dead-end
South Meadows Road to find more parking and free camping in designated
sites. *GPS coordinates:* 44° 11.611' N, 73° 57.326' W.

Trip Description
The trail to Mount Van Hoevenberg has an appealing, remote, and relatively
unkempt character in comparison to the more frequented High Peaks trails,
especially to Mount Jo, which can be described as its partner peak. The thick
red pine forest of tall, thin trees on the first section of trail is prone to blow-
downs, and the trail has been rerouted around a beaver flow at the base of
the mountain.

Begin walking east along South Meadows Road. At 0.2 mile from the
parking area, watch for the blue-marked trailhead on the left; the trail
passes through a designated camping area. The red pine (a.k.a. Norway
pine) plantation that nearly tunnels over the trail was created by the Civilian

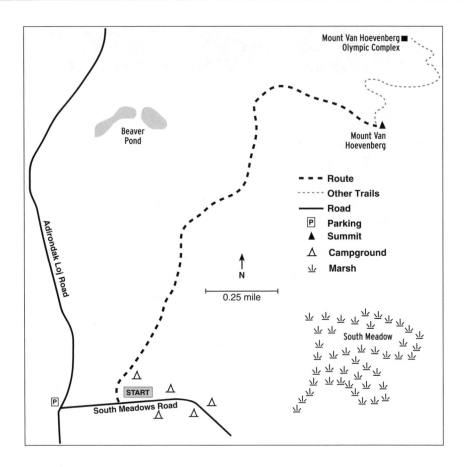

Conservation Corps during the 1930s. This densely overstocked forest has evidently never been thinned, and many of the sun-starved trees are dying off, some of them inevitably falling across the trail. Because this trail is not as heavily used as the neighboring trails to the High Peaks, it may remain unmaintained for longer periods of time.

At the northern edge of this enchanting plantation, the forest makes a sharp transition to northern hardwoods, where in the early spring you will encounter many wildflowers blooming. Among these are the flowers typically found in rich woods throughout the Adirondacks: trilliums (painted and purple), trout lilies with their mottled leaves and white flowers, and downy yellow violets, the latter usually appearing as the first blooms of spring. The purple trillium is sure to follow the violets. This dark, nodding flower of the lily family is called a carrion flower; it exudes an unpleasant

South Meadow forms the upper reaches of the Ausable River's west branch.

odor, which functions to draw flies that in turn act as as pollinators. The naturalist John Burroughs called this early-spring flower the Wake Robin. You'll see hundreds blooming along the trail in early May.

As you approach a beaver pond, which drains into the upper west branch of the Ausable River, you may see trail markers on partially submerged, standing dead trees out in the pond. Fortunately, the trail has been rerouted here, and makes a 90-degree turn to the left (west) skirting around the pond's perimeter. This is a pretty spot, with Mount Van Hoevenberg rising in the north beyond the skeletonized trees in the foreground. Raptors, owls, and songbirds are plentiful, and all around the pond you may see moose tracks pressed deep into the mud. The rich habitat of this extensive wetland brings predators as well. You might see fox and coyote tracks, and perhaps even bobcat tracks. Watch carefully for markers as the trail disappears in the muck for a short distance.

Work your way along the western perimeter of the pond and you will soon regain solid ground. The footway is well established here, and the trail ascends gently around to the west, climbing to ridge elevation at 1.5 miles, where a small stream flows off the mountainside. The climb relaxes

amid a few low ledges, but begins to ascend once again as it nears the final pitch up the western side of the mountain, where the welcoming spruce-fir growth of the upper elevations appears. Suddenly you find yourself on an open ledge at near-summit height. After a few moments to catch your breath, continue to the true summit, another five-minute walk past a series of open outcroppings on the summit. Use caution—these are high vertical drops. The true summit is located on the eastern-most outcropping of the same ledge, a small triangular shelf located at a point where the trail makes a sharp turn to the left into scrubby woods.

Mount Van Hoevenberg's 180-degree viewshed is complex and offers several variations. From the summit lookout, a forest of thin, even-aged birch stands against the low southern slopes of the mountain. Beyond are Porter and Giant. More expansive views are available from the middle section of the summit ridge. The mountain named for Henry Van Hoevenberg appropriately overlooks a bowl of hills in which the mountain named for his fiancée, Mount Jo (for Josephine Scofield; see page 7), takes center stage. Beyond are Wallface, and the familiar face of Algonquin. You see Mount Colden and Mount Marcy. To the right you see the 1980 Olympics ski jump towers and the long range of the Sawteeth. To the right of Algonquin is Boundary Peak. Rising from Avalanche Pass is Avalanche Mountain, then Caribou Pass between Avalanche Mountain and Algonquin (Avalanche Lake is not seen). To the right of Mount Marcy is Schofield Cobble. Phelps and Howard are seen. Table Top is visible behind Phelps. The Wolf Jaws, Armstrong, and Gothics rise beyond Yard Mountain to the southeast. Below and immediately before you are South Meadow and the meandering South Meadow Brook, which flows out of Little Meadows in easterly Railroad Notch.

Enjoy the views, but don't wander too far away from your lunch, or ravens—the guardian genii of Mount Van Hoevenberg—may swoop down and filch it. These solitary birds prefer cliff dwellings. They mate for life and use the same nest perennially.

Return the way you came.

TRIP 7
GIANT MOUNTAIN

Rating: Strenuous
Distance: 8.0 miles
Elevation Gain: 3,375 feet
Estimated Time: 6.0 hours
Maps: USGS Elizabethtown 7x15: National Geographic Adirondack
Park: *Lake Placid/High Peaks*; Adirondack Maps, Inc.: *The
Adirondacks High Peaks Region*

**From the base of 400-foot-high Roaring Brook Falls to the
open summit of an Adirondack High Peak, this challenging
hike offers several opportunities for overnight camping.**

Directions
From Exit 30 of the Adirondack Northway (I-87) turn left onto NY 73, then
pass under the Northway. Continue 7.5 miles and look for Roaring Brook
Falls (visible high up to the right) as you come downhill to the Roaring Brook
trailhead on the right.

From the village of Keene, travel south on NY 73 for 8 miles to the Roaring Brook trailhead, on the left. The lot accommodates fifteen cars, and an
overflow lot is immediately across the highway. *GPS coordinates:* 44° 09.022'
N, 73° 46.069' W.

Trip Description
Giant Mountain (4,627 feet) rises out of the rugged backcountry of the
Giant Mountain Wilderness Area (22,768 acres). Not only is the peak itself a
spectacular destination, but its trailhead is located in one of the Adirondacks'
most visually wild areas—the rugged Keene Valley. Mountains and vertical
cliffs rise in every direction, with jade-colored ponds cached in steep clefts.
On high, precipitous slopes, young stands of birch cling to landslide rubble.

The Roaring Brook trailhead offers amenities such as free camping in
established sites, near water. One of the main attractions of Roaring Brook
Trail is the falls themselves, and the beautiful designated campsite at its
base. This site, sublimely situated between Beede and Roaring brooks at

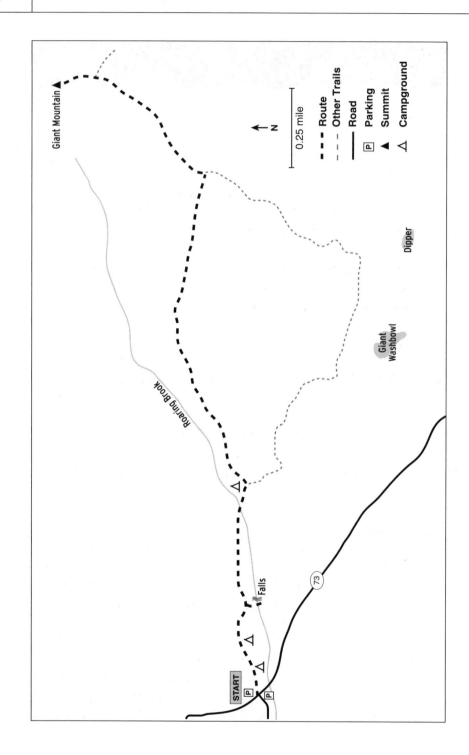

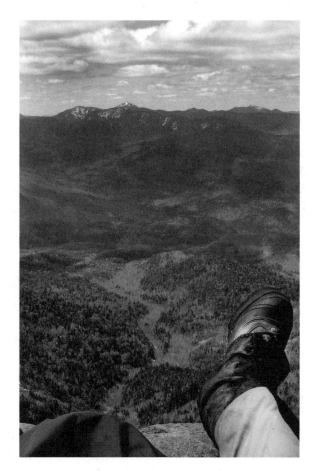

A hiker surveys the views over Keene Valley from Giant Mountain's summit.

the bottom of the waterfall, has three distinct fire rings and an outhouse. Another (less appealing) designated site sits just at the top of Roaring Brook Falls along the trail to Giant, 0.4 mile uphill from the parking area. Yet another site is 0.9 mile along the trail on Roaring Brook, near the junction of Giant and Nubble trails. These staging points make it possible (especially if you're driving a long distance) to treat this demanding hike as an overnight experience, where you can establish a base camp and store your camping equipment while you summit the mountain with your day gear.

You will need the better part of a good day to fully enjoy Giant, allowing extra time to linger on its summit. While the trail is steep and long, the summit is high and exposed, and accordingly can be windy and cold, so prepare carefully. Bring enough food, water, and clothing for a daylong

alpine mountaineering experience. Be advised that hundreds of hikers covering these trails in snowshoes all winter long will pack the snow, and the hardpack eventually turns to ice that can persist into the warmer months, especially along this shaded westerly approach from the falls.

Sign in at the trail register, which you'll find along with other information at the trailhead signboard, then walk along on the level for a bit. The ascent begins at 1,270 feet in elevation and rises 400 feet in 0.4 mile to the top of Roaring Brook Falls. Bear right at the marked spur trail, which leads a short distance to a designated campsite. This site shows considerable impact. Use caution nearing the falls. The slabs at the top are tilted downward above a long vertical drop, and there have been terrible accidents and loss of life here. Stay well back from the edge. You won't miss much—the limited views of Noonmark and the Great Range from this small vantage point are nothing compared to those ahead.

Returning to the trail, you will walk parallel to and within earshot of Roaring Brook. The trail walks level through an ancient hemlock woods. Some of the hemlocks within a half-mile of the falls are more than 450 years old. You will see the brook again where the trail crosses it at 0.9 mile. Just before you cross the brook, a designated campsite appears on the left. This site can be appreciated only if you follow the yellow camping markers up a low, sheltered evergreen knoll, where some exploration will reveal a few fire rings amid druidic white pines and hemlocks. It is an enchanting spot.

Cross the brook. Up to the left and north, a slide (one of Giant's many over the years) eradicated the trail in 1963, when 4.5 inches of rain fell in less than three hours. At the trail junction, bear left and climb. In the next 1.3 miles, you will gain 1,800 feet in elevation.

Views begin to open up on the right, and at the junction with Zander Scott Trail to Chapel Pond, an open rock to the immediate right provides scenic respite. Go left, continuing north, and the climbing is easier now, but you're still ascending. Crossing a false summit around 4,200 feet, you'll be granted a few tantalizing glimpses of Giant looming ahead. The trail flattens out before rising steeply. At the next trail junction, leave East Trail to your right, where you'll see the Rocky Peak Ridge. Shortly, you will scramble to the summit and its open views, and you'll be right at the edge of Giant's bare rock slides. Thirty-nine peaks can be seen from the summit. This nearly incomprehensible puzzle of peaks and landmarks will challenge your map and compass skills. Orient yourself to a known peak with your orienteering compass.

Unmistakable Gothics and the Great Range peaks, and Mount Marcy beyond them, rise above the Ausable Valley. The Ausable Club lies directly below. Cascade and Porter are clearly seen, as are Pitchoff and, north of it, Whiteface. Between the MacIntyre Mountains and the Sawteeth Range are Nye, Street, and MacNaughton. To the east you'll see Lake Champlain and the Vermont mountains. To the north, Hurricane is easily identified by its bare summit and fire tower.

When you've had enough of identifying the viewshed and have taken enough time to simply absorb the majestic and captivating world of Giant's summit, return the way you came.

TRIP 8
AMPERSAND MOUNTAIN

Rating: Strenuous
Distance: 5.5 miles
Elevation Gain: 1,750 feet
Estimated Time: 4.5 hours
Maps: USGS Saranac Lake 7.5 and 7.5x15; National Geographic
 Adirondack Park: *Lake Placid/High Peaks*; Adirondack Maps, Inc.:
 The Adirondacks High Peaks Region

Hike through old-growth forests to an open, panoramic summit poised between the High Peaks and the northwest lake and forest regions.

Directions
From Saranac Lake, take NY 3 west toward Tupper Lake. At 8 miles, park at the trailhead parking area (room for twelve to fifteen cars) on the right.

From Tupper Lake, take NY 3 east toward Saranac Lake. The parking area will be 12 miles ahead, on the left. *GPS coordinates:* 44° 15.092′ N, 74° 14.376′ W.

Trip Description
Knowledgeable Adirondacks hikers will tell you that Ampersand Mountain (3,352 feet) is the perfect peak, because its location rewards visitors with the best of both worlds—views of the High Peaks to the east and south, and views of the lakes from north to west. It is the ideal destination for a long and self-indulgent outing, saved for a clear day when you have extra time to linger on this remarkable summit, absorbing the engrossing views that spread out in every direction. The same people will also mention that while the mountain's scenic payoff is generous indeed, you will earn it with every step—the second half of the trail requires a 1,300-foot elevation gain in only 1.2 miles. Make adequate preparations for the full enjoyment of a rigorous outing to this bare summit, with extra food, plenty of water, and your best boots and outerwear. Snowshoes will prove ineffective on the steeper sections, where crampons are needed under icy conditions.

Carefully cross the highway to the trailhead, sign in at the trail register,

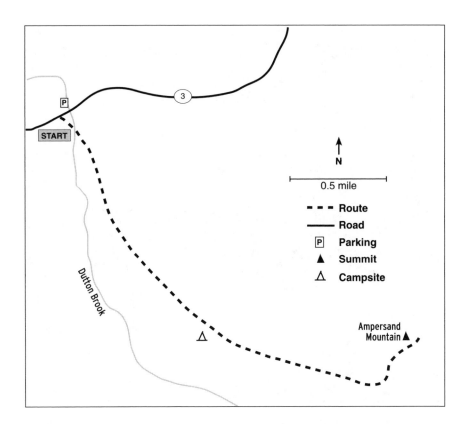

and enter the dark, primordial forest. Two thousand acres of old-growth trees surround this first flat section of the trail, featuring 300- to 400-year-old sugar maples and yellow birches. Bruce Kirshner and Robert T. Leverett, authors of the Sierra Club guide *Ancient Forests of the Northeast*, tell of a 58-inch (in diameter breast height, or dbh) birch that was identified here. Note the old-growth hemlock and white pine, several pure stands of which you will penetrate as the trail crosses two small branches of Dutton Brook.

Walk along a 300-foot-long plank puncheon over soggy ground through a red spruce stand. The trail is flat for a while, ascending gradually as it turns to the south, entering the hardwoods and rising to the point of a small clearing at 1,900 feet, 1.3 miles from the trailhead. Here you may notice the remnants of the old fire tower observer's cabin. On a small rise to the right off the trail are a crude campsite and fire ring. Cross a seasonal rill and ascend.

The cleft between Ampersand's two summits (the eastern summit, your destination, is the true summit) is narrow and steep. The trail has

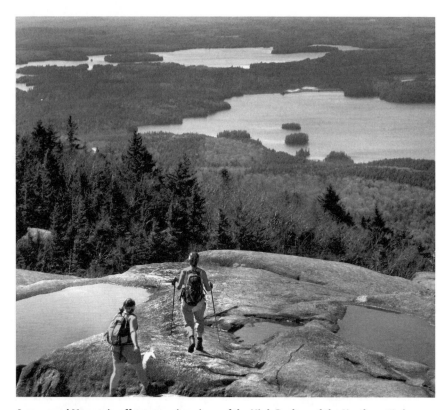

Ampersand Mountain offers sweeping views of the High Peaks and the Northwest Lakes.

been relocated a few times over the past century, and today's more direct ascent involves less cumulative elevation gain. Recent improvements in this trail have addressed the severe erosion caused by intensive use (at one time it was considered one of the worst trails in the Adirondacks), and have made the trail more stable and friendlier underfoot. Where previously the upper section of trail had degenerated into a worn-down track of mud and exposed roots, the construction of several stone stairways has both restored and stabilized the trail. As the ascent intensifies, you'll find yourself gratefully contemplating the manner in which these large stones were so skillfully positioned.

When you arrive in the flat and often wet saddle enclosed in balsam firs, a ledge to the left may fool you into thinking you've arrived at the summit. However, another 0.3 mile and a 300-foot rise in elevation remain. Pass a

sheer and cavernous split rock on your right as the trail bears left. Though steepening still, the last bit of ledgy terrain is easily managed except in the presence of deep snow or ice (when creepers or snowshoes are required). The trail winds around to the west and you scramble up a few low ledges before topping out on the bare summit. Continue along, following yellow paint blazes, to a point where you can go no higher. Here you'll find benchmarks. The large summit provides plenty of opportunities to find a private lookout.

The origin of the peculiar 140-year-old place-name Ampersand is mystifying. From a distance, the peak somewhat resembles the double helix of the ampersand symbol (&) viewed horizontally, and typonymists will be quick to point out that to the romantic imagination, even a vague likeness was more than enough. In his authoritative history of the Adirondacks, author Alfred Donaldson suggested that the name derives from the "amber sands" of Ambersand Lake, as it was originally named. The Adirondack Mountain Club's *High Peaks Region* guide suggests that the name is attributed to serpentine Ampersand Creek, which resembles an ampersand's shape.

Verplanck Colvin, measurer of mountains, credits W.W. Ely with naming Ampersand. (Ely made the first recorded ascent of Ampersand, in 1872.) Ely, along with Colvin, had a hand in clearing the summit of trees for observation and triangulation, while fires completed the task. The fire tower, which was erected in 1911 and replaced with a higher one in 1920, was abandoned in 1970 and removed in 1977. A memorial to Walter Channing Rice (the "Hermit of Ampersand"), tower observer between 1915 and 1923, can be seen just beyond and below the summit.

Ampersand is said to be the first Adirondack peak that conservationist and forester Robert Marshall (1901–1939) climbed along with his brother George and their guide, Herb Clark of Saranac Lake. Inspired by this climb, he decided to pursue a life's work in conservation, and in the meantime went on to climb (under Clark's watchful eye) all 46 of the Adirondack High Peaks. The three men became the first Adirondack 46ers (see page xxxi). Robert Marshall went on to become one of this country's most influential environmentalists, cofounding The Wilderness Society. He is memorialized in the million-plus-acre Bob Marshall Wilderness ("The Bob") of Montana's Flathead National Forest.

When you've finished exploring the summit, return the way you came.

<div style="background:black;color:white;padding:10px">

TRIP 9
LAKE PLACID LOOP

</div>

Rating: Moderate
Distance: 10.5 miles
Elevation Gain: 600 feet
Estimated Time: 1.0–2.0 hours
Maps: USGS Lake Placid 7.5 and 7.5x15; National Geographic
　　Adirondack Park: *Lake Placid/High Peaks*; Essex County road map;
　　Adirondack Maps, Inc.: *The Adirondacks High Peaks Region*

**The most popular road cycling loop in the Olympic Village of
Lake Placid, featuring alpine scenery, covers several miles
along the Ausable River and around Mirror Lake.**

Directions

From the intersection of NY 73 and NY 86 in Lake Placid, go south toward
Keene. At 0.1 mile, turn right onto Station Street, and park at the large
Park and Ride lot behind the railroad station (room for 100 cars).
GPS coordinates: 44° 16.580' N, 73° 59.135' W.

Trip Description

You can park at many places in the heart of the village of Lake Placid,
including on the street and at a few municipal pay lots on Main Street, but
the Park and Ride lot is free, and will provide you with the elbow room (and
shade) to unload and prepare your bike for this tour. The Lake Placid-North
Elba Historical Society has an interesting, free display of early Olympic
and related photos here at the Station Street depot (the old Penn Central
Railroad Corporation's station, which long since discontinued freight and
passenger service into Lake Placid). The depot is now the historical society's
permanent home.

From the Park and Ride, take Station Street back out to NY 73 (Sentinel
Road), and turn right, toward Keene. On a busy weekend, you might
share the road (briefly) with triathletes in training, as well as with serious
recreational cyclists and fitness riders. Motorists here are accustomed to
cyclists, so traffic is generally biker-aware and friendly. The initial section
of road tends to have heavy traffic, but has a speed limit of just 25 MPH,

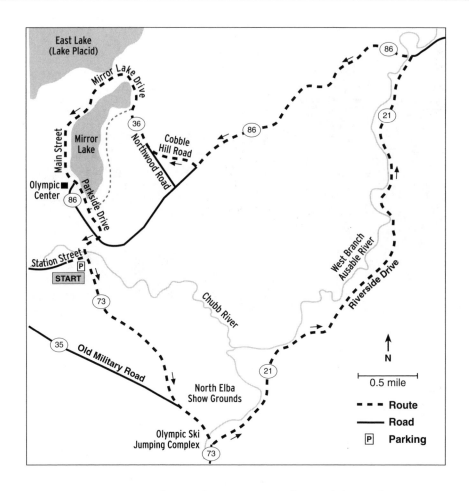

increasing to 45 MPH where it becomes Cascade Road (NY 73). Soon you will ride past the North Elba Show Grounds on your left. Beyond the show grounds and the airport are sweeping views of Whiteface Mountain and its neighboring peaks. At 1.8 miles, you'll soon see the Olympic Ski Jumping Complex on your right, unmistakable with the high towers of the 70- and 90-meter jumps rising above the landscape. Prepare to signal and turn left onto Riverside Drive (CR 21), just ahead.

At 1.9 miles, go left onto the more sedate Riverside Drive (CR 21). This is one of the few flat valley rides in the Adirondacks, so it's very popular with local cyclists, triathletes, team cyclists, and recreational runners. The paved shoulder is generally 2 feet wide and the road is in excellent condition. Open fields and views of the Sentinel Range wilderness open up ahead. The West Branch of the Ausable River is on your left. This is a special "no-kill" section

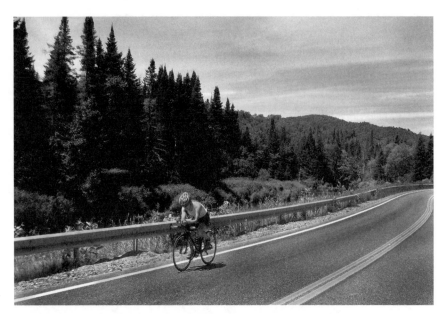

A cyclist enjoys a ride along scenic Riverside Drive.

of river, which is popular with fly fishers, whom you will see parked in the many anglers' parking areas between here and Wilmington Road. The traffic is light and motorists are considerate—but as ever in pretty countryside, drivers may be looking at the scenery. Ride defensively, stay to the right, and always signal your intentions.

At 5.8 miles you're at the corner of Riverside Drive and Wilmington Road (NY 86). Wilmington Road has a rougher surface and more traffic than Riverside Drive, especially on weekends. To complete the loop, turn left onto Wilmington Road and cross the Ausable River, heading southwest toward Lake Placid. Fine views of the High Peaks wilderness spread out to the southwest. Go 2.1 miles (total 8.2 miles), and bear right onto Cobble Hill Road, which takes you to Northwood Road. Continue straight ahead, joining Mirror Lake Drive in less than a mile. Turn right, following Mirror Lake Drive around the lake.

The village of Lake Placid is situated on Mirror Lake, not on its much larger adjacent neighbor, Lake Placid. You will have the opportunity to get a limited view of Lake Placid as you cycle past the public boat launch, which you will see to your right as you swing around the north end of Mirror Lake past George & Bliss Lane. It's worth the short detour. Continue on beautiful

Mirror Lake Drive, with its many fine cottages, inns, and restaurants (of which The Cottage is a local favorite), to its intersection with NY 86 (Saranac Avenue). Turn left onto Main Street. Now you can either walk your bike along the sidewalk, window-shopping as you go, or ride along the right-hand side of Main Street, taking care to avoid the sudden opening of car doors to your right and the slow, passing traffic to your left. Use caution here, as the many parked cars will necessitate that you ride in the traffic lane through town. As you ride east, you will pass the Olympic Center on the right.

That cyclists are given the consideration and respect they enjoy in Lake Placid is largely due to the Lake Placid Ironman Triathlon (organized by the World Triathlon Corporation). The three-event race consists of a 2.4-mile swim, a 112-mile bike race, and a full marathon run (26.2 miles). Athletes train year-round for the Lake Placid Ironman, which is held in July.

As you head through town you will pass the Olympic Arena Visitors Bureau on your right. This is the famed Olympic Center, where the U.S. men's hockey team beat the Soviet Union's in Herb Brooks Arena (named for the 1980 "Miracle on Ice" coach). The large rink outside the center is the speed skating oval. The center houses the 1932 and 1980 Olympic Museum, and runs a variety of programs for figure skaters. During the summer, the center hosts its Saturday Night Ice Shows series. The Lake Placid Olympic Complex consists of the Olympic Jumping Complex, the Mount Van Hoevenberg Olympic Recreation Center, and Whiteface Mountain, in addition to the U.S. Olympic Training Center. Visitors can take advantage of exhibitions and activities.

After passing through town, turn right onto NY 73 at 10.6 miles and coast 0.1 mile down the hill to Station Street, back where you started.

TRIP 10
THE BARKEATER (BETA) TRAILS

Rating: Moderate
Distance: 9.0 miles (with 4.2 street miles)
Estimated Time: 2.0 hours
Maps: USGS Lake Placid 7.5; Barkeater Trail Alliance: *BETA Trail Map*, barkeatertrails.org

This is a well-designed single-track trail system, ideal for accomplished or advanced-beginner off-road enthusiasts.

Directions

No parking is available at the BETA trailhead, so parking in the village of Lake Placid is necessary. From the intersection of NY 73 and NY 86 in Lake Placid, go south toward Keene on NY 73. At 0.1 mile, turn right onto Station Street, and park at the large Park and Ride lot behind the railroad station (room for 100 cars). You can also find street parking on Mirror Lake Drive. *GPS coordinates (parking lot):* 44° 16.580' N, 73° 59.135' W. *GPS coordinates (BETA trailhead):* 44° 17.122' N, 73° 58.012' W.

Trip Description

Mountain biking in the United States probably represents the fastest-growing user group in the evolution of modern outdoor recreation. By the late 1980s, technology had responded to the realization that a bicycle could provide access to hitherto unexplored miles. Fatter tires, tougher and lighter frames, and more-aggressive designs that would stand up to the rigors of rugged backcountry exploration quickly appeared on the market.

Because mountain bikes were not immediately embraced by parks across the country, advocacy groups and trail alliances offering trail maintenance became part of the appeal-for-access package. Enthusiasts and park management realized that multi-use trail designation or new trail construction would be necessary for the accommodation of the fat-tire crowd.

The Adirondacks presented a unique set of circumstances. In contrast with fringe areas of the park (many of which offered an already existing infrastructure of roads, rail beds, and a flatter, more erosion-resistant

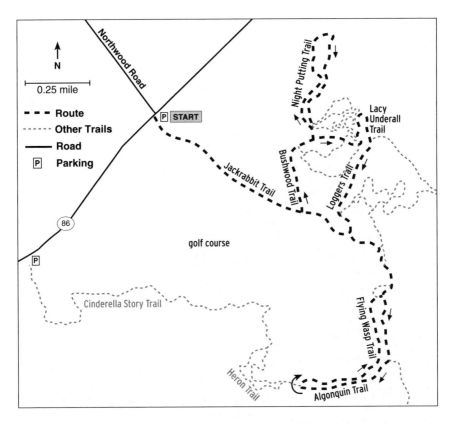

topography that was suited to cycling), the terrain of the park's upper elevations—steep, hilly, and demanding even for road touring cyclists—proved self-limiting. A well-conceived and executed single-track trail system in any community is a rarity. The existence of a diamond-in-the-rough off-road matrix in the Adirondacks, especially this close to the High Peaks, is miraculous.

That matrix, called the Barkeater Trail Alliance (BETA) system, is well marked and well maintained, offering a number of single-track trail options for riders from beginners to experts. The trails presented here are within the beginner-to-intermediate level and will serve as an overview of the trail system.

Because the trailhead has no designated parking, you must park in Lake Placid and ride your bike to the trailhead. While experienced road cyclists will probably elect to take the most direct route on NY 86 (heading north for 0.9 mile from its intersection with NY 73), traffic is heavy and often fast. A far better choice, especially for those with younger riders, is to go up the

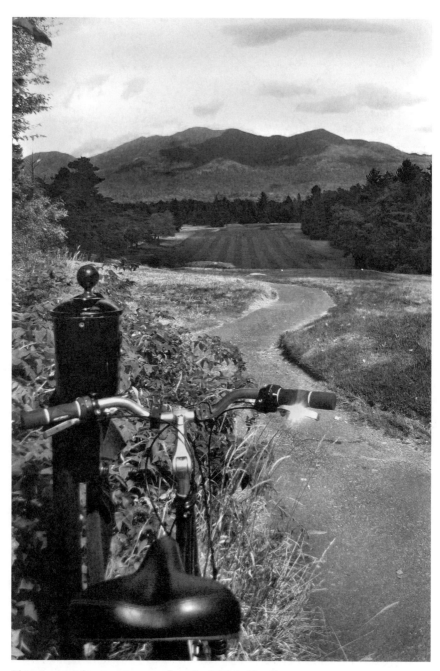

Distant mountain ranges are seen from the BETA trailhead.

hill to the junction of NY 86 and NY 73, and turn left onto NY 86 (Mirror Lake Drive). Go 0.2 mile and turn right, continuing on Mirror Lake Drive (which loops around Lake Placid village), and follow it 1.0 mile to Northwood Road. Take Northwood Road 0.8 mile to its intersection with NY 86. Go straight across Wilmington Road (NY 86). Come downhill through the golf course, leaving putting green No. 7 to your left. This is the trailhead (Jackrabbit Trail).

Continue straight ahead on Jackrabbit Trail. Pass a sandpit on the left, at which point the trail becomes a double-track. At the fork about 0.5 mile in, turn left onto Bull Run (a.k.a. Bushwood). The trail is well marked. Follow the dirt road. As you approach the golf course, continue on Bushwood as it goes to the right. Follow the trail markings (yellow diamonds on a black background). Pass Ty's Ties on the right. Go left on Night Putting, a single-track loop for advanced beginners. The turns are tight on this narrow trail, but it is never hilly. Upon completion of the loop, you're back at Bushwood. Turn left. Pass Twisted Sister on the left. Within 500 feet at a three-way intersection (ahead is a steep downhill), turn left onto Lacy Underall. This is a fast, rooty, rocky trail that snakes downhill through spruce woods.

At the approximately 2.0-mile point, at an intersection at the bottom of Lacy Underall, go right onto Loggers, following a level stretch through a hardwood forest. Pass loop 1 on your left. Climb on easy single-track. At a T intersection, go left onto Algonquin. Pass Billy Barule on your left. Pass Gunga Galunga on the right, after which a downhill follows. Set to your lowest gear and climb the next hill, passing the Flying Wasp loop on the right. Bear right to stay on Algonquin as it veers off to the right. Avoid Cinderella Story, continuing right on Algonquin, which loops around to Flying Wasp, a beautiful single-track. Turn left onto Flying Wasp, heading back to Algonquin. (The Algonquin loop begins and ends here.) Turn left here at the approximately 3.6-mile point. At the T intersection you came through earlier, go left onto Jackrabbit Trail (orange). This will bring you back out to Bushwood, which you will recognize. (Avoid the road to the left, which goes onto the golf course.)

Your route back out is straight ahead, the way you came into the trail system. Continue up through the golf course and straight across the road onto Northwood Road. Follow Northwood Road back to Mirror Lake Drive, and turn left to return to NY 86/NY 73. Follow NY 73 back to your car.

TRIP 11
HENRY'S WOODS

Rating: Moderate

Distance: 2.4 miles

Elevation Gain: 350 feet

Estimated Time: 1.5 hours

Maps: USGS Lake Placid 7.5; Henry's Woods kiosk map; National
Geographic Adirondack Park: *Lake Placid/High Peaks*; Adirondack
Maps, Inc.: *The Adirondacks High Peaks Region*

**This state-of-the-art off-road cycling trail in the village of
Lake Placid makes for an easy, hilly ride.**

Directions

From NY 73, coming west into the village of Lake Placid, bear left following
the ski jumps onto Old Military Road. At 0.8 mile, turn left onto Bear Cub
Road. At 0.1 mile, bear right into the parking area (well marked; room for
30 to 40 cars).

From Saranac Lake, bear right off NY 86 onto Old Military Road. Go 3.0
miles to Bear Cub Road and turn right. *GPS coordinates:* 44° 15.838' N, 73°
58.868' W.

Trip Description

This beautifully designed park was built as a hiking and cross-country ski
trail system, and is a popular multi-use area for mountain bikers as well.
Mountain bikes and hybrid bikes alike can handle the well-groomed terrain.
Expertly laid out and meticulously maintained, the trail is one of the most
well built and nicely designed you are likely to see in the Adirondacks.
Situated in an attractive, heavily wooded area, Henry's Woods has a quiet,
deep forest atmosphere even though it is just a stone's throw from the many
attractions of Lake Placid. There are two loops: the Plateau Loop, which
has some crossover trails that are not bike-designated, and the Rocky Knob
Loop, a foot trail, which climbs a 2,200-foot hill to the north of the parcel.
Cyclists are asked not to use the Plateau Loop during wet periods.

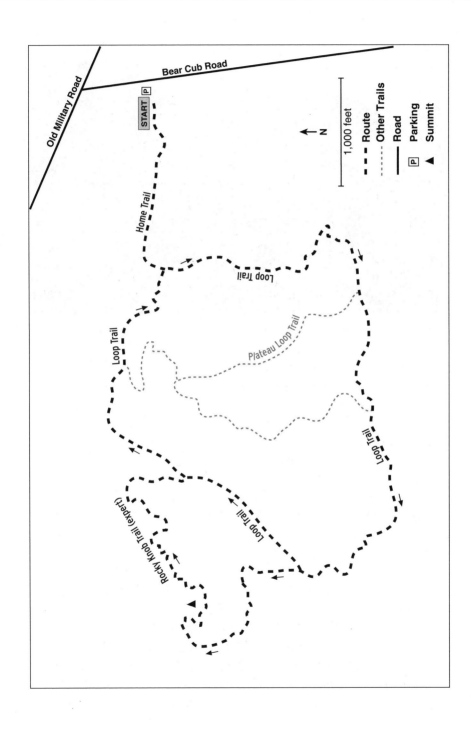

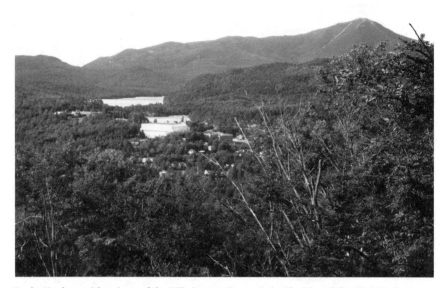

Rocky Knob provides views of the Wilmington Range, Lake Placid, and the High Peaks.

At 2.4 attractive miles, Henry's Woods is a short, non-technical, off-road bike trip, making it an ideal beginner-to-intermediate mountain-bike ride for children. Warn them ahead of time, however, about the hill they'll have to climb at the beginning of the trail, reminding them of the equally long downhill section that follows. For more advanced riders, this trail could easily be added to the Lake Placid Loop, the NY 73 leg of which passes Military Road at the entrance to the North Elba Show Grounds. Because both are short (at 11 miles, the Lake Placid Loop is a quick touring ride), the two taken together would add up to a full day's cycling over scenic and varied terrain.

Begin the trail at the west end of the large U-shaped parking area. The trail is well marked, wide enough to accommodate multi-use traffic, and is covered in gravel for most of its length. Visit the attractive, rustic log kiosk on the left to review the map. The trail has been machine-graded and cleared of rocks, so you can focus on the woods and the other trail users more than on the trail's surface. At a sign for the Loop trail, bear left and climb for a while. The trail switches back as it climbs and then relaxes over sand and hardpack covered in pine needles. Now you level off on the plateau, where the terrain undulates easily. (Note the maple benches, cut from trees with

the roots still intact.) Some large white pines appear, as the trail winds down to cross a wooden bridge. After the bridge, you'll see the red-marked Rocky Knob Trail on the left, which is narrower than the main trail. The trail is not ideal for biking, although bikes are allowed. This is expert-level terrain. Lock your bike to a tree and hike the trail if you want to hike Rocky Knob rather than bike it, and you will be treated to views of Lake Placid and the High Peaks from two separate outcroppings. From the first ledge there are views of Algonquin, Colden, Marcy, Mount Van Hoevenberg, and Mount Jo. Continuing a bit more uphill, you'll have views of Mirror Lake, Lake Placid, and the McKenzie mountains, as well as of Whiteface. The red trail continues down the north slope of the mountain but is longer than the first leg (and is a technically more difficult section for bikes), so backtrack to your bike.

Mount your bike and continue along Plateau Trail, which heads downhill at this point.

Advise younger children to favor their rear brakes now, and stay to the right of the trail, giving pedestrians the right of way at all times. You will pass a hanging log bridge on your left, which leads to a little rest spot. Cross another little bridge ahead, and then pass through a red spruce woods. Bear left at the beginning of the loop again, which you'll recognize. Avoid the trail on the right, which leads to private property. Soon you pass the kiosk again, on your right, and you're back out at the parking area.

The 212-acre Henry's Woods Park is owned and maintained by the Henry Uihlein II and Mildred A. Uihlein (pronounced *ee-line*) Foundation for the benefit of Lake Placid residents and visitors. Henry Uihlein II, a wealthy philanthropist, died in 1997 at the age of 101. He was the grandson of Henry Uihlein, president of the Schlitz Brewing Company. Like so many others of his era, he came to the Adirondacks in his late teens seeking relief from tuberculosis (see page 52). He had a great interest in sports, is credited with helping to bring the Olympic Games to Lake Placid, and served as an official timer in the 1932 Winter Olympics. He contributed generously to the Mayo Clinic and Cornell University's College of Agriculture. At Heaven Hill Farm, the Uihleins' home in Lake Placid, he worked to develop a disease-free source of seed potatoes, a prize herd of pure Jersey cows, and a maple syrup research program.

The White Plague

Edward Livingston Trudeau was born in 1848 in New York City, in the years when one out of seven people worldwide would die of tuberculosis. His brother James died of the disease when Edward was a teen. Trudeau attended Columbia's College of Physicians and Surgeons, from which he graduated in 1871. Two years later, he too was diagnosed with tuberculosis. The so-called "rest cure," which was being practiced successfully in Europe, convinced Trudeau to relocate to the Adirondack Mountains. Here, with proper rest and fresh air, he regained his health, though he would suffer relapses of the disease throughout his lifetime.

Trudeau loved the Adirondacks, and—between his brief recoveries from bouts of consumption—frequently hunted and fished the area. He noticed improvements in his own health, which convinced him to focus on the region for further research into the rest cure. Residents of Saranac Lake donated the land for Trudeau's first treatment center, the Adirondack Cottage Sanitarium. Trudeau admitted patients regardless of their ability to pay, raising most of the money privately. Here he developed the Trudeau School of Tuberculosis, which offered a six-week practicum in the study of tuberculosis treatment.

Trudeau's was the model for the tuberculosis treatment and sanatorium movement in the United States. Many new facilities were constructed. By the 1920s, applications to Trudeau's various sanatoria outnumbered the available beds. To meet the demand, private homes in Saranac Lake were renovated to include open-air porches, which became known as cure cottages. Saranac Lake began to prosper with its new identity as the "City of the Sick." Druggists opened stores. Physicians moved in. Large care facilities were built, such as the Will Rogers Hospital. But in the ruinous wake of the Great Depression and the 1940s discovery that the antibiotic streptomycin provided a "cure" for the disease, Saranac Lake lost its previous prosperity. Sanatoria were converted to state prisons and places of business; cure cottages reverted to private homes and summer rentals.

Though early diagnosis and treatment do provide relief from tuberculosis, a cure has never been found. The same virus (which has been discovered in 4,000-year-old mummies) resurfaced in people with AIDS in the 1980s, in a tougher, mutated, more drug-resistant form. It had simply gone underground for years—perhaps to escape the discerning eye of Edward Trudeau himself, or those of his later colleagues at today's Trudeau Institute in Saranac Lake, where the search for a cure continues.

TRIP 12
SANTANONI PRESERVE

Rating: Easy
Distance: 9.0 miles
Elevation Gain: 380 feet
Estimated Time: 4.0 hours
Maps: USGS Newcomb 7.5x15; National Geographic Adirondack
Park: *Lake Placid/High Peaks*; Adirondack Maps, Inc.: *The
Adirondacks High Peaks Region, The Adirondacks Central Mountains*

**An easy bike ride on a carriage trail leads to a historical Great
Camp on Newcomb Lake, with free, designated campsites.**

Directions
From the intersection of NY 30 and NY 28N in Long Lake, go 14.5 miles east
on NY 28N to Newcomb. Turn left onto Newcomb Lake Road, crossing the
bridge over Harris Lake narrows.

From the east, take Exit 29 of the Adirondack Northway (I-87) onto CR 2
(Blue Ridge Road, a.k.a. Boreas Road). Travel 17 miles and turn left onto to
CR 25. Go 1.2 miles and turn right onto NY 28N. Go 5 miles and turn right
onto Newcomb Lake Road, and continue past the gatehouse to the parking
area (room for twenty cars) on the right.

From Exit 28 of I-87, go north 27 miles on NY 28N from NY 28 in North
Creek. Turn right onto Newcomb Lake Road. *GPS coordinates:* 43° 58.337' N,
74° 09.820' W.

Trip Description
Around the later part of the nineteenth century and up until the First World
War, members of America's wealthy leisure class bought large tracts of land
in the Adirondacks. Many of them built the Great Camps, a style that was
being popularized by William Durant on Raquette Lake. The long-term,
single-family ownership of these large tracts helped to preserve lands that
may otherwise have been broken up and sold. Today, many of these tracts
are annexed to the forest preserve. The 13,000-acre Santanoni Preserve is
such a place.

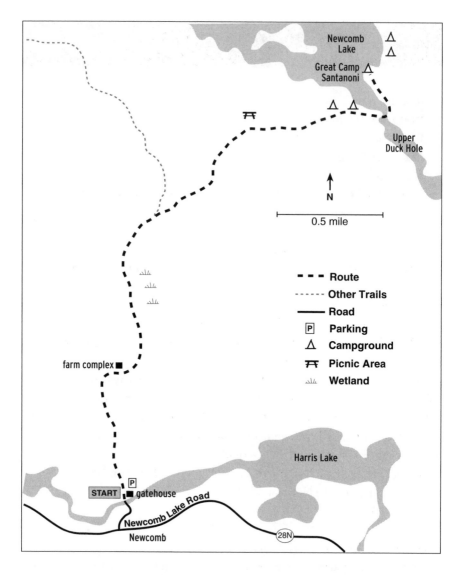

While it is classified as wild forest, the Santanoni Preserve provides a rare opportunity to cycle to an Adirondack Great Camp on a carriage road abutting the High Peaks Wilderness Area. The road is in good condition and can be pedaled or hiked by children, providing the opportunity for an adventurous, unique, and educational family day outing in a relatively tame and sheltered environment. Mountain bikes and hybrids can easily handle the terrain, which has no big hills or difficult obstacles. The road is well marked and maintained. During regular daylight hours, a maintenance

The wide carriage road to Camp Santanoni crosses the Newcomb Lake narrows.

and construction staff is usually present to show you around the camp, which is being restored. This road is sometimes driven by state maintenance vehicles, but you will most likely encounter only nonmotorized users. These include hikers and equestrians, and perhaps the horse team and wagon that is available for hire to transport both passengers and canoes to Newcomb Lake, which has eight designated trail- and lake-accessible camping areas around its perimeter. Camping is free on a first-come, first-served basis.

From the parking area, head north on the hardpacked sand/gravel/dirt carriage road, leaving the old gatehouse to your right. Pass the trail to the Adirondack Interpretive Center on the left. Passing a wetland on the right, you will soon see the remaining structures of a once thriving farm that sustained the many workers and guests of the camp. At 2.0 miles, pass the trailhead into the wilderness area on your left. Bear right. The road very gently ascends to the 3-mile point at 1,950 feet in elevation. Beautifully built stone bridges and retaining walls display the quality of construction typical throughout the Santanoni Preserve. As you begin the gentle descent toward the lake, a picnic area appears to the left. At lake elevation (1,730 feet), cross the narrows between Newcomb Lake and the Upper Duck Hole, which form the headwaters of the Newcomb River. This little river joins the Hudson River east of Harris Lake.

Follow the road across the bridge, as it heads west along the north shore of the lake. In 0.3 mile, you arrive at the main camp. Dismount your bike for a look around. From July 4 through Labor Day, the preservation group Adirondack Architectural Heritage employs three interns at the site, who will answer questions and give tours of the camp. The boathouse and main lodge are usually open year-round, though no interpretive services are available off-season.

Santanoni is considered to be among the finest examples of Adirondack rustic architecture. Its staff quarters, lodgings, kitchen, dining room, and great room are enclosed by a common roof, with the large, covered porches overlooking Newcomb Lake. From here, take a walk down to the boathouse. The views include Santanoni to the north, and in the near foreground, Baldwin and Moose Mountain, all part of the western High Peaks Wilderness Area. A trail around the north side of the lake will take you a short distance past the timber-framed Artist's Studio to a sand beach and a restored beach house.

Santanoni was built in 1893, and was seasonally occupied by the family of Robert C. Pruyn of Albany for 60 years. (Pruyn was the founding forester of the extant Finch-Pruyn lumber company.) The Pruyns eventually sold Santanoni to the Melvin family of Syracuse. What followed would be a tragic mystery that has never been explained. In 1971, Douglas Legg, a grandson of the Melvin family, joined his uncle for a hike around the lake. Eight-year-old Douglas had come wearing shorts, and was sent a short distance back to the camp to get long pants. En route, Douglas disappeared, never to be seen again. His disappearance spurred a 33-day search that was the largest man-hunt conducted in the northeastern United States up until that time, and led to the formation of the state's first search-and-rescue team. Soon after, the Melvin family sold the property to The Nature Conservancy, which in turn sold the preserve to the state. For the next 20 years, the property and its structures remained vacant and unmaintained. In the early 1990s, when the state determined to endorse the proposals of private and public interest groups to preserve Santanoni, several partnerships organized to save the Great Camp. Restoration has been ongoing and will continue with public financial aid and volunteer support.

After you've had a good look at the camp and the scenery, hop on your bike and cycle back to the parking area the same way you came. The ride out is fast following the height-of-land.

Section 2

Northwest Lakes and Foothills Region

THE NORTHWESTERN REGION OF THE ADIRONDACKS is the most remote and undeveloped area of the park. While the eastern fringe of the Lake Champlain–Lake George corridor was very familiar to the first European explorers and settlers, the central and western areas of the Adirondacks remained virtually unknown until the late 1800s.

The Five Ponds Wilderness Area, at 120,000 acres, comprises the largest contiguous classified landmass in the region. It lies near the western boundary of Adirondack Park and forms the southwestern corner of the lakes-and-foothills complex of the northwestern Adirondacks. To the east of Five Ponds is the William C. Whitney Wilderness Area and in the center of the region are the St. Regis Canoe area and the Saranac Wild Forest. The boggy flatlands to the north give rise to the small but scenic Azure, Arab, and St. Regis mountains.

NY 30 runs along the southern edge of the realm with NY 86 on the east. The north is bounded by NY 458 and the St. Regis River, which makes its way into the St. Lawrence. Saranac Lake, on the eastern side of the region, along with Tupper Lake in its middle, are the largest villages. Both offer a jumping-off point for the trips described in this book. The area has many excellent state campgrounds, and within the trips themselves are many free, designated camping sites. The historical town of Paul Smiths, to the north, is the home of one of the Adirondack visitor interpretive centers (VIC); another VIC is in Newcomb, near Goodnow Mountain and the Santanoni Preserve.

Much of the forest preserve's growth has occurred in this region over the past 30 years or so. As in most of the Adirondacks, a great deal of the original forest preserve lands were purchased after being heavily "logged off," a practice of indiscriminate harvesting that was not intended to provide a sustained yield. The majority of landowners, having depleted the value of their lands by clear cutting, then sold those lands to the state to recover some of their original investments. In other cases, the lands were seized for back taxes. Some of the lands annexed to today's forest preserve have been gifts, but the largest parcels, such as the William C. Whitney Wilderness Area, once a part of Dr. William Seward Webb's 140,000-acre Nehasane Preserve, have been purchased by conservation groups with state acquisition funds. Some of the few remaining virgin tracts of timber are within the original purchase of Nehasane in the Five Ponds Wilderness Area.

Today, these lands, combined with the surrounding wild forests and canoe areas, offer a backcountry paradise that is overlooked by most of Adirondack Park's visitors. The matrix of old logging and estate roads; railroad beds; and low, isolated mountains that rise above the surrounding flatlands (many with accessible fire towers) provide unlimited opportunities for hiking and cycling. Pond hopping, trout fishing, and camping in a remote setting within vast holdings of unbroken forest near sandy beaches and on the prows of rocky islets are major attractions in this quiet corner of the Adirondacks, where you can paddle for days on end in quiet solitude.

TRIP 13
MOUNT ARAB

Rating: Easy
Distance: 1.5 miles
Elevation Gain: 730 feet
Estimated Time: 1.5 hours
Maps: USGS Piercefield 7.5 and 7.5x15; National Geographic
Adirondack Park: *Old Forge/Oswegatchie*; Adirondack Maps, Inc.:
The Adirondacks Northwest Lakes

A short climb leads to a fire tower overlooking the lakes and hills in the Cranberry and Horseshoe lakes wild forests.

Directions
From the intersection of NY 3 and NY 30 in Tupper Lake, head west on NY 3. At 6.0 miles, cross the Raquette River at Piercefield Flow. At 6.8 miles, bear left onto CR 62 (Conifer Road). At 8.6 miles, go left at the Mount Arab trailhead sign onto Mount Arab Road. At 9.2 miles, the trailhead appears on the left. Park on the right side of the road in the parking area, which has room for ten to twelve cars. *GPS coordinates:* 44° 12.815′ N, 74° 35.772′ W.

Trip Description
In spite of being an unimposing peak rising off the beaten track, family-friendly Mount Arab (2,539 feet) manages to dazzle upward of 10,000 hikers in a single season—almost as many as the famed Mount Jo. The main attraction is the easy access to the restored fire tower and the vast view it affords. The Friends of Mount Arab (FOMA), a citizens group, maintains the tower, the trail, and the observer's cabin on the Mount Arab summit with private funds. FOMA's success with Mount Arab demonstrates how a small group of concerned citizens can contribute substantially and effectively to the environment. FOMA publishes a newsletter and seeks donations from hikers, footing the bills with only management support and no financial help from the state. The lands on which the trail begins are those of the Conifer Easement, belonging to Rayonier Inc., a paper company that provides

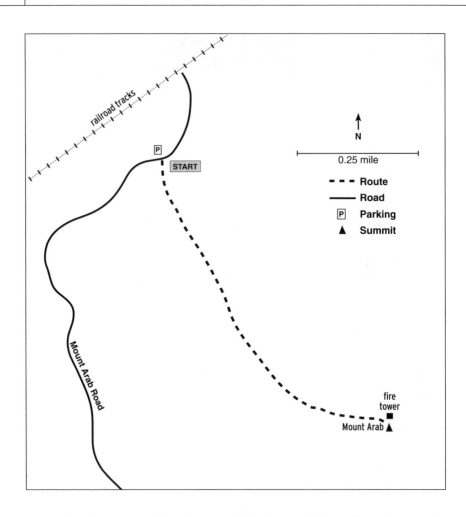

recreational access to this private working forest. (The trail continues onto state land.) In turn, the state provides Rayonier with a tax break.

The red-marked trail begins at the iron ranger, a donation box opposite the trailhead sign, and following the trail register, rises through young northern hardwoods of beech, birch, and maple. Because the terrain is not steep, the trail goes straight uphill on a beeline for the summit. The gradient is gentle and the footway is clear, but this is not a stroll, it's a hike, and you will work up a sweat. In a few areas where hikers were widening the trail by detouring around wet spots, puncheons (2x8 decking on 4x4 sleepers) have been laid across the trail to prevent further erosion. The St. Lawrence County Youth Conservation Corps completed this project. AmeriCorps interns and FOMA volunteers have undertaken other projects.

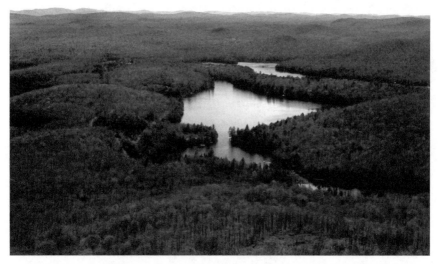

Mount Arab Lake and Eagle Crag Lake lie northeast of the Five Ponds Wilderness Area.

You will reach the summit in 30 minutes or so. The fire tower and observer's cabin stand close together on the wooded summit, which has a few open rock outcroppings facing toward the south. The tower cab is open during seasonal fair weather. You can open the large wooden panels that have replaced the windows, but be sure to secure them before you leave. During the summer months when a summit intern is present on the mountain, the alidade and map are kept in the tower. An alidade is a sighted brass rod that swivels in a full circle over a topographic base map. During the tower's active service, in the event that a tower observer spotted smoke, the sights of the alidade were aligned in its direction and a compass bearing was taken from the end nearest the observer (for this reason, on most tables, the cardinal directions are rotated by 180 degrees). This rendered a back bearing, which was then called in by telephone to the local ranger. Radio communications between the Adirondacks' 57 towers were established in the 1940s; this hastened the response by ground personnel, resulting in less-widespread and less-destructive fires. It also relieved the tower observer of having to maintain a long system of telephone wires.

The Mount Arab fire tower surveyed 625 square miles of forest for fires, but much more is visible to today's casual observer. Over the 70 years of its operation, a long succession of observers lived on the summit and main-

tained the tower and the trails. One, "Doc" LaVasseur, lived on the summit from 1937 to 1964. He was the first, according to FOMA, to call Mount Arab his "home." Observers lived in tents until the cabin was built in 1918 (rebuilt in 1950). Between 1944 and 1949, there were 21 fires reported from Mount Arab. In the 1950s, more than 30 were reported.

If the summit steward is present during your visit, you will learn a great deal more about the extensive views from Mount Arab's tower. Your compass won't work because of the steel framework, but the alidade will. Orient yourself to the village of Tupper Lake, which you can see clearly to the east across Raquette Pond (the northerly basin of Tupper Lake). Coney Mountain rises south of Mount Morris, and far to the south you see Blue Mountain. The lake just below the mountain is Mount Arab Lake. Horseshoe Lake lies hidden to the south of it. Wheeler, Buck, and Haystack (which looks like a haystack) line up in the southwest. South of the Horseshoe Lake Wild Forest is the William C. Whitney Wilderness Area, which contains Little Tupper Lake and Lake Lila, both popular canoeing destinations. To the southwest is the Five Ponds wilderness. At 118,000 acres, it is the park's third largest. Due west is the Cranberry Lake Wild Forest, but Cranberry Lake itself is hidden by a long line of mountains on its eastern side.

Today, only the summit interns live in the cabin, sharing the history and interpreting the natural environment of Mount Arab to visitors. They are usually college students with an interest in environmental science and ecology. While most of the Adirondack fire towers were either dismantled or left to decay where they stood, Mount Arab's is a proud exception. It is a reminder of the rich forest legacy we enjoy today: a lonely sentinel of bygone days preserved as a shining example of a rich, living history.

Return the way you came.

The Great Forest Fires

Many references are made to the famous Adirondack forest fires of the late 1800s and early 1900s, in particular the fires of 1903. In the 51 days after April 15 that year, only one-fifth of an inch of rain fell on the Adirondacks, making the entire state forest preserve and surrounding lands highly flammable. In 1904, the *New York Times* reported that thousands of small fires burned that summer, causing a greater loss of acreage of mature timber than the larger fires.

In charges described by the *Times* as "sensational," the Federal Forestry Bureau claimed that the very men who were responsible for the control and suppression of forest fires were in many instances the ones who were setting them. This provided them with sustained employment at the wage of $2 a day, the third-highest wage available in the area. Local residents resented the larger landowners in the park, who had recently limited previously unchecked hunting and fishing. Also, citizens were angry that they could not cut timber or even firewood from state lands.

While convictions were difficult to procure and therefore rare, deliberate incendiarism was documented as a cause of forest fires in the Adirondacks (one man was charged with setting 24 fires in a single day). Among other causes of the fires were sparks from locomotives, escaped fires from farmers clearing their lands, intentional fires set by berry pickers and ginseng harvesters for the purpose of promoting growth, and escaped flames from structure fires.

Though there was no reported loss of human life and little loss of livestock resulting from the 1903 fires, which burned 600,000 acres, an estimated $7 million of damage was done. The only positive result was the recognition that early detection of fires was the only effective method for forest protection. This led to the construction of the fire tower system, which began in 1909. By 1920, there were 115 towers in the state, 57 of them in Adirondack Park. Eventually, the cost of maintaining the towers resulted in their abandonment (though some remain intact and are considered national historical landmarks), when aerial surveillance took over as the sole method of detection. However, some experts point out that the warming climate of recent years and relaxed standards of detection may once again provide the conditions for large forest fires in the Adirondacks.

TRIP 14
ST. REGIS MOUNTAIN

Rating: Moderate
Distance: 6.0 miles
Elevation Gain: 1,500 feet
Estimated Time: 4.0 hours
Maps: USGS St. Regis Mountain 7.5 and 7.5x15; Paddlesports Press:
Adirondack Paddler's Map; National Geographic Adirondack Park:
Old Forge/Oswegatchie; Adirondack Maps, Inc.: *Adirondack Canoe
Map, The Adirondacks Northwest Lakes*

**Enjoy a scenic half-day hike to open ledges overlooking the
St. Regis Canoe Area and more than 30 lakes and ponds, as well
as the High Peaks.**

Directions
From the intersection of NY 86 and NY 30, go north on NY 30 and turn left
immediately onto Keese Mill Road. Go south for 2.5 miles. Pass the Black
Pond/Long Pond access parking area on the right, and park just ahead at the
St. Regis Mountain trailhead parking area on the left (room for fifteen cars).
GPS coordinates: 44° 25.925' N, 74° 18.009' W.

Trip Description
Isolated and nearly bare-summited, St. Regis (2,874 feet) is a popular
mountain that many hikers claim has the best view in the Adirondacks. The
trail has been rerouted in recent years, adding a bit more cumulative rise
and distance, but this has done little to frustrate the estimated 5,000 hikers
who use the trail each year.

After parking, walk south on the Spectacle Pond road, crossing the outlet
of Lower St. Regis Lake, which forms the headwaters of the St. Regis River's
middle branch. By midsummer, wild rose and milkweed grow along the
roadside; in the shaded woods the trillium blooms have withered and gone
to seed. At 0.1 mile, bear right onto the trail and sign in at the register on
the left. Follow the red markers. The forest is dense and comprises mixed
hardwoods and a few large white pines. Passing a vernal pond, the trail rises

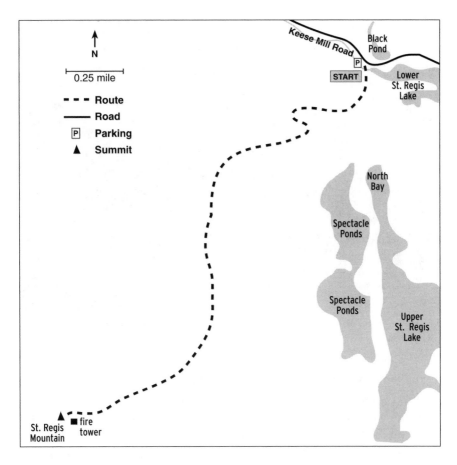

easily and is often poorly marked, but the footway is, with few exceptions, well established and self-guiding. You will climb easily for the first half hour. After you reach a small hemlock knoll, walk its low ridge and descend slightly on its southerly slopes. You'll see boulders lying scattered throughout the woods, dragged here by the Wisconsin Ice Sheet at least 10,000 years ago.

The trail levels for a while before rising to cross a wooden bridge over a tiny creek just before it reaches the open site of the former fire tower observer's cabin on the left. All that is left are a few rusty chunks of the old woodstove. Campers have built a crude fire ring here in a small clearing of ferns where violet asters grow. Bunchberry blooms in the shade along the next stretch of the trail, which is deeply eroded into the duff layer. At 1,800 feet of elevation, 1.8 miles into the hike, the trail is a series of steep rises and easy flats. Soon it turns gently into the southwest, climbing nearly

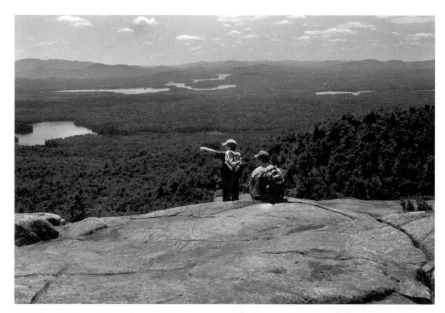

Hikers identify ponds and lakes of the St. Regis Canoe Wilderness from St. Regis Mountain's rocky summit.

1,000 feet in the next mile. Sections of the upper trail are deeply eroded among a series of large, broken ledges of Marcy anorthosite. Much of the soil here was damaged or completely burned off in the 1876 forest fire while survey work was being conducted, which left the summit bare and the remaining soils sandy and thin. On the summit, a few tenacious spruce trees grow in the poor soils, somewhat obstructing the views to the north and east.

As you gain the granite summit dome, you will see the fire tower to your left and a series of terraced ledges providing plenty of space for observing the nearly 360-degree viewshed. The lower stairs of the fire tower have been removed from the aging structure, which is at this time in a state of critical disrepair. Closed after the 1990 fire season, the tower was listed on the National Register of Historic Places in 2005, and a citizens group has formed in the interest of preserving it.

Most of the nearby landmarks are easily identified without the aid of a compass, but the distant horizon is complex. You'll see Whiteface at 110 degrees magnetic, with Moose Mountain to the right of it. Cascade is at 134

degrees. The array of the Great Range summits spreads out at 146 degrees, with Gothics at its center. Marcy and Algonquin follow, along with the Sawteeth and the Sewards. Ampersand is at 167 degrees.

For the easiest identification of the nearby landmarks, use the *Adirondack Paddler's Map*, because the big attractions here are the mountains and ponds nearby and within the St. Regis Wilderness Canoe Area. You can see Mount Morris and the ski slopes of Big Tupper. Mount Arab is at 237 degrees. Directly in front of you and almost due south is St. Regis Pond with its islands. To the left is Little Clear Pond, then Lake Clear. To the left of St. Regis Pond is Little Long Pond. Farther to the left is Upper St. Regis Lake. The large, long lake to your right is Upper Saranac. Beyond Hoel Pond, in the south, is Floodwood Mountain. Past the airport in Lake Clear is the McKenzie Mountain Wilderness Area. You can readily see Paul Smith's College on Lower St. Regis Lake. The primary landmark in the northwest is Azure Mountain, with its unmistakable cliff face, at 336 degrees. Farther to the right, just east of north are Meacham Lake and enormous Debar Mountain.

After you've enjoyed the summit, head back the way you came. Mountain ash and viburnum (witch-hobble) grow along the trail's upper elevations near the summit, the latter turning a deep purple as late summer progresses into autumn. In early summer, thousands of bees audibly work the ash blooms where the trail is tunneled over in foliage. In the middle elevations, northern hardwoods are dominant.

Hidden to the west of the trail are the Spectacle Ponds, which lay along the northeast border of the St. Regis Wilderness Canoe Area. This is the location of famous Camp Topridge, former estate and summer residence of Marjorie Merriweather Post. Married four times, once to financier E.F. Hutton, she founded the General Foods Corporation and was at one time the richest woman in America. In its heyday, this spectacular Adirondack Great Camp had more than 70 buildings, a main lodge, and a Russian dacha, with every guesthouse staffed by its own butler. Topridge is now privately owned.

Continue along the trail back to the parking area and your vehicle.

TRIP 15
AZURE MOUNTAIN

Rating: Moderate

Distance: 2.0 miles

Elevation Gain: 880 feet

Estimated Time: 2.0 hours

Maps: USGS Lake Ozonia 7.5; USGS Meno 7.5; Paddlesports Press: *Adirondack Paddler's Map*; National Geographic Adirondack Park: *Old Forge/Oswegatchie*; Adirondack Maps, Inc.: *The Adirondacks Northwest Lakes*

A short, stiff hike leads to one of the northern Adirondacks' most solitary and scenic mountain summits, with a fire tower and views as far as the St. Lawrence Seaway.

Directions

From the intersection of NY 86 and NY 30, go north on NY 30 and turn left immediately onto Keese Mill Road. Go south, at 2.5 miles passing the Black Pond/Long Pond fishing access parking area on the right, and, within 0.1 mile, the St. Regis Mountain trailhead parking area on the left. Continue straight on Keese Mill Road, which becomes Blue Mountain Road, for another 15.5 miles. Pull into the Debar Mountain Wild Forest's Azure Mountain trailhead parking area on the left (room for fifteen cars). *GPS coordinates:* 44° 32.263' N, 74° 29.150' W.

Trip Description

Out of the way and off the beaten track, Azure Mountain (2,518 feet) is still close enough to climb after a visit to the Paul Smith's Visitor Interpretive Center, or before an evening of trout fishing on Black Pond. You can even climb both St. Regis and Azure mountains on the same day; they are in many respects "sister peaks": both rise above the St. Regis River valley near the western edge of Franklin County and their trailheads are only 15 miles apart by road. Keep in mind, however, that although Azure Mountain's summit trail is short, it is one of the steepest trails you'll encounter in the Adirondacks.

The trail begins on a dirt road in a Norway spruce stand and heads immediately into the woods. A sign over a rock pile to the left encourages hikers

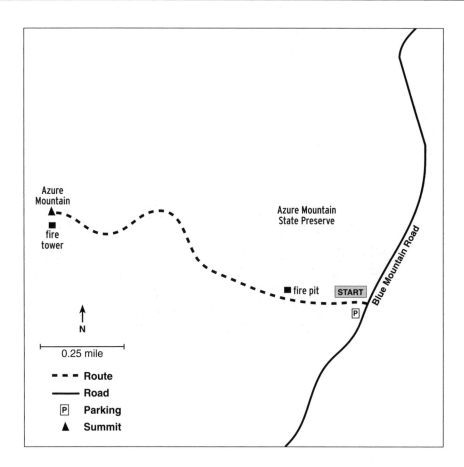

to carry a rock to the summit, and, by placing it where it will help to slow erosion, contribute in a small but meaningful way to the Azure Mountain Friends' (AMF) ongoing summit restoration efforts. About 500 feet ahead, the trail register appears. Sign in and continue. Pass an old picnic table and fireplace on the right. The trail rises easily into a maple wood, where many of the trees are the standing dead and dying victims of a recent fire. The trail sidehills through a long switchback and then turns to climb directly up the steepest part of the mountain. From this point the grade is unrelenting and you'll be stopping to catch your breath frequently. An open rock to the left of the trail provides a limited lookout, and a more-than-welcome rest.

The remaining travail relents as the tower finally comes into view. Azure Mountain's fire tower is one in a small but growing group of fire tower success stories. Built in 1918, the tower had become derelict, and in 2001 the Department of Environmental Conservation announced its plans to remove

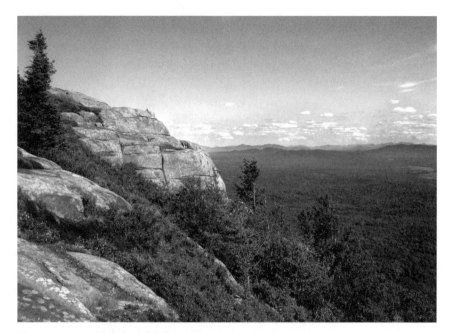

The St. Lawrence River is visible from Azure Mountain's fire tower.

the tower, considering it a safety hazard. But it was also a place that many people fondly regarded as an important and valued landmark. A committee of local volunteers joined together to form the AMF. The tower was restored in 2002 and is now listed on the National Register of Historic Places.

The cab is open year-round, featuring a guest register and the same map that was once used to spot fires. The map is roughly oriented to true north, and will help you to identify numerous landmarks. Your compass won't work for landmark identification here because the tower is made of steel, but you can use your GPS (on most units you can program your compass bearings to read in either true or magnetic north). Orient yourself to St. Regis Mountain and its fire tower, which is at 152 degrees magnetic, 12.5 miles distant. Mount Arab is at 205 degrees, 23 miles distant. To the right is Debar Mountain and to the south is Whiteface Mountain, easily identified as it stands alone above the Wilmington Valley. You can see into the High Peaks, from Gothics to Marcy and Algonquin (152 degrees, 37 miles distant) to the Sawteeth. You look down upon the middle branch of the St. Regis River. Lake Ozonia, the Deer River Flow, Loon Lake Mountain, and a host of other hills and water bodies lay before you.

A surprise about Azure's viewshed is that on a good day, you can see the St. Lawrence River, less than 40 miles to the north–northwest in the vicinity of Massena, New York. The Raquette and St. Regis rivers join the St. Lawrence Seaway after flowing through the St. Regis Indian Reservation at Hogansburg. On the other side of the St. Lawrence is the province of Ontario. The ability to see into Canada to the north and the High Peaks to the south will give you a broader understanding of regional geography; it's just 85 linear miles to Ottawa and 80 miles to Montreal from this point.

This proximity is evident in the history of the region: Both the Raquette and the St. Regis were vital travel corridors for the Mohawk, who settled in great numbers just 30 miles north of here. From the vicinity of today's village of St. Regis, they carried on trade and relations with both the French settlements in Canada and the rest of the Six Nations people to the west.

Today, the summit of Azure Mountain has a few dead-end trails as well as an informal fire ring and tenting spot north of the tower. Explore the cliffs in a westerly direction, where open rock ledges will lead you to a large, solitary boulder. This glacial erratic was left here in the wake of the Wisconsin Ice Sheet. The glacier departed along with the reindeer, hairy mammoths, and archaic period nomads that followed them at some point around 10,000 years ago. This and earlier sheets of ice dating from the Quaternary Period of up to 2 million years ago were once thousands of feet thick and pressed the Adirondacks into a dome shape, smoothing and rounding its peaks and leaving a radial drainage pattern. Its moraines left boulder-sized deposits that would block runoff, forming the multitude of lakes and streams you see all around you.

From Azure's summit, retrace your steps to the parking area.

TRIP 16
CONEY MOUNTAIN

Rating: Easy
Distance: 2.0 miles
Elevation Gain: 500 feet
Estimated Time: 2.0 hours
Maps: USGS Little Tupper Lake 7.5 and 7.5x15; Paddlesports Press: *Adirondack Paddler's Map*; National Geographic Adirondack Park: *Old Forge/Oswegatchie*; Adirondack Maps, Inc.: *The Adirondacks Northwest Lakes*

This very easy hike leads to a scenic, accessible , and kid-friendly peak.

Directions

From the intersection of NY 3 and NY 30 in Tupper Lake, go south on NY 30. Pass Horseshoe Lake Road at 8.6 miles. At 10.5 miles, look for the large turnout (room for ten cars) on the right. The trailhead sign is located on the other side (east) of the road, just before the parking area, and it's small and easy to miss. If the first parking area is full, another, smaller one is a bit farther ahead (south on NY 30).

From Long Lake village, the trailhead is 11.5 miles north on NY 30, on the left side of the road. *GPS coordinates:* 44° 05.974' N, 74° 31.747' W.

Trip Description

Coney Mountain is a very easy, kid-friendly hike you can take on a lazy afternoon. If you plan ahead, you'll have time to climb it, plus another short outing nearby (such as Mount Arab, or a paddle on Little Tupper Lake in the William C. Whitney Wilderness Area).

A herd path to the summit of Coney Mountain has been used for more than 200 years, but until recently no official, designated trail existed. Today's marked trail takes a different route around the north side of this low, cone-shaped peak that rises above Cold Brook, a headwater of Little Tupper Lake.

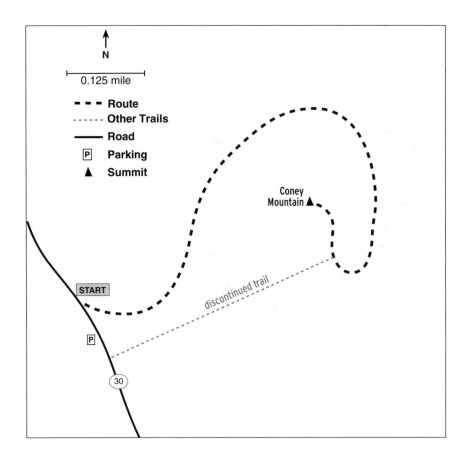

To begin, walk north from the parking area, back in the direction of Tupper Lake, 400 feet to the trailhead. A short distance into the woods you will find the trail register and map kiosk. A detailed history of the mountain is posted here, which describes the historical trail up Coney. The information was taken from Barbara McMartin's *Discover the Northern Adirondacks*.

Don't confuse this discussion of the earlier trail with the new trail you're about to take. Trails are rerouted for many reasons. Some encroach upon private lands, where boundaries are ambiguous. Sometimes, change of ownership leads to the retraction of previous easements. More often, trails are relocated to avoid the degradation of the resource by erosion and to avoid areas of sensitive vegetation. The earlier trail takes a beeline to the summit, and is therefore not designed to limit the impact of an increasing number of

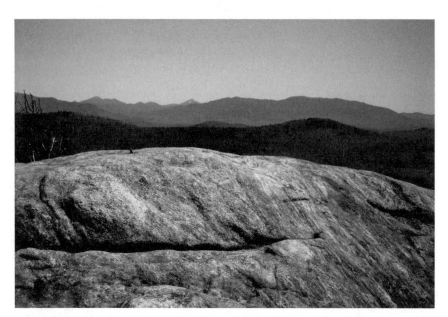

The easy hike up Coney Mountain provides views of wilderness and wild forest in every direction.

hikers and the unchecked erosion this usually causes. The new trail takes the potential for intensive use into account.

Follow blue markers into a hardwood forest. The trail is well marked and unobstructed by rocks and roots. It winds around the mountain from the north, and approaches the summit from the southeast. You may notice the unmarked trail junction where the old trail comes in from the right as you approach the summit. Shortly beyond this point, the summit—and its 360-degree views—is gained. Landmarks are fairly easy to identify using only your map and compass.

Haystack and Buck mountains appear in the northwest. Goodman Mountain (2,176 feet) lies in the north. Mount Morris, with its towers, is easily identified to the right of Goodman. Arab lies across the top of Tupper Lake's south basin, with Matumbla to the right of it. The smaller body of water at 250 degrees (magnetic) is Round Lake, and beyond it, Little Tupper Lake. To the south are Buck and Cat mountains, and farther south are Owl's Head and the familiar profile of Blue Mountain in the Blue Mountain Wild Forest. Beyond Little Tupper Lake are the little hills in the Pigeon Lake

Wilderness Area. Far to the north–northwest is the Cranberry Lake Wild Forest. Cranberry Lake itself is hidden behind the long ridge extending between Berkley and Bear mountains, and the foreground peaks of Silver Lake, Rampart, and Iron mountains. Deeper into the southwest is the Five Ponds Wilderness Area. You can see Mount Marcy and the Great Range in the High Peaks. You can also see the Seward Range above Long Lake.

A few benchmarks are on the summit, indicating that it was once an important triangulation station. Previously called Peaked Mountain, in 1882, state surveyor Verplanck Colvin named it (or generically referenced it as) Monument Mountain. In 1891, it appeared as Cone Mountain on a Seneca Ray Stoddard map. As early as 1722, Coney's summit was a reference point for Archibald Campbell, the surveyor who ascertained the boundaries of a large tract of land that would become the historical Totten and Crossfield purchase, from the Mohawk.

According to the state engineer and surveyor, the 1903 survey verified the original lines as drawn by Campbell. The boundaries were marked with iron I beams. One such marker can be seen immediately into the woods a very short distance from the northwest edge of the parking area, where state lands (yellow blazes) abut private lands. Farther into the woods and uphill 0.2 mile to the west, a tricorner marker identifies the boundaries of Franklin, Hamilton, and St. Lawrence counties.

Return to your vehicle the same way you came.

TRIP 17
BLOOMINGDALE BOG RAIL TRAIL

Rating: Moderate

Distance: 22.0 miles

Estimated Time: 5.0–6.0 hours

Maps: USGS Saranac Lake 7.5 and 7.5x15; USGS Gabriels 7.5; USGS
Bloomingdale 7.5x15; Paddlesports Press: *Adirondack Paddler's
Map*; National Geographic Adirondack Park: *Saranac Lake/Paul
Smiths*; Adirondack Maps, Inc.: *Adirondack Canoe Map*

**A flat, scenic rail trail ride through the extensive wetlands of
Bloomingdale Bog leads onto hard roads into the village
of Onchiota.**

Directions

From the corner of Main Street and NY 3/NY 86 in Saranac Lake, go
northeast on Bloomingdale Avenue through the village. At 2.9 miles, bear
right onto a small side road and pull over immediately on the left into the
small parking area (room for four cars). *GPS coordinates:* 44° 21.798′ N, 74°
06.254′ W.

Trip Description

Bloomingdale Bog Rail Trail is one of the very few old railway beds in the
Adirondacks that has been converted into a bike-friendly, multi-use trail.
It is used frequently by cyclists and pedestrians and rarely by equestrians,
and is closed to all motor vehicle traffic with the exception of snowmobiles.
No evidence of the rail tracks or ties remains—only the built-up ballast and
bridges. The treadway is in excellent condition, and of course no hills exist
on the rail trail itself—only an imperceptible gradient gain of 40 vertical feet
between Saranac Lake and Onchiota. A short section has an uneven, rooty
surface where spruce and tamarack trees have grown up on the trail's edge,
but the rest is a combination of smooth single- and double-track that you
can ride for most of the way on your middle chain ring gears. You could even
make this a bikepacking trip, carrying your gear in your panniers and spend-
ing the night at Buck Pond state campground. You'll need a mountain bike
(preferably) or a very capable hybrid to ride the rail trail.

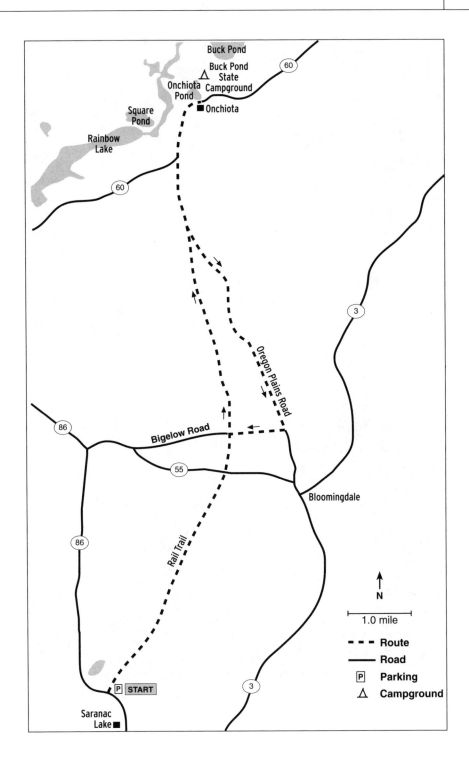

Buck Pond

Buck Pond
State
Campground

Onchiota
Pond

△

■ Onchiota

Square
Pond

Rainbow
Lake

60

60

3

Oregon Plains Road

86

Bigelow Road

55

Bloomingdale

86

Rail Trail

N

1.0 mile

- - - **Route**
——— **Road**
P **Parking**
△ **Campground**

P START

3

Saranac
Lake ■

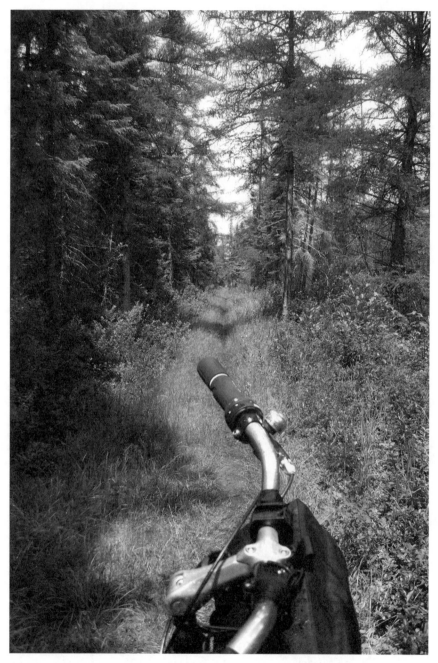

The Bloomingdale Bog Trail follows a strip of rail ballast through a dense spruce bog.

Plan for the unexpected as you will be heading into some very wild country. Anticipate possible breakdowns in a remote setting, and bring your pump or inflator, some tube sealant and/or some tire levers and patches. Carry plenty of liquids and snacks—no convenience stores are along the way. By all means bring insect repellent, since the bug situation in an Adirondack bog is more than likely worse than it is elsewhere. If deerflies are present, the same flies that find you at the trailhead will harass you for miles. Protect your head with a backward ball cap or bandanna, because the flies will find their way through your helmet vents and onto your scalp, where you can't easily kill them while both hands are engaged in driving your bicycle.

Unload at the little parking area and head through the gate to the rail bed. A small pond is on the left. The bog opens up immediately as you travel north. Jones, Blue, and Negro Hill rise to the left, with the larger, more distant Kate Mountain (2,841 feet) lying ahead. As you progress, crossing the bridge over Towbridge Brook at 3.0 miles, you will enter the woods. Blowdowns may appear through this section. At 3.8 miles, you will cross CR 55 (the village of Bloomingdale is 1.7 miles to the east). At 4.3 miles, you will cross Bigelow Road (dirt), your return route. The trail is covered in pine needles, with a grass-strip, single-track center, and is tightly enclosed by spruce and fir trees. Colorful hawkweeds and reindeer moss grow on the sides of the trail. Dense forest recedes into wet lowlands. As you cross Negro Brook, views open up to the southeast. Go around a gate and cross a dirt road at 6.2 miles. Following a scenic view over the wetlands, enter the woods again, passing a few isolated stands of Scotch pines, with their distinctive light-red bark. At 8.0 miles, you will reach paved Oregon Plains Road.

Get off the rail trail (which deteriorates ahead) here. Bear left on Oregon Plains Road and follow it 0.8 mile to CR 30. Turn right and climb a long, easy hill into Onchiota. You've come a total of 9.7 miles from the trailhead. At this writing, Onchiota has a charming antiques shop on the corner (formerly the Camper's Pantry, which served the campground), where you can get a soft drink from a machine. The larger, boarded-up building across the street was a small supermarket in 1925, and later became the Onchiota general store. The Six Nations Indian Museum (opened in 1954) is also here, featuring pre- and post-contact period artifacts of the Haudenosaunee Mohawk.

Onchiota was for many years a lumber town. When the New York Central and Delaware and Hudson (D&H) railroads came through town in the 1880s,

a sawmill was built there. The D&H ceased passenger service in the 1940s, and the New York Central followed suit in the late 1950s. As was the case in many parts of the Adirondack woods, when the forests were depleted, the area became a tourist spot, popular with hunters and anglers—perhaps as it had always been for the Mohawk, whose language includes the word *ochota*, or "lazy man's place."

If you want to tour the beautiful Buck Pond state campground (where you can cool down with a quick swim or relax and have a picnic), bear right onto CR 30 and pedal 0.3 mile to the campground's entrance road. Turn left into the campsite.

Return to Saranac Lake by backtracking to Oregon Plains Road to the rail trail. You may wish to skip the return trip on the northerly part of the trail for a change of pace, or because of blowdowns or bugs. On the paved surface you can enjoy some freewheeling for a while, staying on Oregon Plains Road for the next 4.7 miles back to Bigelow Road, at which point you will turn right and go 1.2 miles to the rail trail, then turn left. Oregon Plains Road is a quiet, very bike-friendly, enjoyable road with sandy shoulder, pretty scenery, no centerline, and few residences. From Bigelow Road, get back onto the rail trail and retrace the route back (4.3 miles) to the trailhead parking area.

Rating: Moderate
Distance: 18.0 miles
Estimated Time: 4.0 hours
Maps: USGS Little Tupper Lake 7.5; USGS Sabattis 7.7x7.5;
National Geographic Adirondack Park: *Old Forge/Oswegatchie*;
Adirondack Maps, Inc.: *The Adirondacks Northwest Lakes*;
Paddlesports Press: *Adirondack Paddler's Map*

**This mountain and hybrid bike trip takes you into the William
C. Whitney Wilderness Area to the sandy shore of Lake Lila on
a dirt canoe access road.**

Directions

From Tupper Lake, travel south on NY 30 for 12.0 miles, and turn right
onto CR 10A (Sabattis Road). At 3.0 miles, bear right onto CR 10 and con-
tinue for another 1.4 miles to the William C. Whitney headquarters sign.
Turn left, and bear right through the compound, 0.3 mile to the boat launch
parking area.

From Long Lake, go north 7.0 miles to CR 10, and turn left (west). Go 2.9
miles, cross the inlet, and bear left at the intersection of CR 10A. Continue
another 1.4 miles to the headquarters sign and turn left, then, bearing right,
go 0.3 mile to the boat launch parking area (room for 50 to 70 vehicles;
overflow parking is along the entrance road). *GPS coordinates:* 44° 03' N,
74° 35' W.

Trip Description

Lake Lila is a remote lake lying well inside the 20,000-acre William C.
Whitney Wilderness Area, which includes some of the state's most recently
acquired and protected lands. What's unusual about a bike ride through this
area is the fact that bicycles are not permitted on wilderness lands anywhere
in the state forest preserve. Since vehicular traffic is permitted on the Lake
Lila access road, however, this section of the tour gives you the sensation of
riding through the wilderness area itself. The roads are fairly flat, almost

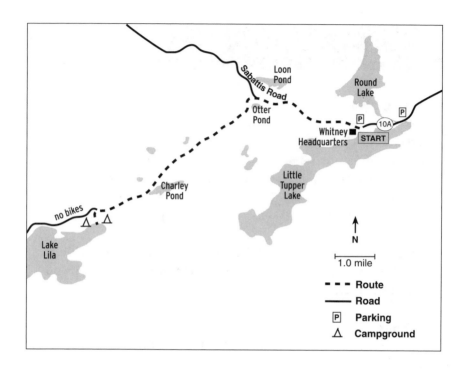

all dirt, and very lightly traveled, making this a good choice for a family ride. Although at 18 miles the tour in its entirety may prove rather long for younger children, you can turn back at any time you wish and still enjoy miles of carefree riding. But resist the temptation if your group can handle the longer ride, for once you arrive at the canoe carry, you can lock or stash your bike and walk down to the water's edge for a swim and a picnic or even an overnight on wild Lake Lila.

Bring your canoe with you and you can make your trip to the Whitney a multisport weekend. Camping on the shores of these waters is free. Allowing enough time, you can paddle to a campsite on either Lake Lila or Little Tupper Lake after you finish your bike ride. Look at the map of the Whitney Wilderness Area, which is posted in the kiosk at the trail register near the boat launch. This will give you an idea of the area's roads, trails, and campsites. (Also, see Trips 22 and 24.)

From the parking lot, ride your bike back out to Sabattis Road (CR 10) at the entrance to the Whitney Headquarters and turn left. The road is paved at this point but has neither a centerline nor fog lines. Traffic is light, though

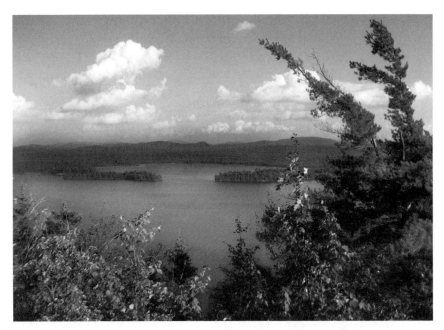

Lake Lila spreads out below Mount Frederica in the William C. Whitney Wilderness.

it will be busier during the summer camping season. In the off-season, the road is gated at its extreme west end, where it enters the Sabattis-Hiawatha scout reservation, which helps to minimize road use. The road deteriorates into broken pavement and then to well-maintained dirt as you progress. At 3.0 miles, turn left onto the dirt Lake Lila canoe access road, which is well identified by a state sign, with the traditional yellow letters over a brown background. The speed limit is 15 mph, but use caution and stay to the right, especially as there are several blind turns and rises. Ahead are a few easy climbs and descents. You will see several other woods roads here and elsewhere, which lead to private parcels and inholdings. Several foot trails in the area follow old roads into the interior wilderness area, and these are for nonmotorized use only. No bicycles are permitted. You may see deer and even a moose running across the road.

The Lake Lila canoe access road heads southwest through a hardwood forest. The first landmark is Otter Pond, immediately on your left. The next is Charley Pond at 7.0 miles (from the Whitney Headquarters) on your left, followed by a camp on the right. At 9.0 miles you will arrive at the Lake Lila

parking area. The road you're on continues into the wilderness area and is, unfortunately, off-limits to cyclists, although it is open to hikers as well as private landowners and state vehicles. You have the option of locking your bike up and hiking in to Frederica Mountain, for example, should you care to do so (the round-trip is 9.4 miles). See Trip 24 for details.

If you want to enjoy the lake, the canoe carry heads downhill and arrives in 0.3 mile at a sand beach. Foot trails to either side of the beach lead to designated campsites. Allow yourself enough daylight to ride safely back to Whitney Headquarters. At this point, if you're interested in adding a few more (paved) miles, continue past the headquarters on Sabattis Road to the Round Pond parking area. Turn around at the outlet of Little Tupper and cycle back to the headquarters to enjoy one of the prettiest cycling roads in the Adirondacks.

TRIP 19
LOWER SARANAC LAKE TO WELLER POND

Rating: Moderate

Distance: 17.5 miles

Estimated Time: 8.0 hours (overnight suggested)

Maps: USGS Saranac Lake 7.5 and 7.5x15; USGS Upper Saranac Lake 7.5 and 7.5x15; National Geographic Adirondack Park: *Lake Placid/High Peaks*; Paddlesports Press: *Adirondack Paddler's Map*; Adirondack Maps, Inc.: *Adirondack Canoe Map, The Adirondacks Northwest Lakes,* and *The Adirondacks High Peaks Region*

Experience miles of open water among the many islands of Lower Saranac Lake, and paddle up the lazy Saranac River through the state locks to Middle Saranac Lake and the remote Hungry Bay and Weller Pond lean-tos (no portages).

Directions

From the corner of Main Street and NY 3 in Saranac Lake, go west on NY 3 toward Tupper Lake. At 3.9 miles, turn left into the Second Pond fishing access site (Saranac Lake Islands public campground; boat access only).

From Tupper Lake, go east 5.0 miles on NY 30/NY 3, bearing right at the fork to continue on NY 3. Go an additional 11.0 miles to the Second Pond boat launch. *GPS coordinates (for put-in):* 44° 17.241′ N, 74° 11.113′ W.

Trip Description

Lower, Middle, and Upper Saranac lakes (the Saranacs) are a veritable paradise for paddling and camping enthusiasts. The appeal of these waters lies in their beauty and sheer magnitude. No matter how busy they become on the warm weekends of summer and during the peak foliage period of autumn, you will always be able to find a private and peaceful place.

Lower and Middle Saranac lakes are a part of the Saranac Lake Islands public campground and day-use area, which includes 87 campsites (most of them on or near to the water's edge; reservation required online or at the registration booth) and five lean-to sites. The sites have outhouses, fire rings, and picnic tables. The boat launch at Second Pond provides secure overnight

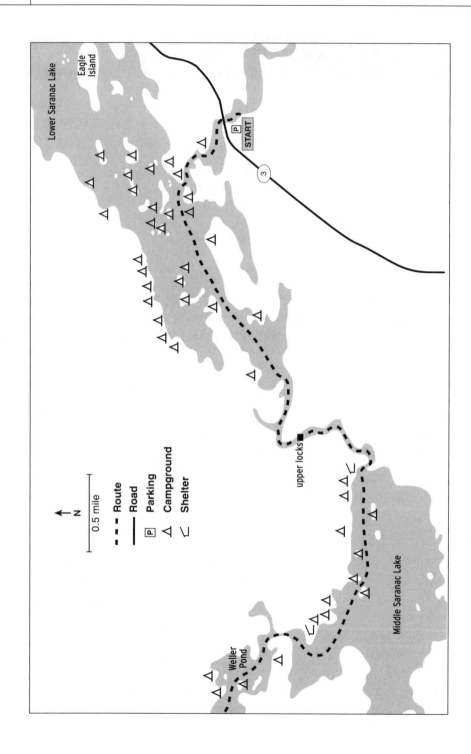

parking and a deep-water launch. The water quality, like the scenery, is excellent. Choose the time of your visit carefully (an off-season weekday, with a fair forecast, fair winds, and a rising moon would be ideal) and you will find that these beloved lakes will provide what Adirondack folks have enjoyed for two centuries: canoe tripping and camping at its best. You may, of course, choose to treat this outing as a rigorous out-and-back day trip.

Unload your canoe and gear at the launch. Secure your gear and set out, heading in a northerly direction, passing under NY 3. Soon the sounds of traffic are left behind as you wind your way through First Pond on the Saranac River (little or no current, flows south) following the channel markers, entering the lower lake through a narrows. At 1.0 miles, Bluff Island, with its sheer rock face, comes into view and the lake is revealed. You'll see Boot Bay Mountain in the west. Be cautious: Strong winds, rollers, or even a capping chop can prove challenging on Lower Saranac Lake.

Turn southwest, leaving Pope Bay to your left (south). Follow the northerly shore of the Pope Bay Tongue through the Narrows, keeping Loon Bay to your left as you head for the section of the Saranac River into Middle Saranac Lake. The low, grassy outlet of the river becomes evident at 3.0 miles. Enter the river and paddle easily upstream past floating bogs and backwaters, passing Kelly Slough, a deeply receding wetland. The languid river leads you northwest before turning south toward the Upper Locks. If no lockkeeper is on duty, you will operate the manual lock yourself, a simple and straightforward procedure for which directions are provided. (You may choose to carry your boat and gear around the lock if you're going light, as you'll have a short wait while the lock chamber fills.) After the lock fills to river level, lead your boat to the dock and set out onto the river again, which winds circuitously past Halfway and McKenna brooks, to a point where it enters Middle Saranac Lake in Bull Rush Bay. Ampersand Mountain in the High Peaks Wilderness Area stands to the south, along with the nameless hills and humps spreading westward from Stony Creek Mountain.

Clearing Bull Rush Bay, head for Halfway Island, leaving First, Second, and Norway islands to your left. If the breeze is against your direction of travel, stay close to the northerly shore, passing between Bartlett Island and the mainland's Saranac Lakes Wild Forest area. Head north past Halfway Island into Hungry Bay. Follow the eastern shore of the bay, rounding the little point at Campsite 81 (perhaps the most attractive lean-to campsite in the Saranac Lake Islands), and head northeast into the little slough that leads to Weller Pond. Here you will encounter delicate amethyst blooms of blue flag

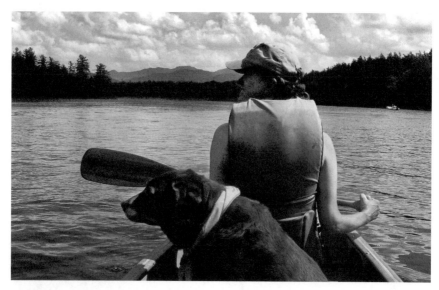

With their many fine campsites and great scenery, the Saranac Lakes are a popular canoeing destination.

(wild iris) and hundreds of dark, liver-colored pitcher plants. Tamaracks, the deciduous evergreens, grow around the rim of the wetlands. Pink blooms of sheep laurel festoon the bog.

Head out into Weller Pond and paddle to the western shore to explore Site 87, where a lean-to is hidden in the woods. This is the most private campsite on the pond. If you feel like stretching your legs, take the portage trail from this point to Saginaw Bay in Upper Saranac Lake.

The western shore of Middle Saranac Lake (like the eastern end of Lower Saranac and most of Upper Saranac) is mostly private land. You can still, however, portage your boat from Middle Saranac into Upper Saranac Lake over Bartlett Carry. Entertain the possibility of a longer overnight paddling trip using a two-car shuttle, placing another vehicle in the north at the Saranac Inn boat launch on Upper Saranac Lake (12 miles by water via Bartlett Carry, passing many free, designated campsites on the upper lake) or through Fish Creek Bay to the take-out at Follensby Clear Pond (10 miles via Bartlett Carry). Bear in mind that Upper Saranac is a large and often tempestuous lake, which is generally best traveled from north to south, with the prevailing northwesterlies.

From Weller Pond, retrace your route back through the locks, allowing time to explore the little bays and emerald isles of the enchanting Lower Saranac Lake archipelago.

TRIP 20
ST. REGIS CANOE AREA

Rating: Easy

Distance: 7.0 miles

Estimated Time: 6.0 hours (overnight suggested)

Maps: USGS St. Regis Mountain 7.5 and 7.5x15; Paddlesports Press:
Adirondack Paddler's Map; National Geographic Adirondack Park:
Saranac/Paul Smiths; Adirondack Maps, Inc.: *Adirondack Canoe
Map, The Adirondacks Northwest Lakes*

**This go-light, day or overnight paddling trip leads into the
famous route of the 7 Carries—the only designated canoe
area in the state, heavily populated with loons and
surrounded by mountains and wetlands.**

Directions

From Paul Smiths, at the intersection of NY 30 and NY 86, go south on NY
30 for 3.8 miles. Turn right onto St. Regis Carry Road on the right, and go
0.3 mile to St. Regis Landing. From Saranac Lake, go north on NY 86 for
4.5 miles to NY 186 and turn left. Go 4.0 miles to Lake Clear Junction (in-
tersection of NY 30 and NY 186), and turn right. Go 2.9 miles to St. Regis
Carry Road, and turn left. Go 0.3 mile to St. Regis Landing. There is room for
twelve cars in the lot and along the road. *GPS coordinates (put-in):* 44° 23.710′
N, 74° 16.191′ W.

Trip Description

The St. Regis Wilderness Canoe Area (SRWCA) is the largest wilderness
canoe area in the northeastern United States and the only designated
canoe area in the state of New York. No motorboats are allowed on its 58
interior lakes and ponds, the majority of which are connected by marked and
mostly short, wheelable portage trails. The 18,000-acre SRWCA also has 75
campsites and 20 miles of hiking trails. Most of the ponded waters contain
trout. The canoe area is also an important loon breeding habitat, where the
birds are free from the boat wash, noise, and activity typical of the larger
surrounding lakes. It is highly unlikely that you could spend an evening in

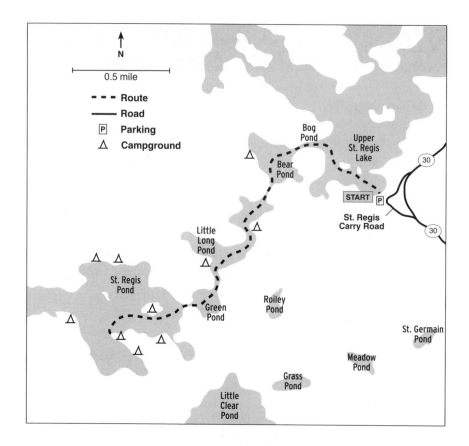

"the ponds" without being serenaded by the loons' mournful, echoing trills and tremolos. Campsites here tend to fill up early, and in recent years many sites have been closed due to intensive use. It's always possible to find a tentsite, however, since it is legal to camp 150 feet from any water or trails, anywhere in the SRWCA.

St. Regis Pond, your destination, is the largest pond in the SRWCA, and is in many ways its centerpiece. The pond is frequently the objective for paddlers coming into and across the famed route of the 7 Carries, a system of ponds that have provided a travel corridor between the hotels of the area since the mid-1800s.

This trip requires five short portages (or, in Adirondack vernacular, carries) between Upper St. Regis Lake and St. Regis Pond. While they are short (the cumulative distance of the carries one-way is less than 0.4 mile), you probably won't want to do them twice in a single day's round-trip, so camping is the logical choice here.

Quiet evenings, interrupted only by the cry of loons, are commonplace on St. Regis Pond.

Launch from the dock at St. Regis landing and paddle west, passing two small islands and leaving the large wetlands of Roiley Bog to your left. St. Regis Mountain rises in the west, identifiable by its fire tower. You'll see many residences on the mostly private lands and islands of Upper St. Regis Lake, many of them built in the tradition of the Adirondack Great Camps. Head for the obscure carry to Bog Pond, which is located between two boathouses you will see on the western shore. A large stone wall and (usually) a sign are to the right of the carry. This first carry into Bog Pond is a mere 150 feet long. Follow the path across a dirt road and put in at the state trail register. Follow the slough into the pond. You may discover that a small wedge of floating bog vegetation is blocking the channel, but this can easily be nudged aside with your paddle. Pitcher plants and sundews (both carnivorous; see page 220) grow on the bogs, along with various species of orchids and the colorful pink blooms of the common sheep laurel.

Continue to the end of Bog Pond to the Bear Pond Carry, and portage your boat 150 feet into Bear Pond. The eastern side of Bear Pond, though it is not posted, is privately owned, but the west side is state land that has a few designated campsites. Bear Pond is well-loved for its remarkably clear water, which is turbid at higher levels. A popular swimming spot is the large rock in

deep water at the pond's north end, which is exposed during periods of low water. Leave the (private) peninsula with its lean-to to your left, and look for the 0.15-mile carry to Little Long Pond (signed) in the southwesterly area of Bear Pond. The carry is slightly hilly but wide and self-guiding.

Little Long Pond is among the larger ponds in the canoe area. It is a popular trout-fishing destination in the early months of spring and has some fine campsites. Bear west through the narrows and take out for the carry at the southwest corner of the pond. The carry into Green Pond is also 0.15 mile long, and trends downhill. Paddle west to the carry into St. Regis Pond. Four-hundred-acre St. Regis Pond has four islands and a dozen campsites. The most interesting and desirable campsites are those on the islands and points. However, many of these have been closed and relocated over the years and will continue to be managed in the interest of minimizing overuse.

Wildlife is abundant in the canoe area, and moose have been spotted here, although they prefer to feed on vegetation that is more abundant in earlier successional stages of forest growth. Loons, osprey, northern goshawk, vesper sparrows, and redheaded woodpeckers are confirmed breeders here. Bear and deer inhabit the area, as well as martin, bobcat, red and gray fox, river otter, beaver, muskrat, raccoon, skunk, porcupine, and various hares.

Return to Upper St. Regis Lake the way you came.

Loons, the Great Northern Divers

Visitors to the Adirondacks will inevitably encounter the great northern loon (*Gavia immer*), also known as the great northern diver, or common loon. Its sonorous and haunting voice has come to symbolize the northern forest. Canoeists, in particular, will often see loons at close quarters. The birds may even rise from the depths so close to your canoe as to startle you. Almost as suddenly, they will dive again, going as deep as 200 feet and for as long as two minutes to catch fish, surfacing far away.

Loons are often wary, as they are prone to predation by a number of birds and mammals. Loons are classified as a species of special concern in New York State and are considered threatened worldwide. Because Adirondack Park is one of the largest intact eco-regions in the Northeast, it provides the many lakes and ponds that are of vital importance in sustaining a healthy, breeding loon population, although shoreside development and increased recreational use has had a detrimental impact. Loons nest primarily on islands, where they are less prone to predation from land mammals. The birds and their young are most vulnerable during the nesting period, when they become agitated and disrupted if approached, which can result in the loss of their entire clutch of up to four eggs or young. Boat wash (waves, splash, and intense sounds) from motorboats, personal watercraft, and even canoes and kayaks can disrupt nesting loons, which may leave their eggs vulnerable to chilling or overheating and, ultimately, abandonment.

Loons are also particularly prone to lead poisoning from fishing sinkers, which birds may ingest among pebbles (which they swallow to aid in digestion) or from the broken-off tackle in a fish's mouth. The birds also can become fatally entangled in discarded monofilament lines. They are further threatened by loss of habitat through the acidification of ponds and lakes, and through the bioaccumulation of mercury, which is introduced by acid rain (see page 185), along with sulfur and nitrogen. Loons can become disoriented and stranded as a result of their mistaking roads or parking lots for rivers and lakes, and may strand themselves in ponds that are too small to take off from. Their feet are positioned far back on their bodies, making them expert swimmers but rendering them anatomically ill equipped for efficient locomotion on land. In an effort to walk on solid ground, they appear drunken and unstable—behavior that prompted the name "loon." The root word is found in the Scandinavian *lam* for "lame."

TRIP 21
BOG RIVER

Rating: Easy

Distance: 6.0 miles

Estimated Time: 4.0 hours

Maps: USGS Sabattis 7.5; National Geographic Adirondack Park: *Old Forge/Oswegatchie*; Raquette River Outfitters: *Paddlers and Hikers Map, Low's Lake and Bog River*; Paddlesports Press: *Adirondack Paddler's Map*; Adirondack Maps, Inc.: *The Adirondacks Northwest Lakes*

This sheltered and picturesque section of the Bog River leads paddlers through scenic wetlands into Hitchins Pond and Low's Lake.

Directions

From Tupper Lake take NY 30 south, passing Raquette River Outfitters on your left. At 8.5 miles turn right onto Horseshoe Lake Road (NY 421). Cross the Bog River after 0.6 mile. At 5.7 miles, turn left toward Low's Lower Dam canoe access (gated in mud season). Go 0.7 mile to the launch.

From Long Lake, go north on NY 30 for 13 miles to NY 421 and turn left (west). Continue on NY 421 for 5.7 miles to Low's Lower Dam canoe access road. *GPS coordinates:* 44° 06.957′ N, 74° 37.586′ W.

Trip Description

The preservation of the wild character of the Hitchins Pond primitive area, through which the most gentle and canoeable section of the Bog River flows, has proven a boon to paddlers of every ability level. Canoers and kayakers come to enjoy its peaceful waters and abundant wildlife. Many take advantage of the free camping and easy access the river provides to Low's Lake (Bog River Flow) and the seemingly endless Five Ponds Wilderness Area.

Situated in the heart of Adirondack canoe country, the Bog River may be treated as a day trip or as the staging point for multiday forays into the Five Ponds Wilderness Area. The parking area at the lower-dam put-in is small, holds only a dozen cars, and is often congested. Fifty or more cars might be parked along the narrow road leading to the put-in. If this is the case, drive

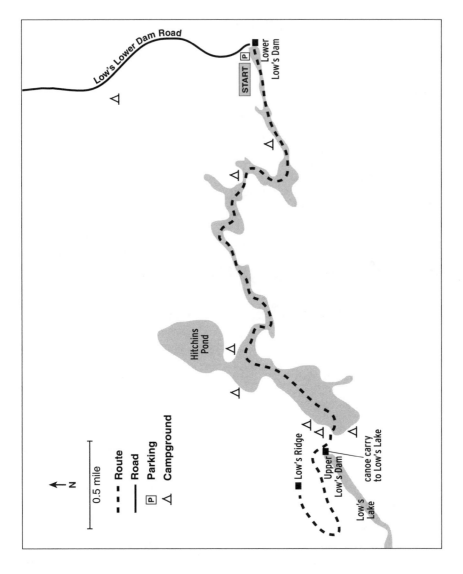

all the way down to the parking area and trailhead register and off-load your gear, then find a space back along the roadside. Be careful that you don't sink your tires into the soft shoulders and get stuck. (This road is gated in early spring to protect the road's surface. Call ahead to the local forest ranger for more information.) If you arrive to find the gate locked, you can park on the road and carry around the gate on NY 421, and portage 0.25 mile north to Horseshoe Lake Outlet. Put in and paddle downstream. This option cuts off a good deal of the Bog River, however. You can also put in at Horseshoe Lake,

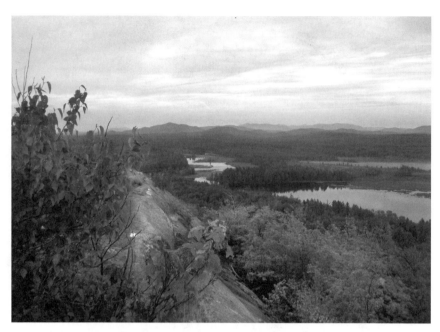

The Bog River can be studied from Low's Ridge.

back to the east where the road turns to dirt, and paddle around the point to the outlet, next to Campsite 12.

The sandy launching area is next to the dam on the north side. The current, which will be against you until your turnaround point at the upper dam, is barely evident. The river is languid and narrow, but widens as you head upriver. Three designated campsites exist on the lower river, and you may encounter campers along the way. Soon the river widens into Hitchins Bog, and you no longer have a sense that you are on a river, but instead that you are afloat on a series of connected ponds. These wetlands are characterized by small stands of red and black spruce as well as balsam fir. Large white pines appear on rocky points where solid ground reaches into the bogs. As the elevation increases beyond the wetlands, beech-maple is the dominant forest type. You can explore the bog's deadwaters, concealed amid little islands and flats of sedges and sweet gale as ospreys hunt overhead and eagles soar high above them. As the happy voices of paddlers fade away beyond thick clutches of speckled alder, you are left with the sounds of marsh wrens and bullfrogs. You may even enjoy the company of a peregrine falcon perched low on the limb of a dead tamarack.

As you pass beneath the railroad bridge the river widens. You see Low's Ridge, with its exposed rock face ahead. As you enter Hitchins Pond, bear left (southwest). Keeping to the north shore will enable you to see some campsites (Site 4 is concealed on the peninsula in the north basin of the pond, and the attractive Site 8 is on the extreme southwestern shore). A gravel landing marks the carry into Low's Lake. As you walk the carry, the tailrace from the upper dam is to your left.

These lands were once owned and developed by A. Augustus Low, the son and business partner of a wealthy New York merchant. By 1896, his holdings included 40,000 acres of forestland in the Bog River watershed. Low built a boarding house at Hitchins, the foundations of which can be seen along the portage trail. Here he housed employees of several business enterprises, including the Horseshoe Forestry Company, a large maple sugar business, and a commercial blueberry operation. Low generated his own electricity by means of the upper and lower power dams, the only structures of the Augustus Low complex (Hitchins Park) that remain intact.

A full investigation of Low's Lake requires at least an overnight and is not dealt with here. Even greater adventures lie beyond the western shores of Low's Lake, where the long carry to the Oswegatchie River begins. If you've allowed the time to explore upstream into Bog River Flow, take the flat, 0.1-mile carry to the put-in at the upper dam. An investigation of the "flow" (a lake that is formed by the widening of a river) is interesting. Visiting Campsites 9 through 12 will prove worthwhile, or plan to have lunch at the picnic area at Site 11 (1.7 miles upstream from the upper dam). Be aware that even moderate winds may produce whitecaps and dangerous swells on Low's Lake. You can avoid considerable expanses of open water by following the north shore and using the short carry between Campsites 19 and 23, crossing the causeway west of Site 25. Pole, Gooseneck, and Frying Pan islands are closed to the public. Virgin Timber, Boone's, and Moose Bay landings are shared with the Hiawatha Council Boy Scouts of America and are available by permit only, June through August.

By all means allow enough time to climb Low's Ridge (a.k.a. Hitchins Pond Overlook), which will give a more comprehensive picture of the Bog River headwaters and the surrounding country. As you reach the end of the canoe carry to the upper dam where it joins the road at a T intersection, the trailhead appears diagonally to the right, somewhat concealed behind a foundation. A trailhead sign and register are posted here. Follow the easy

blue-marked trail 1.1 miles (with a 400-foot elevation gain) through the hardwoods to the east-facing ridge with its panoramic views. Mount Arab is in the north. Mount Morris is to the east. The lower Bog River (which you've just ascended) stretches out to the south. A piece of Horseshoe Lake is seen. The Seward Range is located to the far east. Blue Mountain stands over the top of the ridges in front of you. A slice of Low's Lake can be seen in the near southwest. On a clear day, you can see Whiteface.

Paddle back to the launch the same way you came, leaving enough time to languish in the bog, or better, return to the campsite you selected and prolong your stay with an overnight on the river.

TRIP 22
WILLIAM C. WHITNEY WILDERNESS AREA

Rating: Moderate (depending on weather conditions)
Distance: 13.0 miles
Estimated Time: 10.0 hours (overnight suggested)
Maps: USGS Little Tupper Lake 7.5; National Geographic
Adirondack Park: *Old Forge/Oswegatchie*; Paddlesports Press:
Adirondack Paddler's Map; Adirondack Maps, Inc.:
The Adirondacks Northwest Lakes

**This is an ideal family-friendly destination for wilderness
paddling and camping, with excellent wild scenery, free
camping, good fishing, and vehicle access to the put-in.**

Directions
From Tupper Lake, travel south on NY 30 for 12.0 miles, and turn right onto
CR 10A (Sabattis Road). At 3.0 miles, bear right onto CR 10 and continue for
another 1.4 miles to the William C. Whitney headquarters sign. Turn left,
and bear right through the compound and go 0.3 mile to the boat launch.

From Long Lake, go north on NY 30 for 7.0 miles to CR 10 and turn
left (west). Go 2.9 miles, cross the inlet, and bear left at the intersection
of CR 10A. Continue another 1.4 miles to the headquarters sign and turn
left, then, bearing right, go 0.3 mile to the boat launch (room for 50 to
70 vehicles; overflow parking is along the entrance road). The Whitney
headquarters boat launch is the only legal access point to Little Tupper Lake.
GPS coordinates: 44° 2.982′ N, 74° 35.005′ W.

Trip Description
Since its acquisition by the state in 1998, the enchanting William C. Whitney
Wilderness Area has become increasingly popular with adventure paddlers.
The 20,000-acre wilderness is situated in the wild northwestern region of
Adirondack Park, and adjoins the vast Five Ponds Wilderness Area to the
west. Using the many ponds and streams in the area, paddlers going very
light can travel for as long as a week in a large clockwise loop, enjoying one
of the most solitary wilderness experiences available in the northeastern

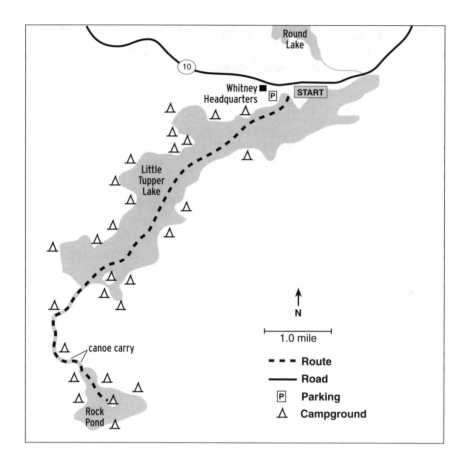

United States. The trip described here is an introductory overnight paddle (or a long day trip) down the length of Little Tupper Lake to remote Rock Pond. Camping in the Whitney is free. Sites are numerous and attractive, and in spite of the area's popularity, they are seldom all occupied on any given weekend. Camping is allowed only at designated campsites, with a maximum of three tents and eight people at each site.

Little Tupper Lake is the centerpiece of the Whitney wilderness because of its size, easy access, and the many fine campsites that exist on its shores and within the adjoining ponds and streams. Because of its relatively large size (6 miles long and a mile or so wide, with 20 miles of shoreline) and orientation, Little Tupper Lake is often subjected to unobstructed southwesterly winds, which can present challenges for small boats. For this reason, the lake is popular with sea kayakers and touring canoeists using tripping or large-

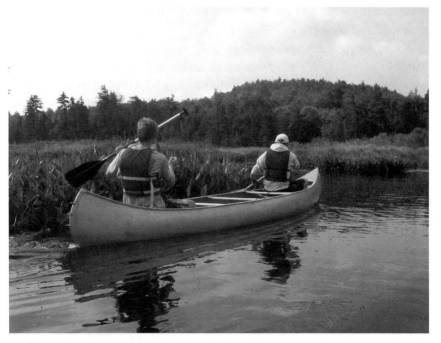

Two canoeists make their way upstream into Rock Pond.

volume solo canoes. On a warm late afternoon when Little Tupper's surface boils with the wind, few but the strongest paddlers in larger boats can (or will want to) make safe or timely southwesterly progress. Because the wind comes directly down the middle of the lake, it is often the case that neither shoreline provides much of an advantage over the other.

Upon your arrival, compare your map with the existing wind strength and direction (which during the summer months is generally weak in the mornings, builds into the afternoons, and eases toward early evening) and settle on the best direction of travel. The most direct route is southwest, down the middle of the lake. In the event that a northwesterly is blowing, stay to the northwest shore, and you can explore the bays and the dozen or so campsites between the put-in and your destination, Rock Pond outlet. Fewer campsites are along the south shore west of Eagle Point, but they increase in number and diversity as Short Island is approached.

Past Short Island's westernmost point, Rock Pond outlet flows northeast into the lake. It is small and obscure, so you'll have to look around for it. The current is weak and easily managed. The stream increases in width as you

enter a vast wetland, where large white pines hover over a broad expanse of marsh, and pickerelweed blooms in brilliant purple during late summer. As you make your way upstream, you will pass three campsites in the outlet. The way becomes twisted, serpentine, and a little confused in a maze of soggy thoroughfares. Follow the moving water as you lift and slide your boat over a few low beaver dams where the outlet becomes very narrow. The huge, solitary white pine you'll see in the distance stands (to date) on the edge of the carry, which is well marked on the left. In a few hundred feet, launch your boat again at the site of a washed-out logging road. Paddle upstream again through a few breached beaver dams to arrive in Rock Pond, with a half dozen campsites to choose from.

You will soon become aware of the silent and undisturbed character of Rock Pond, and its low-lying hills and picturesque wetland landscapes. From the western realms of the pond you can see Antediluvian Mountain to the northeast. Salmon Lake Mountain rises in the south. The ponds stretching to the west are tributaries of Salmon Lake (from Louie to Lilypad ponds), and lie within the Black River watershed, while the remaining areas in the Whitney are in the Raquette River watershed.

Many people come to the Whitney prepared to fish for trout. Little Tupper Lake's genetically unique strain of brook trout, which are descended from postglacial populations, has been trap-netted and used for broodstock in past years. While a majority of waters in Adirondack Park have been subject to the widespread invasion of nonnative and predatory fish, both Little Tupper Lake and Rock Pond are exceptions, a result of private fisheries management conducted by the Whitney family.

A committed conservationist, William C. Whitney (1841–1904) selectively and scientifically managed the original 68,000 acres of his virgin woodlands, shipping hardwood and softwood logs to New York City on a 4-mile-long railway spur joined to the New York Central system. Before its acquisition by the state, the property was managed by the Whitney family for more than 100 years. The family still maintains a home on Little Tupper Lake.

On your return paddle from Rock Pond, when the winds will most likely be behind you, explore the side of Little Tupper Lake you missed on the way in.

TRIP 23
ROLLINS POND LOOP

Rating: Easy

Distance: 7.5 miles

Estimated Time: 4.0–5.0 hours

Maps: USGS Upper Saranac Lake 7.5 and 7.5x15; USGS Derrick 7.5
and 7.5x15; National Geographic Adirondack Park: *Saranac/Paul
Smiths*; Paddlesports Press: *Adirondack Paddler's Map*; Adirondack
Maps, Inc.: *Adirondack Canoe Map, The Adirondacks Northwest
Lakes*

**Rollins Pond is quiet and protected, and the pond and stream
loop is ideal for young families, with three short carries
through the Saranac Lakes Wild Forest Area.**

Directions

From Saranac Lake, go north on NY 86 for 5.0 miles to NY 186. Turn left and
go 4.0 miles to NY 30 (Lake Clear Junction). Go west another 5.5 miles to
Floodwood Road on the right. Go 4.0 miles on Floodwood Road and park on
the right just after crossing the railroad tracks, across the road from St. Regis
Canoe Outfitters. This is a public parking area (room for ten cars) and canoe
access site. If the lot is full, park on the north side of the road.

From Tupper Lake, go 15 miles north on NY 30 to reach Floodwood Road,
then follow the directions above. *GPS coordinates (put-in):* 44° 20.320' N, 74°
24.307' W.

Trip Description

Guides and anglers have used the many ponds and creeks in the Saranac
Lakes Wild Forest Area for two centuries. As they were then, today the ponds
and creeks are connected by short, wheelable carries, each identified by
signs. Protected from the prevailing winds, the ponds are suitable for novice
paddlers, and are popular with canoe campers and kayakers of every ability
level. Free, primitive campsites are throughout the route (most of them on
Floodwood Pond), which takes you through the very popular and beautiful
Rollins Pond section of the Fish Pond/Rollins Pond state campground area.

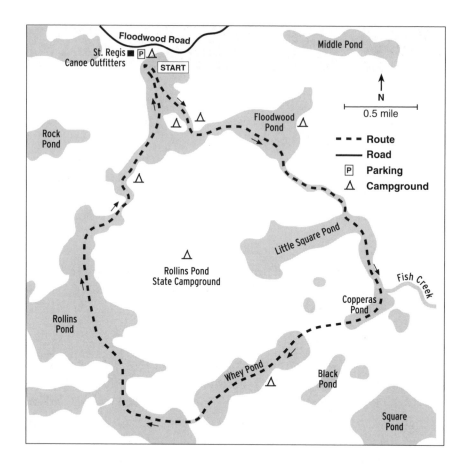

An appealing alternative to parking on Floodwood Road is to park and/ or camp in the Rollins Pond state campsite area (which requires paying a day-use or camping fee) and to then join the loop described here at any point in Rollins Pond. A few reasons for launching on Floodwood Road, however: First, no fees are involved, which will appeal to day users. Second, the launch is next door to the St. Regis Canoe Outfitters' Floodwood base (they have a storefront, livery, and outfitting outlet in Saranac Lake village as well), and the employees can give you the most up-to-date information on the loop and can describe the canoeing opportunities in the adjacent St. Regis Pond Wilderness Canoe Area (and the rest of Adirondack Park). Finally, Floodwood Road has several free, attractive, designated drive-up campsites in the event that you don't arrive with enough daylight or energy to camp on Floodwood Pond.

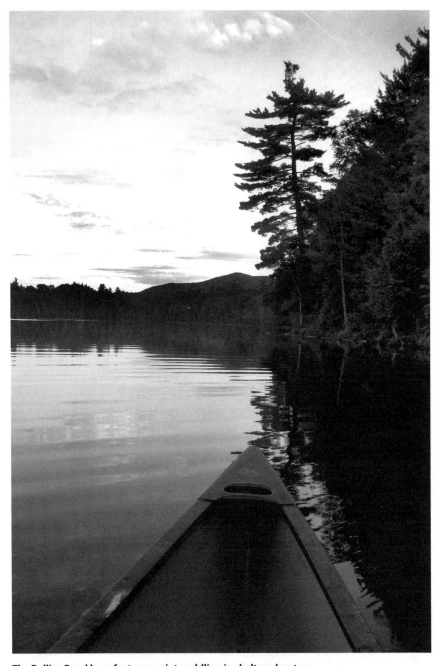

The Rollins Pond loop features quiet paddling in sheltered waters.

From the parking area, backtrack across the railroad tracks a few hundred feet to the launch on Floodwood Pond and head out into the pond, paddling south and then east past a large island. Continuing east, bear right (southeast) past a point and follow the right shoreline into the pond's outlet, called Fish Creek. Fish Creek is shallow and shaded by red pine, hemlock, and birches; in the clear water over the sandy bottom you will see bluegills and pumpkinseeds scatter at your approach.

Fish Creek enters Little Square Pond around to the east, where skittish mergansers and a chorus of belching frogs may greet you. Eagles or osprey are often seen sitting high in the branches of white pines, while sanguine herons sustain the primordial atmosphere. The pretty tamarack tree (hackmatack, or eastern larch) is found here, and with its broad, conical crown is perhaps as symbolic of the North Woods as the loon. American Indians used the strong and slender roots to sew birch-bark canoes, and the roots were sewn into ribs or "knees" in the construction of ships. The tamarack turns a rusty yellow color in fall before losing its needles. Today it is used for utility posts, railroad ties, and pulpwood.

In 0.5 mile, as you paddle down the narrows into the creek, watch carefully on the right for the tiny outlet of Copperas Pond. Paddle through the lilies and pickerelweeds into the pond and head southwest 0.3 mile down the pond's length to the carry into Whey Pond (also 0.3 mile). Avoid the Black Pond carry to the left. Go right, following signage to Whey Pond. The carry can be wheeled with a standard canoe dolly, and is open enough for a traditional yoke-style portage or a two-person bow-stern carry. Bear left ahead at the fork in the trail (keep your group together, because the fork is not marked at this time) and continue 200 yards to the put-in on Whey Pond. The fine sand entry to the pond is a good place to swim. Whey Pond is stocked with trout, but they have a reputation for being wary and difficult to catch. Paddle across Whey Pond (note the nice campsite on the western shore) to the 0.1-mile carry into Rollins Pond. Launch again at the boat launch beach and dock. A canoe and kayak rental concession is on the left, on Rollins Pond.

Rollins Pond is the largest pond in the loop (2 miles long, 442 acres). You will paddle past the state campsite area and see many other people camping and boating. Rollins Pond state campground, which is actually the quieter of the two Rollins Pond/Fish Creek campgrounds, has 287 campsites.

Continue along the eastern shoreline as it bears right and into the outlet to Floodwood Pond. This outlet is narrow and the current is sometimes moving fairly fast. It is not dangerous, but your boat could get scraped up. A carry is to the left of the outlet in the event that you scout the outlet and decide against paddling it.

Once in Floodwood Pond, you will see several attractive campsites on the east (right) side, and some residences on the left. Continue back to the put-in on Floodwood Road.

TRIP 24
LAKE LILA

Rating: Moderate (depending on weather conditions)

Distance: 6.5 miles canoeing; 3.0 miles hiking

Estimated Time: 6.0 hours (overnight suggested)

Maps: USGS Sabattis 7.5; USGS Brandreth Lake 7.5; USGS Wolf Mountain 7.5; USGS Nehasane Lake 7.5; Paddlesports Press: *Adirondack Paddler's Map*; Adirondack Maps, Inc.: *The Adirondacks Northwest Lakes*

This trip offers remote and pristine paddling with free camping on islands and mainland sites, some with white-sand beaches, and an easy scenic hike to Frederica Mountain's summit.

Directions

Follow the directions for Trip 22 to the Whitney headquarters. Go 3.1 miles from the headquarters entrance road (which you pass on your left) to the Lake Lila access road, also on the left. This road leads another 5.8 miles to the parking area (room for 20 to 30 cars). No trailers are permitted, and no parking is allowed along the road. The Lake Lila access road is gated in the off-season and generally opens in May, depending on conditions (call ahead at 518-624-6686). *GPS coordinates:* 44° 1.118′ N, 74° 43.803′ W.

Trip Description

A perennial favorite among adventure paddlers, 3-mile-long Lake Lila offers wilderness paddling, camping, hiking, and fishing in one of the most remote, vehicle-accessible realms of the Adirondacks.

At 1,400 acres, Lake Lila is the largest lake inside Adirondack Park that is entirely state owned. In contrast with Little Tupper, Lake Lila is the preferred destination for those who desire a more complete sense of sequestration and isolation from the outside world. While Lake Lila is subject to the same protections of any wilderness area, the rules for camping there are less strict than those of Little Tupper Lake's. Camping is allowed at designated sites (maximum party of nine), as well as 150 feet away from any road, trail,

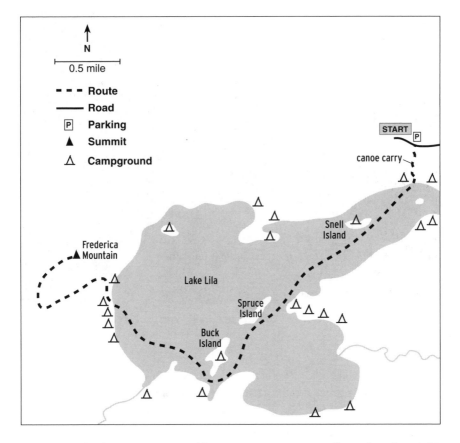

stream, or body of water. In addition, no camping is allowed within 0.25 mile of the parking area.

Lake Lila is part of a historical canoe route system that was well known and utilized by nineteenth-century guides and anglers and by the American Indian hunters who came before them. Lightweight paddlers still follow these routes, undertaking long carries and negotiating small ponds and rivers, lively streams, and large lakes. When preparing your equipment for this outing, bear in mind the 0.3-mile carry that descends slightly between the parking area and the lake. Though this is by no means a significant distance for lightweight paddlers, it requires serious effort for those with heavy tandem canoes and kayaks.

Sign in at the trail register. The gated road that leaves from the parking lot is for the exclusive use of private landowners and DEC vehicles. It is open to hikers but closed to cyclists. You'll see the portage sign on the west side of the

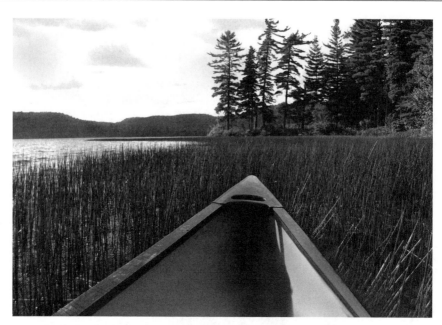

Mount Frederica rises beyond the bulrushes and piney points of Lake Lila.

parking lot. At the end of the carry trail, launch your boat at the sand beach. Head west into the lake, taking into consideration the wind's strength and direction. Although this is a much smaller body of water than neighboring and similarly oriented Little Tupper Lake, moderate to strong winds may affect your progress. One- to two-foot swells are not uncommon. Passing Snell Island, you can explore Spruce and Buck islands and their campsites as you curve around to the east again toward a conspicuous opening in the forest cover, close to the lake's edge. The shore is protected with large rocks (riprap) that were put in place to prevent erosion. Several campsites are located in this area, as well as a lean-to at Site 7. Be aware that bears inhabit this area, and take the usual precautions with food.

A highlight of the Lake Lila wilderness experience is the easy, 1.5-mile hike up Frederica Mountain (2,200 feet). To find the trailhead, paddle along the farthest western shoreline, just to the north of the clearing and the line of riprap. Here you will see a brown sign with yellow letters indicating the trail, along with a blue marker. Secure your boat and follow the blue markers to a Y intersection in the road. Follow the road to the west, as the blue markers lead you across railroad tracks. Walk for another 20 minutes or so and bear

right into the woods as the trail leaves the road, and follow the well-marked, easy foot trail, gaining 500 feet to Frederica Mountain's summit in about 25 minutes. Here you will be treated to the view from a small east-facing outcropping, where Lake Lila and the lands of the Whitney Wilderness Area are spread out to the southeast. Stetson-peaked Blue Mountain is directly in front of you across the Beaver River valley. A small slice of Lake Nehasane is visible. You can spot the fire tower on Owl's Head with binoculars. The Seward Range and the MacIntyres can also be seen. This area was burned in the 1903 and 1908 forest fires that swept across a half million acres of the Adirondacks, leaving balds and open fields that are still bare today (see page 63).

Lake Lila was included in the lands of the 140,000-acre Nehasane Preserve, a large private park belonging to Dr. Seward Webb, builder of the Adirondack and St. Lawrence Railroad. The lake was named for Seward's wife, Eliza Osgood Webb, the daughter of William Vanderbilt, whose considerable fortune financed Webb's ambitious railroad developments.

On your paddle back to the take-out, explore the many sandy beaches and rocky points on Lake Lila as you watch the eagles, ospreys, and red-shouldered hawks that nest in the area. Moose, once extirpated from the Adirondacks, have been spotted here and are expected to increase in number. Boreal birds such as the spruce grouse, a variety of warblers, the three-toed woodpecker, and the yellow-bellied flycatcher nest in the area and prefer the kinds of bogs, wetlands, and spruce swamps that characterize Lake Lila's environs.

White-Winged Crossbills

Many Adirondack visitors will be introduced to the colorful red-to-greenish finches called white-winged crossbills, which arrive only during peak cone years (white pine cone production peaks every three to five years, and spruce-fir every five to seven years). For this reason they are not always found in regional guidebooks, and, further confusing identification, many casual observers mistake them for the larger pine grosbeak. Although the crossbill's range includes a wide span of North America from northern Quebec and Newfoundland to Alaska, and south to the Carolinas and the pinewoods of Hispanola in the West Indies, its presence depends upon healthy boreal forests, particularly of the spruce-fir type. White-winged crossbills will forage to a lesser degree on white pine and hemlock, though these tougher cones are favored more by the red crossbill. The birds will stay in an area only during a good cone year. When cones are few, crossbills fly south.

Crossbills may breed during any time of year that food is abundant, constructing shallow nests at the ends of spruce branches. They often appear in campsites, and can be approached very closely as they take baked seeds from the ashes of a fire pit. They sometimes appear at feeders but will not accept handouts, as will the more familiar gray jay. The crossbills are colorful, ranging from a dark rose to red in the male to a soft yellow or olive in the female. Both sexes have black wings with white wing bars and short, notched tails. They are vocal, with a soft *chiff-chiff* call and a canarylike series of trills and warbles. They travel in small flocks, and congregate among the high cones in small groups like parrots. They will also often be seen in large groups, dusting on dirt roads.

Even though white-winged crossbills occasionally breed in the South, the long-term health and conservation of crossbill populations is tied to the boreal forest, an eco-region presently being used nationwide for logging, fossil fuel extraction, and agriculture. After logging, newly germinated conifers may take 30 years to produce cones, and another 30 years to maximize production. Although a relatively limited portion of the northeastern boreal forest is protected, it is one of the most intact forest systems on Earth, and so there may still be time for successful conservation of abundant, high-quality habitat, protecting white-winged crossbills and all the other wildlife that share their boreal home.

Section 3

Southeast Mountains and Rivers Region

THE SOUTHEASTERN MOUNTAINS AND RIVERS lie within a rectangular landmass enclosed by Schroon Lake in the northwest, Ticonderoga in the northeast, Northville and Lake George in the south, and the state of Vermont to the east. Access is via the Adirondack Northway (I-87), which runs north and south through the center of the area. NY 28N runs diagonally northwest–southeast between Warrensburg and Newcomb. Access to the eastern shore's hiking trails is made through Lake George, via NY 149.

Hiking is the main activity here, and the region's proximity to southern New York State makes it readily accessible to large numbers of people. Hikers generally consider the terrain in this area to be more forgiving and hospitable than in the more northerly Adirondacks; they can also arrive at trailheads faster and in larger numbers (from the Capital District and Glens Falls in particular) than is possible in other areas of the Adirondacks. As a result, there have been many instances of ill-prepared hikers requiring assistance from forest rangers and search-and-rescue teams. The things hikers most commonly neglect to pack, according to local forest rangers, are proper clothing (footwear and outerwear) and, especially, flashlights. With the exception of Severence Hill, these hikes involve mountains with substantial elevation gain and distance. Expect the threat of falls, harsh weather, and the arrival of darkness to be the same as elsewhere in the Adirondacks, no

matter the time of year.

The Tongue Mountain and eastern shore hikes attract many enthusiasts; these are especially busy areas on weekends. An even greater level of enthusiasm will be seen on Lake George, so plan your paddling trips accordingly. Lake George's immense popularity is due to its bewitching scenery and remarkably clean and clear water.

TRIP 25
BUCK MOUNTAIN

Rating: Moderate to Strenuous
Distance: 4.5 miles
Elevation Gain: 1,140 feet
Estimated Time: 4.0 hours
Maps: USGS Shelving Rock 7.5; USGS Bolton Landing 7.5x15;
 National Geographic Adirondack Park: *Lake George/Great
 Sacandaga*; Adirondack Maps, Inc.: *The Adirondacks Lake
 George Region*

**This visually interesting hike, with some moderately
strenuous climbing, pays off with extensive views of the
High Peaks and the southern Lake George basin.**

Directions

From Lake George village, go south on US 9 for 3.0 miles. Turn left at the
light onto NY 149. Drive 6.0 miles, then turn left onto Buttermilk Falls Road
(which becomes Sly Pond Road) and drive another 9.6 miles to the Hog-
town trailhead, which is at Shelving Rock Road's end. The parking area is
well identified and accommodates 30 or more vehicles. In winter, Shelving
Rock Road is gated, meaning the parking lot is inaccessible and hikers must
walk down to the smaller (six to eight cars) Buck Mountain trailhead parking
area, adding a mile round-trip. *GPS coordinates (trailhead):* 43° 31.888' N, 73°
33.930' W.

Trip Description

Buck Mountain (2,334 feet) is one of the most interesting hikes on the
eastern shore of Lake George. Unlike the other popular summits in this
section of the Lake George Wild Forest, such as Black Mountain to the north
and its neighbor Sleeping Beauty Mountain, Buck Mountain features one
of the area's few scenic foot trails not designated as multi-use. The terrain
is steep and therefore limits itself to foot travel only. This not only assures
hikers of a certain degree of distance from the equestrians and snowmobilers
who frequent this area, but presents trail and wilderness conditions that,

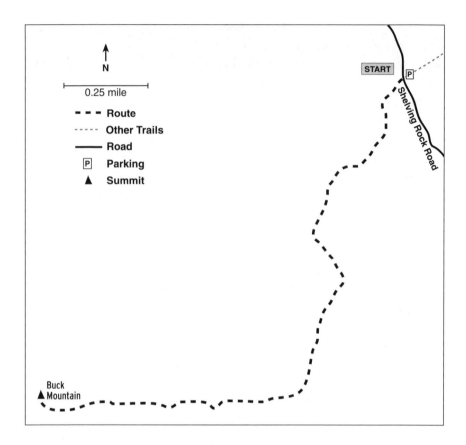

especially with snow cover, become considerably more demanding. Buck Mountain's trails will not reflect the same conditions found on Sleeping Beauty Mountain or the multi-use trails in the Shelving Rock trail system. Buck Mountain Trail is a demanding backcountry route, and particularly during winter and spring you will have to take extra precautions. Carry your snowshoes if you have any doubts at all about the snow conditions, and take your hiking poles. Wear gaiters and waterproof boots. Bring a compass and the proper outerwear. Don't count on your cell phone working here.

From the Hogtown parking area, walk down Shelving Rock Road 0.5 mile to the well-marked Buck Mountain trailhead parking area, which is well identified on the left. (Hiking mileage begins from here.) A similarly small parking area is located directly across the road from the trailhead. These lots will fill up early on a good hiking day. Follow yellow markers into the woods.

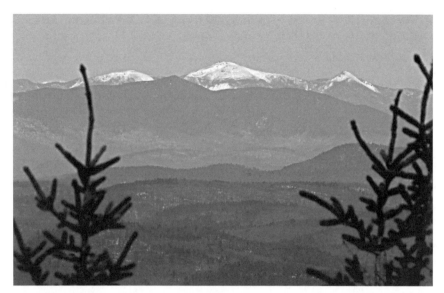

Snow-capped Algonquin Mountain, Mount Marcy, and Mount Colden can be seen from Buck Mountain's summit.

The hike begins at 1,400 feet in elevation over easy terrain, leading you through a vigorous and maturing hemlock forest and across Shelving Rock Brook. The trail skirts private lands to the east and south as it gradually climbs through a transitional hardwood forest. Patches of hemlock appear along the streambed as you climb steadily but gently. Marking is adequate and the trail is self-guiding. You will see older dark-red or faded-orange paint blazes here and there, as well as the yellow foot-trail markers.

If you do this hike in winter, you'll discover one of the best things about hiking in snow: You often get to see who (or what) has been out ahead of you, and if the temperature has been stable you may accurately judge just how long ago their tracks were made. These tracks will not only belong to fellow hikers, but to the other locals—the indigenous wildlife of the Lake George Wild Forest. You'll see where a bobcat stalked a snowshoe hare, or where a raccoon hunted along the edge of a thawing stream, or where an owl pounced on a partridge or a vole. Here and there you will see the shallow impressions created by bedding deer under the sheltering trees. You'll notice that the snow is often covered in a thin mat of conifer leaves, most often hemlock and spruce, which have been dropped by red squirrels as they bite off the tips of branches in order to retrieve the cones.

Forty minutes into the hike, at 1,400 feet in elevation, the trail ascends suddenly, becoming moderately steep, and you'll find yourself stopping every few minutes to catch your breath. Hiking poles will be of great help here. Having already crossed a few capillaries, the trail joins and follows the upper reaches of Shelving Rock Brook again, crossing it at 1,600 feet and turning east. The ascent, while steep, is fairly short. Within 0.9 mile of crossing the brook, you will pass between a pair of low ledges, and shortly thereafter arrive at the summit. There are no "spoilers" on the ascent—the summit yields the first and only views you'll see. The mountaintop comprises two small domes, with a shallow saddle separating them. The true, benchmarked summit is the open rock dome a few steps up and to the right, which is indicated by a sign. This is an open expanse of rock, perhaps an acre in area, looking west over Lake George, across the apparently endless array of peaks from south to northwest. White pine, white birch, and red pine are among the trees that fringe the open rock summit. Blueberries grow in the crevices. It's possible to move around the summit's little pine groves to seek additional views.

Whiteface Mountain appears at magnetic north, from which the High Peaks fan out to the southwest. You see the Tongue in the low foreground, and the islands of the Narrows—Oahu, Uncas, and Turtle Island among them. You'll see the 100-year-old Sagamore Resort hotel on the southern tip of Green Island, just east of Bolton Landing. To the west and south, dozens of lesser peaks make up the viewshed, and you can spend hours identifying them.

Though Buck Mountain is considered a half-day hike, allow yourself the entire day or, better yet, an overnight. Drive or walk down Shelving Rock Road to the day-use area at Shelving Rock Bay, visit nearby Shelving Rock Falls, or spend the night tenting in one of the free, designated tentsites that are disbursed throughout this unique area.

TRIP 26
SLEEPING BEAUTY MOUNTAIN
AND BUMPS POND LOOP

Rating: Moderate
Distance: 7.0 miles
Elevation Gain: 1,400 feet
Estimated Time: 5.0 hours
Maps: USGS Shelving Rock 7.5; National Geographic Adirondack
Park: *Lake George/Great Sacandaga*; Adirondack Maps, Inc.:
The Adirondacks Lake George Region

**Long cliffs facing the Adirondack and Vermont mountains,
with a loop around remote Bumps Pond, await hikers of this
gradual traverse.**

Directions
See Trip 25 for directions to the Hogtown trailhead. *GPS coordinates:* 43°
31.888′ N, 73° 33.930′ W.

Trip Description
Sleeping Beauty Mountain is the gem of the Lake George Wild Forest.
Many seasoned hikers prefer it to the eastern shore's sister peaks, such as
Black Mountain. Because of its gradual approach, it feels like a much eas-
ier climb than Buck Mountain—but at 2,347 feet, it is actually higher by
13 feet.

Standing water and runoff is the norm here, so bring your waterproof
boots in the wet season. From the parking area, walk north to the yellow-
marked trail and sign in at the trail register. The old carriage road descends
gently. Mixed northern hardwoods (beech, birch, and maple) cover the
uphill slopes, with thin hemlock woods to the west and downhill. Oaks
are common in this southerly area of the wild forest, with some very large
specimens appearing.

Your direction of travel here is north–northeast. Several campsites exist
along the trail, and more are ahead at Dacy Clearing. At 0.6 mile, you will
pass Buck Mountain Connector Trail as well as East Old Farm Road Leg Trail
on the left. Less than a mile ahead, you will enter a small clearing about

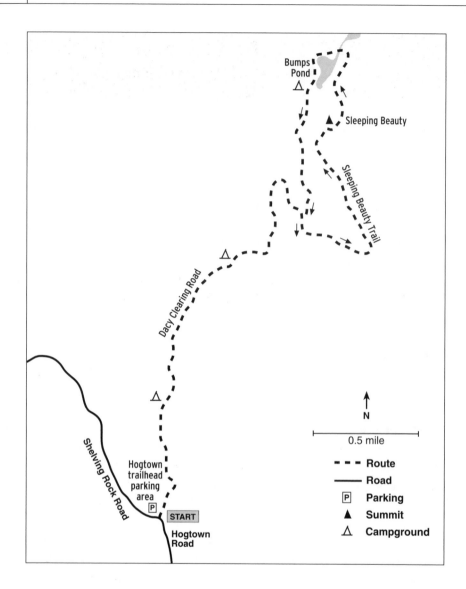

1 acre in size, on the right of which is an old but fairly intact rock foundation, the vestiges of the Dacy homestead. A few apple trees survive here, and large white pines dot the terrain. Shortway Trail leaves to the west from the clearing, heading into the Shelving Rock multi-use trail matrix.

Bear right, descending gently across a tributary of Shelving Rock Brook, where upstream you'll see a small, breached rock dam. During the leafless seasons, you can see the high-angled slabs and vertical precipices of Sleeping

Sleeping Beauty Mountain yields westerly views of the Adirondack High Peaks.

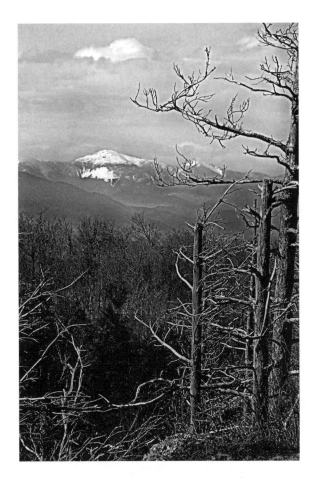

Beauty Mountain ahead. The trail gently rises to Dacy Clearing trailhead, a large designated parking and camping area with two campsites. Several trail signs appear. Go straight across the clearing to the large sign, indicating Bumps Pond and Sleeping Beauty Pond. The yellow trail continues uphill behind it. For the benefit of equestrians and snowmobilers, the yellow trail loops around to the right as well, through the parking lot, and curves back to the north, both trails meeting again at the trail register just ahead. Don't make the mistake of bearing off to the north on the snowmobile trail (Longway Trail), which at this point is also the blue-marked equestrian trail and which passes close to the campsite's outhouse.

The trail rises to the Lake George Wild Forest trail. Now the terrain steepens and switches back, sharing its rock-strewn footway with seasonal

runoff. The trail then turns east and, within 15 minutes or so, brings you to a switchback junction, where the yellow trail goes to the left (north) to Bumps Pond. (You'll be returning on that trail to this junction.) The rise to Sleeping Beauty's summit from this trail junction is 677 feet. Go right, following the blue trail as it flattens out for a while.

A young and vigorous hemlock woods greets you as you progress beneath the high cliffs of Sleeping Beauty Mountain on your left (north), while some sparse views open up to the south. The trail continues easily to the tapered eastern shoulder of the ridge and climbs again, steepening up toward the thickly wooded spine of the mountain. At a switchback, you'll see a well-made stone retaining wall reinforcing this section of trail, a long-unused carriage road. The trail meanders uphill. After a few last pitches of gentle switching back and steadily climbing, you arrive at a T intersection. Go left. Momentarily, you break out onto the open rocks of the summit, where a panorama of mountains runs northeast, through the south, and to the northwest.

Snow-peaked until late May or beyond, Mount Marcy is at the extreme limits of the view to the northwest, where the Great Range can be seen in the foreground. Beyond Putnam Mountain in the low easterly foreground, the long ridges of Vermont's Green Mountains compose the bulk of the eastern horizon. Hidden between you and West Mountain is the southernmost bay of Lake Champlain (South Bay). Hadley Mountain sits prominently in the southwest, and Crane Mountain appears prominently nearly due west, south of Weavertown.

You'll see several acres of skeletonized trees on Sleeping Beauty's summit, mostly hemlocks and white pine standing close to the cliffs. These were killed by fire several years ago. Forest rangers believe the fire was ignited by lightning and spread from the base of the cliffs to the summit. The fire burned for ten days.

Walk back to the trail junction, leaving the trail you came up on to your right, and continue in a northerly direction. The trail is self-guiding. The standing dead, fire-killed forests form an eerie relief along the cliffs before you hike your way around the summit on the descent to Bumps Pond. The trail switches downhill, and the pond soon appears through the trees to your left. Cross the footbridge at the outlet, and turn left at the well-marked junction. (This is where the trail departs to the north for Fishbrook Pond, and to the south for Dacy Clearing.)

Follow along the pond's western shore, passing the trail to Erebus Mountain on the right and continuing south. You're back on the multi-use trail again, which has widened to carriageway width. Ascend easily to a point near the pond's south end before descending steadily around the western slopes of Sleeping Beauty. Up to the left, the familiar cliffs reappear as you walk south to close the loop. Pass the downhill faces of a few low, sheer ledges, gushing with runoff, and, switching back and forth down the eroded trail, you are soon back at the familiar junction with the blue trail. From here, retrace your footsteps to Dacy Clearing and follow the road back to the Hogtown trailhead and your vehicle.

TRIP 27
FIFTH PEAK

Rating: Strenuous
Distance: 5.0 miles
Elevation Gain: 1,540 feet
Estimated Time: 4.0 hours
Maps: USGS Shelving Rock 7.5; National Geographic Adirondack
 Park: *Lake George/Great Sacandag*a; Adirondack Maps, Inc.:
 The Adirondacks Lake George Region

**Hike through a white pine plantation and a stand of
old-growth pines, past cascading brooks to a peak with
a lean-to overlooking Lake George.**

Directions
From Exit 24 of the Adirondack Northway (I-87), go east 4.8 miles on CR 11
to NY 9N in Bolton, and turn left (north). Go 4.4 miles to the trailhead on
the right side of NY 9N (immediately past the canoe launch and Northwest
Bay Brook), next to a small pond (a.k.a. The Quarry). This small lot will hold
six to eight cars, but a much larger overflow lot is situated 100 feet north on
the right. *GPS coordinates:* 43° 37.763′ N, 73° 36.503′ W.

Trip Description
Fifth Peak is the central landmark and the most popular destination hike
on the Tongue Mountain peninsula. The Tongue is the prominent, high,
block-faulted ridge that rises in Bolton, between Northwest Bay and the
island-strewn Narrows of Lake George.

Why is Fifth Peak so popular? In addition to its proximity to the large
population areas of Albany and Glens Falls, this old, well-maintained trail
through an old-growth pine stand is perhaps the most attractive trail in the
Lake George Wild Forest. Some of the hikers who ascend the trail to the
saddle between Fifth Peak and Five Mile Mountain to the north are headed
for the lean-to on Five Mile Mountain. Some are going another mile east and
down to Lake George's Five Mile Mountain Point (1,000-foot elevation loss),

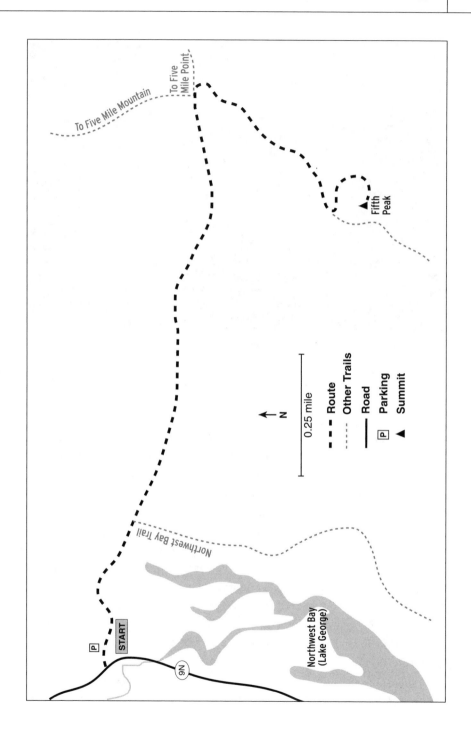

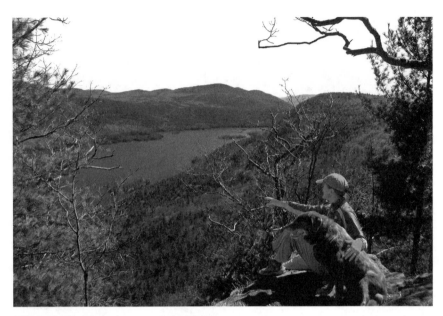

Fifth Peak offers fine views over Lake George.

but most are going to Fifth Peak. Many will stay overnight at the lean-to. If you're expecting to camp, carry a tent or tarp.

From the trailhead just south of the quarry, follow the blue markers. Sign in at the register 300 feet in, on the left of the trail. This area is called Clay Meadow, after a family who farmed it long ago. Descend to cross the long footbridge at the head of Northwest Bay. The dense forest you've entered was planted by the Civilian Conservation Corps (CCC), which was encamped at nearby Alma Farm for six months in the 1930s. Another long-term camp was situated near the trailhead for a period of six years. The CCC reforestation program used red and white pine—species that lend themselves well to plantations—and, to a lesser extent, Norway spruce, a nonnative species that in some conditions is not as resistant to pests. Unfortunately, this stand of white pine trees is suffering from overstocking and many are dying.

Pass the Northwest Bay Trail to Montcalm Point (the loop) on your right. Follow red markers now. As you ascend on the rocky trail, druidic old-growth pines appear. A brook you can explore to the right of the trail has several small waterfalls and pools. Soon the trail crosses a wooden bridge over a stream running off the steep southerly slopes of Five Mile Mountain.

The trail climbs, switching back through a wet ravine, heading for the saddle between Fifth and Five Mile peaks. A few low ledges are skirted as the trail switches back into the saddle and arrives at a four-way intersection. The trail to the east goes to Five Mile Point on Lake George. The left turn heads north to Five Mile Mountain. Bear right, following blue markers now, as the trail turns south. Hemlocks appear as you ascend, interspersed with hardwoods and a few large white pines. The oaks are few and stunted, suffering from exposure. Climb a small nubble in a young, vigorous hemlock woods.

At a point 2.0 miles from the trailhead at 1,650 feet, turn left onto the yellow-marked summit spur trail. The trail junction to the summit is not marked, signed, or otherwise obvious at this writing, so be on the lookout for it. Many hikers miss this turn. If you find yourself descending, you've passed the summit trail. The summit trail is less established than the trail you're on, and appears as a herd path in comparison. If you use your GPS device to orient yourself, allow plenty of time for an accurate fix in this heavily wooded area (trail junction coordinates: 43° 37.270' N, 73° 35.046' W, at elevation of 1,650 feet). Turn left and ascend another 200 feet in elevation to the summit. A ledge to the left provides a scenic lookout to the east. Continue past the lean-to, to the main summit, which looks south across the main basin of Lake George.

From the rocky, grassy, open summit on the mountain's south lookout, Prospect Mountain is easily identified by its towers. The long descending ridge of Tongue Mountain extends before you in the southerly foreground, and you can see far down into the Hudson Valley at 208 degrees, into the Highlands. The northerly Catskill High Peaks can be seen. From east to south you'll see Black Mountain, Sleeping Beauty, Pilot Knob, and Buck Mountain, and across Northwest Bay are the Three Sisters. You can see Hadley, Crane, and Blue mountains on the far horizon. You'll see Cat and Thomas mountains down in the Schroon River Valley. From the east lookout, you look down at the East and West Dollar Islands.

Be aware that several documented rattlesnake dens are on the Tongue, so it is possible that you will see a rattlesnake sunning itself on the rocks. They do this not for pleasure, as hikers do; they need the warmth in order to molt. They prefer to be left alone and will avoid unpleasant situations when given the opportunity.

Return the way you came.

TRIP 28
FIVE MILE MOUNTAIN

Rating: Moderate

Distance: 7.0 miles

Elevation Gain: 1,200 feet

Estimated Time: 5.0 hours

Maps: USGS: Silver Bay 7.5; National Geographic Adirondack Park: *Lake George/Great Sacandaga*; Adirondack Maps, Inc.: *The Adirondacks Lake George Region*

A quiet section of the Tongue Mountain Range, Five Mile Mountain offers seclusion, a lean-to for overnighting, and views of the High Peaks and Lake George.

Directions

From Exit 24 of the Adirondack Northway (I-87), go east 4.8 miles on CR 11 to NY 9N in Bolton, and turn left (north). Head north on NY 9N, passing the Quarry trailhead at 4.4 miles, and continue on NY 9N to the northerly trailhead, at 9.5 miles on the left, where there is room for six to eight cars. The trail begins across the highway. *GPS coordinates:* 43° 39.674' N, 73° 32.684' W.

Trip Description

Tongue Mountain, the multipeaked peninsula that projects into Lake George from its middle western shoreline, features several popular hiking destinations—Fifth Peak (1,770 feet) and Five Mile Mountain (2,256 feet) being the most prominent among them. Many hikers head for the northerly trail access of the Tongue, climbing Five Mile Mountain in order to avoid the busier trails around southerly Fifth Peak. It is possible to approach Five Mile Mountain from Five Mile Point Trail (from the Quarry trailhead), but this is not recommended. The northerly approach has the better scenery, and saves hikers 700 feet in vertical elevation—energy that can be used to explore the lovely woods and scenic outlooks of Five Mile Mountain. Take plenty of water with you—the Tongue is notoriously dry.

On the east side of NY 9N, the blue-marked trail begins easily, following

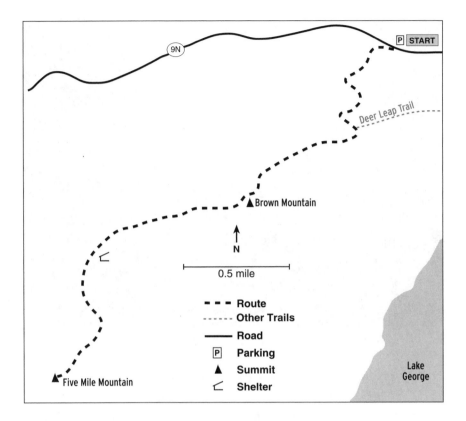

a short, flat section of fire road, passing the trail register, and ascending slightly, soon passing a wet area. At 0.7 mile, the trail forks. The trail to the left descends a few hundred feet in elevation over the course of a mile to scenic Deer Leap, a scenic ledge above Lake George where it is believed that American Indians hunted using the age-old method of herding deer over the cliffs to their deaths. Bear right following blue markers and ascend the northerly ridge of Brown Mountain (1,966 feet). This is the northerly extreme of the ridge that extends the full length of Tongue Mountain (it is 10.2 miles from here to Montcalm Point, at the southerly tip of the Tongue). Views to the lake open up a bit to the left as you climb. White pines appear, some of them quite large. Hemlocks also appear, sometimes in homogenous stands, and maple is ever-present in the understory, along with companion birch. The old plantation favorite, red pine (Norway pine), appears as the trail flattens out. This is a high-quality, maturing forest. This ecosystem is considered fragile, consisting of lichens and mosses on exposed rock. Timber

Five Mile Mountain provides seclusion and views of the High Peaks Wilderness Area.

rattlesnakes inhabit areas of open ledge and will not harm you if left alone.

Trail markers are not profuse, but at this point the trail is well established and self-guiding. Once upon the flat, easterly heights of Brown Mountain, you will be treated to views over Lake George and the island groups below, with Black Mountain beyond. A herd trail to the left of the ledge leads downhill slightly to another lookout, and still another, with increasingly good views over the lake. Beyond Brown Mountain, which is simply a short, flat section of upper-elevation ridge, the trail descends slightly, crossing a stream and rising again to the lean-to on Five Mile Mountain. The setting is peaceful and isolated, free of the activity hikers will witness at the more popular Fifth Peak summit.

Five Mile Mountain is composed of two distinct, wooded summits and a pair of scenic ledges, both of which lie beyond the lean-to considerably farther along the trail. To explore them, consider stashing your pack (taking your valuables with you) to lighten your exploring. Don't leave food lying around or in your pack for too long, or you may find a porcupine investigating it upon your return. Black bears also frequent the area, and they will make even shorter work of an unattended pack that smells good.

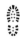

To see the additional viewpoints, continue on the trail as it wends its way behind the lean-to, heading east now. Observe the pure red pine forest you're passing through; it is one of several mature stands on the Tongue, most of them planted in the 1930s by the Civilian Conservation Corps. The Tongue was once nearly logged over completely, its hardwood forests providing charcoal for the Lake Champlain iron forges during the Civil War.

Watch the markers, as they again tend to be sparse. The trail switches back downhill and the feeling of isolation here increases. Marking is poor now. Winter hikers lacking the benefit of an established track may have difficulty following the trail. This is the realm of stunted beech, birch, and maples. The trail weaves circuitously around hummocks and higher, pine-covered knolls. If you become disoriented, return to the previous trail marker and try to locate the next one. When that isn't possible, try your hand at tracking other hikers by studying the footway. Only a short section of trail lacks adequate marking. If in doubt, turn around.

At a point 0.3 mile beyond the lean-to, from a small, open ledge, you can see Black Mountain (with its towers) and behind it Elephant Mountain. South of these are Buck and Sleeping Beauty mountains. Below are the islands of the Lake George narrows. The Vermont mountains loom large on the farthest horizon of hills. Pilot Knob rises to the south of Buck Mountain. The trail continues after this overlook, winding through the woods for an additional 0.4 mile, arriving at a trail sign adjacent to a small rock outcropping nearly enclosed in conifer growth. Because of limited views and poor trail marking, inexperienced hikers may wisely elect not to visit this last outlook (the true summit of Five Mile Mountain).

From the summit(s) or lean-to of Five Mile Mountain, return the way you came.

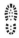

TRIP 29
CAT AND THOMAS MOUNTAINS

Rating: Strenuous

Distance: 6.5 miles

Elevation Gain: 1,600 feet

Estimated Time: 4.0 hours

Maps: USGS Warrensburg 7.5; National Geographic Adirondack Park: *Lake George/Great Sacandaga*; Adirondack Maps, Inc.: *The Adirondacks Lake George Region*; Cat and Thomas Preserve brochure map, lglc.org/naturepreserves/catmountain

This loop hike through the little-known forests of the Schroon River valley offers views over Lake George and the Hudson Valley.

Directions

From Exit 24 of the Adirondack Northway (I-87), go east on CR 11 for 1.9 miles. Bear right at the Valley Wood Road sign, and go 0.1 mile. The trailhead parking area is on the right (south) side of the road. This is a small parking area with room for six to eight cars. (Take care not to block the adjacent resident's driveway.) *GPS coordinates: 43° 36.213′ N, 73° 41.527′ W.*

Trip Description

Cat and Thomas mountains are two scenic, low peaks lying between the Schroon River to the west and Lake George's Northwest Bay to the east. Until recently, these privately held lands were inaccessible, but with the efforts of the Lake George Land Conservancy (which formed the Cat and Thomas Mountain Preserve), they were acquired for public use in 2003. The new parcel added an interesting hiking destination to the western side of Lake George (where comparatively few exist, in contrast with the eastern shore), and many hikers have since discovered and enjoyed these two charming little peaks. However, be advised: Though they may be smaller than the nearby peaks of the Tongue Mountain Range, this loop hike is rated as strenuous because of the distance and elevation gain involving the two peaks.

From the trailhead (elevation 1,300 feet), the trail follows a level logging road south, soon climbing uphill, and within 15 minutes bringing you to

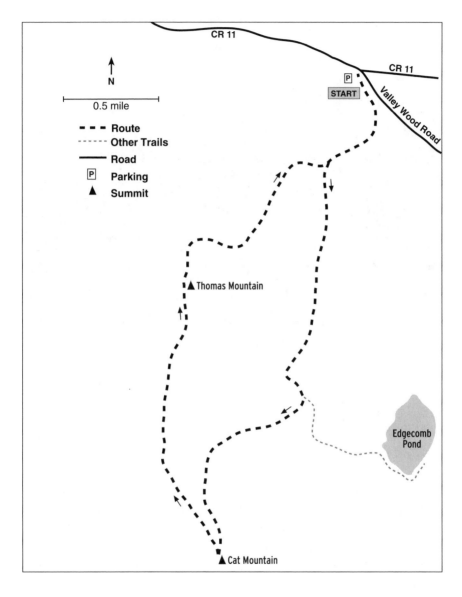

a T intersection. Bear left at the trail sign indicating Cat Mountain, following yellow markers. (The trail to Thomas Mountain goes off to the right here, following orange markers.) The trail is a wide, sandy dirt road at this point. The terrain is cutover second-growth woods—the result of a recovering logging operation. While such forests are often unattractive, there are spots of vigorous young hemlock growth, as well as familiar pioneer species birch, alder, and pine.

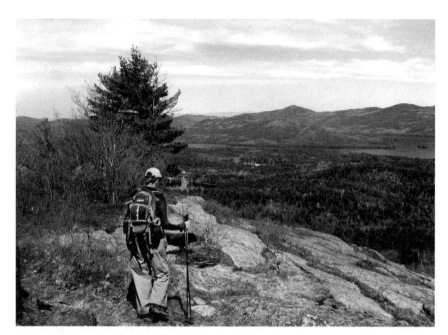

The balds of Cat Mountain overlook Lake George.

Ahead you will have glimpses of Cat's boreal crest. At a Y, in an open former log decking area, bear left. Skid roads, where logs were "skidded" out of the woods, lead into the forest on the right. Continue straight ahead. The trail leads to a small wetland pond (which aside from a small stream or bog is not shown on maps; 43° 34.972' N, 73° 41.932' W), then skirts its northerly edge. Cat Mountain is seen to the south. Cross the outlet, where a makeshift earthen dam was built. Continue as the trail follows around the pond to the east, and passes through a gate. Bear right at the Y. The trail climbs easily.

At the next Y, which may not be marked, bear right. The trail descends slightly, crossing a culvert before rising again in the direction of the mountain. This is an extensive wetland area, the headwaters of Edgecomb Pond (the Cat and Thomas mountains watershed provides the drinking water for the town of Bolton). When the water table remains high, there is a small pond here, with a beaver dam. After the wetland area, the trail levels, crossing a small stream at the pond's inlet. As you're ascending, the footway becomes a combination of mud and loose rock—watch your footing. Now the trail rises dramatically, and the hemlock cover increases to a few maturing stands.

The trail switches back steeply as it makes its way up the northerly slope of the mountain. Watch for the blue trail markers on your right as you ascend; this is the loop trail to Thomas Mountain.

At the ledgy summit of Cat Mountain there are two distinct lookout points. Views sweep from the northeast through the southwest over Lake George. Prospect Mountain can be seen with the naked eye. The Three Sisters, Hadley, and Crane mountains are visible to the south and west. Black Mountain, with its radio tower/wind generator; Sleeping Beauty and Buck mountains; and Pilot Knob are all easily identified to the east. You can see Dome and Recluse islands off Bolton Landing, and the very tip of Clay Island. Fourteen Mile Island, the Hen and Chickens islands, and Ranger Island lie close to the eastern shore around Shelving Rock Bay. French Mountain rises at the south end of Lake George. Trout Lake is just down below, nearly due south. The Schroon River valley forms the westerly bounds of the preserve. Hackensack Mountain rises just north of Warrensburg. Gore, Bear Pen, Wolf Pond, and Cherry Ridge are in the Wilcox Lake Wild Forest. The little nubble right across the Schroon is Kellum Mountain. The one south of that, lying low above Warrensburg, is Hackensack Mountain.

A faint herd trail leads from the eastern ledge area of Cat's summit, downhill to rejoin the trail you came up on. Directly across the trail is the blue-marked trail to Thomas Mountain. The trail descends slightly before beginning a long, gradual ascent over the connecting ridge between Cat and Thomas mountains. As you ascend a rise to 1,800 feet, a spur trail to the right leads to a scenic west-facing ledge. The trail makes its way north, over varying terrain, uphill and down, and approaches Thomas Mountain from the west through a heavily cutover area. Scaling a few low ledges, you walk through a hemlock forest that managed to escape being logged, partly because the previous owner maintained a cabin on the summit of Thomas Mountain, but also because of the rough terrain—a feature that saved many of the Adirondacks' old-growth forests. The view from Thomas's ledges is directly toward Cat Mountain and the southerly basin of Lake George, including many peaks to the south and west.

Continue downhill on the orange Thomas Mountain Trail now, which is a dirt road. Within 20 minutes or so you will reach the familiar junction with the yellow Cat Mountain Trail. Bear left and downhill, returning to the trailhead parking area.

Alpenglow

Those who spend enough time in mountainous regions such as the Adirondacks will eventually witness the optical phenomenon known as alpenglow. Alpenglow is an illuminated (or "glowing") strip of deep-red or purple-colored light on the summits of peaks or in the sky above them during either a sunrise or sunset. When the sun is below the horizon, indirect light filtering through the atmosphere diffuses into a radiant color (generally described as purple) that we are unaccustomed to seeing on mountaintops.

Based on the German word *Alpengluehen*, the effect is the result of the sun's light-wave action imposed upon particles of dust, water, snow, or ice in the atmosphere. It may also be the result of light passing through aerosols (particles suspended in a gas) such as smoke, smog, or other air pollutants. Although it is most commonly seen in mountainous regions with a wide range of color contrasts and where large expanses of open sky can be seen above a bright and broad horizon (such as in the Alps, for which it is named), alpenglow may also be witnessed in more subtly colored sea and desert landscapes. The effect is fleeting, like a sunset or sunrise, lasting not much longer than the transit of the sun above or below the horizon.

Oddly, the color purple does not actually exist. It is perceived in the color wheel but does not appear in the rainbow spectrum. Purple is a hue originating among the reds and blues, which our eyes deceive our brains into interpreting as a pure color, although it is not one. (The same is true of white, which does not exist as a pure color, but only as a combination of other colors.) Alpenglow is enhanced by illuminating ultraviolet light, which is not visible to the human eye. When invisible ultraviolet light strikes certain objects or particles, the excited elements shed hues of apparent purple (or deep violet).

Much of our outdoor time and interest is dedicated to the pursuit of beauty in the form of natural phenomenon, and the curious effect of alpenglow is certainly included among these. Perhaps it was the motive for our country's most patriotic hymn, "America the Beautiful," which celebrates the beauty of nature's colors in the line "for purple mountain majesties." The words were taken from Katherine Lee Bates' poem "Pikes Peak," which she composed during a summer trip to the Colorado Rockies in 1893, where she evidently witnessed the atmospheric phenomenon known as alpenglow.

TRIP 30
PHARAOH MOUNTAIN

Rating: Strenuous
Distance: 10.0 miles
Elevation Gain: 1,700 feet
Estimated Time: 6.0 hours
Maps: USGS Pharaoh Mountain 7.5; National Geographic
Adirondack Park: *Lake George/Great Sacandaga*; Adirondack Maps,
Inc.: *The Adirondacks Lake George Region*

**Extensive views of the Adirondack High Peaks are the
payoff of this visually interesting hike with some relatively
strenuous climbing.**

Directions
From Exit 28 of the Adirondack Northway (I-87), take NY 9 south for 0.6
mile. Bear left onto Alder Meadow Road. Go 2.1 miles, then bear left onto
Crane Pond Road. At 3.5 miles, park at the large trailhead parking area (room
for ten to twelve cars) at the point where the road bears right. Walk an
additional 1.6 miles on this dirt road to the trail at Crane Pond.
GPS coordinates: 43° 51.549′ N, 73° 41.316′ W.

Trip Description
Pharaoh Mountain (2,558 feet) is the central and largest peak in the Pharaoh
Lake Wilderness Area. Lying due east of Schroon Lake, this moderately sized
(46,000 acres) wilderness has 63 miles of trails, 39 lakes and ponds, and
15 lean-tos. The many access points from the north and south allow large
numbers of anglers, hunters, and hikers to enjoy a rewarding wilderness
experience here, in spite of the area's popularity.

While there are several approaches to Pharaoh Mountain, the easiest
route is from the northwest, using Crane Pond Road. From the parking lot,
walk along the rugged and heavily forested road, passing the Goose Pond
trailhead on your right. At a point in a hemlock forest at 1.3 miles, the road
crosses the western end of Alder Pond, where beavers have created a dam and
pool that is often over 3 feet deep. Just 200 feet before you reach this point,
a yellow-marked trail detours around to the left (north) of the flooded road

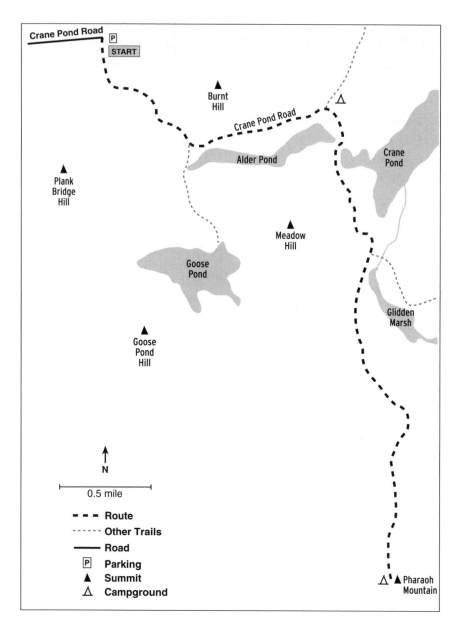

section, then rejoins it on the other side. Take this trail if the water is covering the road. On the other side of the road, continue straight ahead, noting the north section of Long Swing Trail to Blue Hill departing to your left. In a few minutes' time you will arrive at Crane Pond, an attractive designated camping area surrounded by many large white pines. An outhouse and boat

launch are here. This is the end of Crane Pond Road, and a very pretty spot (43° 51.097' N, 73° 39.784' W).

The trail bears to the right, crossing Crane Pond outlet on a wooden footbridge and following an old tote road. Ahead, sign in at the trail register. The footway is rocky and often proves to be a muddy channel for seasonal runoff. Soon you'll reach a trail junction, where the blue-marked left turn heads for Oxshoe Pond on Long Swing Trail. Bear right here, following the red markers toward Pharaoh Mountain. In a few minutes, Glidden Marsh appears to your left, and beyond it to the south you can see Pharaoh rising out of the forest. The trail is a bed of pine needles and begins to switch uphill gently through hardwood and softwood stands. It is self-guiding and well marked. At 1,500 feet the terrain becomes steep and seemingly relentless with no flats, and the trail heads directly up the fall line of the mountain with a minimum of switching back, increasing in elevation over exposed and often slick, wet bedrock. Hiking poles and boots with lugged soles will be of great help here. A series of mossy and scenic, north-facing slabs begins at 2,600 feet. The vegetation turns to stunted birch, and spots of the spruce-fir black growth (for which Pharaoh Mountain is known and easily recognized from afar) appear. The trail follows an exposed northern spine of the mountain, passing a cavelike split rock to the left, and rises into a saddle between two "summits." You'll see where the red trail continues on the other side of the saddle, toward Pharaoh Lake.

The most interesting of Pharaoh's views are seen from the northerly summit. Allow time to explore the herd trails here and enjoy the vistas they provide. Bear left from the saddle, passing through two very attractive designated campsites and arriving at an expansive sloping rock slab with astonishing views from east through northwest. Grizzle Ocean Mountain and Thunderbolt Mountain are seen to the east. Treadway Mountain with its cliffs (also a popular hike) lies to the northeast. Both Lake George and, north of it, Lake Champlain can be seen. The Hammond Pond Wild Forest is due north. Hoffman Notch Wilderness Area is to the northwest. Vast numbers of mountains can be seen beyond these, including those of the Dix Range as well as a stunning array of the Adirondack High Peaks. (Mount Marcy is 22 miles distant, though it will seem farther.) Identifying one peak from another at this distance will test your map and compass skills.

By all means visit the adjacent southwesterly area of the summit, an open cornice with far-reaching views into the Hoffman Notch wilderness and Vanderwhacker Mountain Wild Forest. Pharaoh Lake is obvious below,

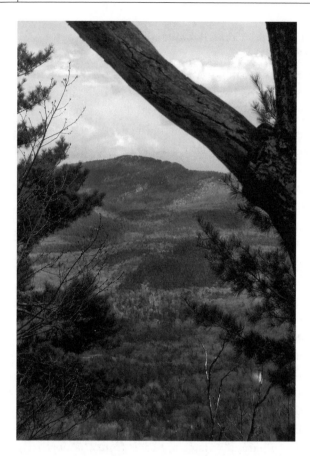

The remote Pharaoh Lake Wilderness holds many opportunities for camping, hiking, and fishing.

as are the hills skirting it to the west—Spectacle Pond Hill, Dam Hill, the numbered hills, and Stevens and Little Stevens to the south.

Schroon Lake is seen, as well as Desolate Pond and its namesake swamp in the near foreground. Severance Hill (Trip 31) can be identified on the western shore at the northerly end of Schroon Lake—but it will help to know where to look only if you've already climbed it. Pharaoh Mountain was once an important triangulation station for the establishment of peak elevations, and until recent years had both a fire tower and an observer's cabin.

Unless you've allowed for the extra time and distance to return via Pharaoh Lake, don't make the mistake of thinking that the southerly descent off Pharaoh Mountain will be any easier. Though the cumulative elevation gain is somewhat less, the rise is actually steeper than the described ascent (especially near the summit) and the trip around the lake and back to the Glidden Marsh junction is 8.5 miles. Your route to the Glidden Marsh junction is less than 2.0 miles. Return the way you came.

TRIP 31
SEVERANCE HILL

Rating: Easy
Distance: 2.0 miles
Elevation Gain: 750 feet
Estimated Time: 1.5 hours
Maps: USGS Schroon Lake 7.5; National Geographic Adirondack
 Park: *Lake George/Great Sacandaga*; Adirondack Maps, Inc.:
 The Adirondacks Lake George Region

This easy hike leads to a wooded, southeast-facing ledge over-looking Schroon Lake and the Pharaoh Lake Wilderness Area.

Directions

From Exit 28 of the Adirondack Northway (I-87), take NY 74 east for a few hundred feet, turning south on NY 9 toward Schroon Lake village. At 0.6 mile, just south of Alder Meadow Road (which is to your left, or east), watch closely for the small Severance Hill trailhead sign on your right. The parking area (room for twenty cars) is another 400 feet off the road. If you need food or water, Schroon Lake village is 2.0 miles south of the trailhead parking area. *GPS coordinates:* 43° 51.746′ N, 73° 45.351′ W.

Trip Description

Severance Hill (1,638 feet) is a relaxed, easy hike with a large, scenic reward. Save it for a day when you're not feeling up to a more demanding outing, or hike it in addition to a paddling or fishing trip on the Schroon River. Though its ledges look out over the eastern mountains of the Pharaoh Lake wilderness and the Lake George Wild Forest, Severance Hill lies on the eastern bounds of the Hoffman Notch Wilderness Area.

From the trailhead parking area, which is in a quiet residential area, head west, walking under the Adirondack Northway through a pair of large culverts. Sign in at the trail register, and follow the yellow markers. The trail enters a wet area, where a stream frequently overruns the trail. Hikers have placed stepping-stones along the way here, but some are precarious and you should bear that in mind when you choose your footwear. Other than this spot, the trail is well drained and cared for. It is also wide and self-guiding.

The trail climbs easily, crossing a stream and ascending an attractive

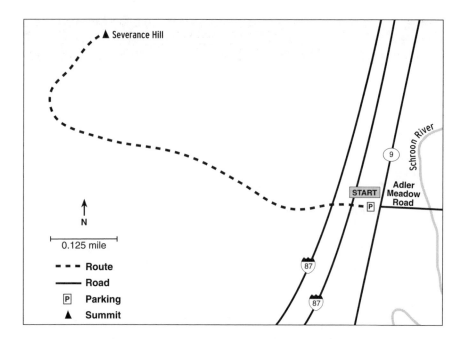

stone stairway. An arrow points to the right, where the trail passes a pair of rustic benches. The trail begins to ascend, with easier flats in between the ascents. Some very large hemlocks and white pines loom over the trail, which soon enters a hardwood forest. Little spruce and fir trees greet you as a short, steep pitch brings you to the crest of the hill.

The view encompasses lake and mountain terrain, fanning south across Schroon Lake. You can see Black Mountain, Sleeping Beauty, and Buck Mountain in the Lake George Wild Forest, across the top of Tongue Mountain. Pharaoh Mountain is seen to the east–southeast. If you have already climbed Cat and Thomas mountains (Trip 29), you will probably be able to pick out the isolated brow of Cat Mountain, lying nearly due south. Hundreds of small hills rise in every direction. At one time, there were excellent views of Paradox Lake from the northeasterly shoulder of Severance Hill, but these views are largely obscured by new growth. However, it is still possible to see the lake and some landmarks to the north if you poke around in the woods.

The forest cover in the vicinity of Severance Hill and in the Hoffman Notch Wilderness Area is primarily of the northern hardwood group, which consists of beech, birch, and maple. The occurrence of old-growth softwood forests is rare in this area and in the southern Adirondacks in general because of the proximity of rivers (in this case the Boreas, Schroon, and

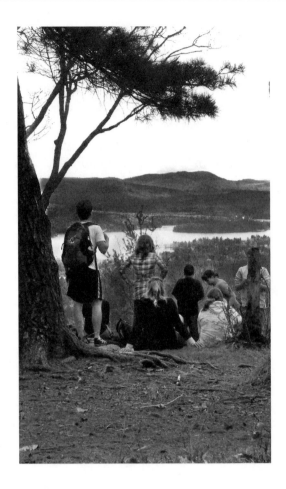

Severance Hill is an easy climb, with fine views over Schroon Lake.

Hudson), which could readily carry logs to market. Hemlock was decimated throughout this area in the mid-1800s, for use in the tanning of leather. This colossally wasteful process utilized only the tree's bark, leaving the trunk to rot in the forest. These primordial climax forests would never regain their original scope and grandeur. When the demand for building materials increased with the region's population growth, more of the tree was utilized, especially where inexpensive construction materials were required. More in-demand and expensive species such as white pine were harvested earlier in the century, followed by red spruce. But the harvesting of hardwood lagged far behind that of softwood because of the difficulty in transporting hardwood logs to market. Rivers could not be used, because hardwood logs don't float. According to the DEC's Hoffman Notch unit management plan, today's extensive hardwood forests lying within the Hoffman Notch

Wilderness Area result from the fact that most of the land within its bounds were acquired by the state prior to the existence of cost-effective means for transporting hardwoods.

Another feature that would create a permanent impact on this wilderness area (and one for which a constitutional amendment was necessary) was the creation of the Adirondack Northway (I-87), which you walk under to begin this hike. The road was built primarily to support the national defense system, and was designed to provide access to Plattsburgh Air Force Base, a Strategic Air Command base that has since been decommissioned. The Northway used a small (256 acres) section of the wilderness area and formed its easternmost boundary. The highway opened in 1967.

By the early 1800s, Schroon Lake and its environs was already a popular recreational destination. Local inns promoted boating, hiking, and horseback riding. The Schroon River is popular with paddlers, and the section above the lake, around the North Hudson area, is a popular fly-fishing spot. The Eagle Point state campground at the south end of the lake above Pottersville makes an ideal staging area for a canoe trip on the lower Schroon River, as well as for the hikes of the Pharaoh Lake and Hoffman Notch wilderness areas.

While Severance Hill was named for the early farmers who settled in this area, a popular legend holds that Schroon Lake was named for Madame Scarron (Francoise d'Aubigné), wife of the French novelist Paul Scarron (1610–1660). After her husband's death, she became mistress and second wife to Louis XIV, assuming the title Marquise de Maintenon.

Retrace your steps back to your vehicle.

TRIP 32
CRANE MOUNTAIN LOOP

Rating: Strenuous
Distance: 4.5-mile loop
Elevation Gain: 1,360 feet
Estimated Time: 4.0 hours
Maps: USGS Johnsburg 7.5; National Geographic Adirondack Park:
 Lake George/Great Sacandaga; Adirondack Maps, Inc.:
 The Adirondacks Lake George Region

**A steep climb to open scenic cliffs goes along the rocky shores
of a remote wilderness pond with designated camping sites.**

Directions

From Exit 23 of the Adirondack Northway (I-87), take US 9 north for 4.5
miles. Bear left onto NY 28 and drive 5.0 miles. A short distance north of the
Glen after NY 28 crosses the Hudson River, take a left onto Glen Creek Road.
At 4.4 miles from the start of Glen Creek Road, turn left onto CR 57 (South
Johnsburg Road). At 6.6 miles, turn right onto Garnet Lake Road (CR 72) in
Thurman. A sign at the corner indicates the Crane Mountain trailhead. Turn
right onto Ski-Hi Road at 7.9 miles. At 9.4 miles, winter road maintenance
ends. The dirt road continues (drivable in good weather) another 0.4 mile to
the trailhead parking lot, which has room for fifteen to twenty cars. (In win-
ter, park along Ski-Hi Road and walk 0.4 mile to the trailhead parking lot.)
GPS coordinates: 43° 32.084′ N, 73° 57.862′ W.

Trip Description

Although Crane Mountain (3,256 feet) lies in the lower, southerly realms of
Adirondack Park, it imparts the atmosphere of a more northerly mountain—
a sort of miniature High Peak. Its trails are steep and challenging, and
its summit forests are dense and boreal, with open cliffs providing far-
reaching vistas.

 Experienced Adirondack hikers will feel right at home on Crane's steep
trails during winter, while beginners will enjoy the hike more during the
dry months of summer. The steep approach to Crane Mountain's summit is
not for the faint of heart, and the trail can be treacherous when ice or snow

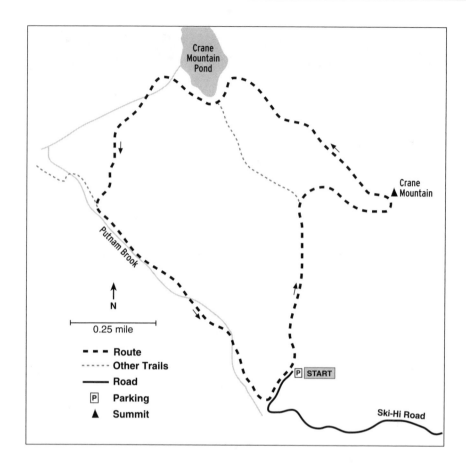

is present. Do not attempt to climb Crane Mountain without the proper winter hiking and emergency gear, and don't rely on your snowshoe claws for climbing in either direction on the headwall's trails—they're too steep. If you are planning to climb Crane during the presence of any ice or snow, creepers or crampons and trekking poles will be useful. Always bring your snowshoes if there is any doubt about snow conditions, which can seldom be accurately assessed at trailhead elevation. No matter the season, you'll frequently need to use all fours when ascending and descending the trails of this dramatic and rewarding peak.

From the parking area, the red Crane Mountain Trail departs to the northwest, leaving the trail register and an old connector trail to the left. Follow the sparse red markers in a northerly direction over the rocky trail through second-growth hardwoods. Though very poorly marked, the trail is generally self-guiding in all but deep, untracked snow. If you have trouble

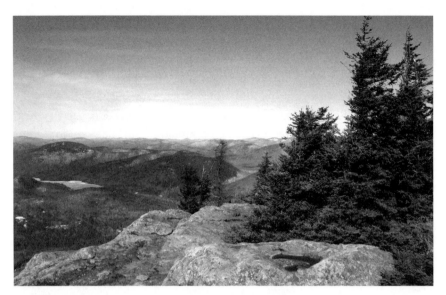

With its alpine lake, rugged trails, and open rock outcroppings, Crane Mountain is a near-perfect hike.

identifying any trail where the footway is bare rock, look for crampon scratches, which will help to show the way. The trail now follows a boulder-strewn streambed and you climb steeply. In the next 0.5 mile, you will climb 800 feet in elevation.

En route, you will see one or two orange arrows (paint blazes) on the rocks. Where an open slab appears to the left, an arrow points to the right and the terrain flattens somewhat. Bear right, still climbing. Another open slab is reached, providing some open views—mere hints of what's to come. Birch and spruce-fir growth appears. The trail becomes a tangle of thick roots, and finally levels at a Y intersection in a small, flat spruce pocket. Bear right, toward Crane's summit. (Cut-Off Trail departs to the west here, leading 0.4 mile to the pond.) Ahead, a wooden ladder spans a low ledge. The trail trends east and levels through the spruce-fir woods, and you can see the summit ledges up high on your left (north). A second, longer ladder scales a ledge and soon you are at summit elevation, walking northwest to a point where the trail summits, on the first of an open cluster of ledges where blueberries appear in season.

Crane's viewshed encompasses a wide angle of terrain running from southeast through the south, west and north. A few ridges away and nearly hidden, Hadley Mountain stands to the south. Garnet Lake is the largest of

several bodies of water seen immediately to the southwest. The bare rock and black growth (spruce-fir) summit to the west is Blue Mountain, with the deciduous Ross Mountain to its north. Gillingham Knoll sits just to the south of Garnet Lake. Wolf Pond Mountain, Bear Peak, Cave Knoll, and Cherry Ridge are seen over the Pine Ridge in the low southerly foreground. Wilcox Lake Wild Forest (to which Crane Mountain belongs) lies to the west, showing Harrisburg Lake on its easterly boundary. The Luzerne Mountains lie in the southeast. The Three Sisters (Bald, Pine, and Hickory mountains), standing above the confluence of the Hudson and Schroon rivers, rise at 140 degrees magnetic and ten miles distant, revealing the ski slopes on Hickory Mountain. East of Warrensburg is the Lake George Wild Forest, and beyond it, the Green Mountains of Vermont and the Berkshires of Massachusetts.

The long scenic ledges and isolated outcroppings of Crane's summit extend to the western side of the mountain. A benchmark is seen in proximity to the true summit, where iron bolts once secured a fire tower; the observer's cabin stood nearby and was later moved to pond elevation.

After relaxing on the summit outcroppings, follow the trail downhill through the spruce-fir woods into the northwest, toward Crane Mountain Pond, dropping 600 feet in the next 0.6 mile. The gradient of Crane Mountain's north slope is more forgiving than on the approach trails (giving you a chance to prepare for the very steep descent following the pond). A short spur leads to the pond's edge as you pass it to your right. The trail withdraws from the pond and heads into the woods again, following closer to the water ahead. To the left you'll see a very attractive designated campsite with a fire ring amid tall trees. In another ten minutes of hiking, a ledge near the water's edge provides the best camping (observe the 150-foot rule) and resting area, where a large rock slopes gently into the pond. Continuing on the main trail, cross the pond's outlet and descend across an open slab. Be extremely careful here in the presence of snow or ice. The trail traverses the slope diagonally, but soon heads directly down the fall line of the mountain. Exercise caution and prepare to use all fours; in the next 0.5 mile, you will descend 700 feet!

The trail then crosses the outlet of a bog, near the forest preserve boundary. Turn left at the trail junction, walking on a level fire access road. The trail veers away from a washout, heading to the south and soon coming back to the gated access point you saw on your way into the trailhead parking area. Bear left and walk the 0.1 mile back to the trailhead parking area.

Rating: Moderate
Distance: 3.5 miles
Elevation Gain: 1,500 feet
Estimated Time: 2.5 hours
Maps: USGS Stony Creek 7.5; National Geographic Adirondack Park:
Lake George/Great Sacandaga

A short but steep climb leads to a seasonally staffed fire tower overlooking the southern Adirondack foothills.

Directions

Take Exit 18 of the Adirondack Northway (I-87) and turn left (west) on Corinth Road (CR 28) to Corinth. At 9.0 miles, go north from Corinth on NY 9N for 5.0 miles to Lake Luzerne. (Coming from the north, take Exit 21 of the Adirondack Northway, and head south on NY 9N for 10.5 miles to Lake Luzerne.) From Lake Luzerne's only stoplight, go west (CR 1/CR 4), crossing the Hudson River into Hadley. Within 0.3 mile of the light in Hadley, turn right (north) onto Stony Creek Road (CR 1). Continue 3.1 miles and cross the train tracks just before turning left (west) onto to Hadley Hill Road. Go an additional 4.4 miles and turn right onto Tower Road. Continue 1.6 miles to the trailhead parking area (room for twelve to fifteen cars) on the left. *GPS coordinates:* 43° 22.440′ N, 73° 57.031′ W.

Trip Description

Well known regionally and well cared for locally, Hadley Mountain (2,675 feet, a.k.a. Wells Peak) is the dominant summit of the long West Mountain ridge in the Wilcox Lake Wild Forest. Because it is close to the most heavily populated areas of the southern Adirondacks, this cordial little mountain with its easy trail and sweeping views attracts many repeat day-hikers, and has proven a perennial favorite of school groups and outing clubs.

A large part of Hadley's appeal are the fire tower and its steward, present during the summer months (July 4 through Labor Day), when access to the tower's cab is provided. The rest of the year, hikers can climb to the tower's

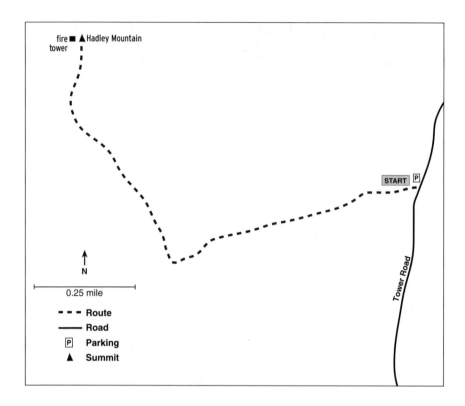

upper-most landing, just below the cab. The tower replaced a wooden structure in 1917, was rebuilt in the '90s, and is continuously upgraded and maintained. Even if you don't climb the tower, Hadley's viewshed is spectacular.

Prepare yourself for a fairly stiff initial climb and carry plenty of water. The trail begins easily, passing the trail register on the left and following a disused roadbed through hemlock woods. The trail is self-guiding and heavily used, and is accordingly not marked with blazes or state trail markers. (The designated marker color at the trailhead is red.) Soon the footway turns to angled bedrock, which accounts for the trail's resilience and carrying capacity. This tilted bedrock trail base is typically wet with runoff and ice melt, so the first leg of the ascent can be very slippery. The forest fires that swept through this area in the early 1900s burned everything—including the thin topsoils—leaving many large areas of exposed bedrock (such as ones typically found on summits). Under certain conditions, what looks likes water on this smooth rock surface may actually be a thin coating of

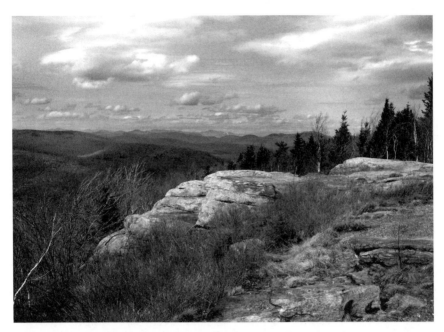

Hadley Mountain and its fire tower attract hikers year-round.

ice. Be aware of such conditions, which usually occur in spring and late fall. Wear boots with lug soles and use creepers if you are in doubt. Because no ledges or extremely steep pitches are along the way, the trail is popular with snowshoers—but it is far too narrow and steep to safely ski.

From the trailhead, the trail rises steadily for 1.0 mile, sidehilling up the southerly slope of the ridge. After a half hour or so, and having gained 1,050 feet in elevation, you will be relieved to arrive in the saddle at ridge elevation, where the trail flattens for a while between the low ridge's peaks to the south (trailless) and the summit. The hardest work is behind you, but there is still some climbing to be done. Bear right (north–northwest), and enjoy a brief respite along the level ridge. Limited views begin to open up on both sides of the trail, which rises and switches back across the southerly slope of West Mountain ridge. The typical northern hardwood group of beech, birch, and maple is dominant here.

Within 20 minutes of the saddle, a large, open ledge to the left of the trail provides the first extensive views to the west. Proceed along the trail as it enters the woods again, and soon you will see the fire tower. Bear left at a Y intersection where the trail splits between the observer's cabin and

the tower, and you're at the top. Climb the tower for more-expansive views. This tower was erected in 1917, and like many of the Adirondack towers, fell into disrepair when aerial fire surveillance replaced the staffed towers. In 1994, a group of tower enthusiasts and outdoors people formed the Hadley Mountain Fire Tower Committee, beginning restoration of the tower and the summit observer's cabin, and developing a public education program.

In the immediate vicinity of the tower, the earth is worn to mineral soil (grit), and here, Hadley's popularity becomes visibly evident. The glacially scoured peaks of the Adirondacks typically have thin soil layers, and you'll notice where these upper-elevation, softer soils have endured surface erosion caused by wind and heavy foot traffic. Avoid stepping on the fragile vegetation of trails and summits, many of which not only require reforestation and long-term management, but which in some cases become irreparably damaged.

The views from Hadley Mountain include the Catskills and the Helderberg escarpment to the south beyond Sacandaga Lake; the Green Mountains and Berkshires to the east; and an assortment of Adirondack High Peaks to the north. You can spot Snowy Mountain, Dix, and Nippletop. To the north and east you should have little problem identifying several of the other hikes in this book, including Crane Mountain (Trip 32), Cat and Thomas mountains (Trip 29) in the Lake George Wild Forest, and Pharaoh Mountain (Trip 30) in the Pharaoh Lake Wilderness Area.

When you're ready to leave, return to your vehicle the way you came.

TRIP 34
WARREN COUNTY BIKEWAY

Rating: Easy

Distance: 9.6 miles

Estimated Time: 2.0 hours

Maps: USGS Lake George 7.5; USGS Glens Falls 7.5; National Geographic Adirondack Park: *Lake George/Great Sacandaga*; Adirondack Maps, Inc.: *The Adirondacks Lake George Region; Warren County Parks and Recreation Bikeway Area Map*; Adirondack Lake/Glens Falls Transportation Council: *Regional Bicycle Map*; Warren County road map

Superb off-road riding on a paved and designated bike path—ideal for children—begins at Lake George's Million Dollar Beach.

Directions

From Exit 21 of the Adirondack Northway (I-87) at Lake George, go east on NY 9N, and take the first left onto NY 9 (Canada Street). In the middle of the village, turn right onto Beach Road (a.k.a. Million Dollar Beach Road). Continue a short distance to West Brook Road and turn right. You will see the Warren County Bikeway trailhead on your left. No designated bike trail parking area is available. Find a place to park on or near West Brook Road. *GPS coordinates:* 43° 25.157′ N, 73° 42.529′ W.

Trip Description

Few towns capture the spirit of summer fun in the mountains like Lake George. For some, it is the ultimate family vacation destination, while for others, it is a jumping-off place for adventures farther afield in the surrounding Lake George Wild Forest. The Warren County Bikeway is a compromise between the two. You can experience the shops and arcades of downtown, enjoy a relaxing day on the sand at Lake George Beach State Park, camp near the center of town at Battlefield State Park, and cycle off into the woods on the bike path when you need to get away from it all.

The bikeway begins in the village, next to the lake. Here you will be treated to the spectacular "million dollar" views of the northern mountains. You see

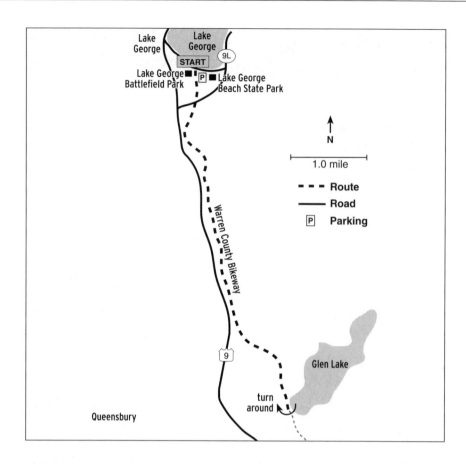

Buck Mountain and its neighbors on the lake's east side, and the peaks of the Tongue Range in the north.

Get on the trail at the trailhead sign. This section of the bikeway is referred to as Feeder Canal Trail. It is an interpretive trail for some distance. The trail heads up into the woods to the left of Battlefield State Park, where the vegetation is lush. The forest is mature and attractive, with its open understory and many fine trees creating a beautiful wild-forest setting. Pass through the picnic area with its huge white pines.

Pass a few private drives and come up to NY9, bearing left on the bike path past Magic Forest, and stop before you cross CR 59. (Remember: Teach younger children to dismount at all road crossings.) The trail enters the woods again. Pass through a hemlock glen, where a stream appears to the right through some ledgy terrain. At 3.0 miles, the Ephraim Williams

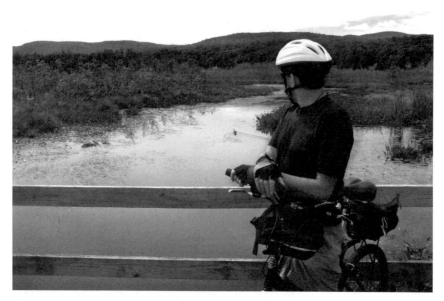

Bikers enjoy a variety of scenery on the Warren County Bikeway.

Monument trail appears on the right. The trail is named for the colonel who defended the frontiers of the state with Sir William Johnson against the French and their American Indian allies. Williams College was established by his estate.

Ride over NY 149 on the arched bridge and cruise downhill. Large oak and pine trees shade the trail. Cross Glen Lake Road. The trail becomes more open and sunny through this section. At 4.8 miles, cross Ash Drive. Ride over a wet meadow on a bridge, from which you can see Darling, Bucktail, and Bartlett mountains. The bike trail continues heading south, but just ahead it enters the back streets of Glens Falls, where it is less than ideal for children; you should turn around and head back over the bridge. Those who want more mileage will enjoy Feeder Canal Park Heritage Trail, which this trail connects with via an asphalt, multi-use trail through the back roads of Glens Falls, crossing the border into Washington County, and ending at the Old Champlain Canal Towpath in Fort Edward.

The twin fortifications of Fort Edward and Fort William Henry are the subject of a tragic story, retold as fiction in James Fenimore Cooper's Leatherstocking tale *The Last of the Mohicans*. Battlefield Park in Lake George was the site of several battles preceding the construction of

Fort William Henry, built by Sir William Johnson to defend northern New York from the invading French. The fort could not withstand the onslaught of the French commander Marquis de Montcalm's 8,000 troops and cannon, who planned to march south on the colonies. British commander George Munro, realizing the fort could not hold up under the onslaught, still would not surrender. Instead, he held out for six days before handing the ruined fort to the French. This short period of time allowed British troops to organize in the south. Many civilians—most of them women and children—had sought shelter in Fort William Henry, because the outlying countryside was no longer safe. Upon the fort's surrender, these people were released under the protection of an English escort, whereupon they undertook what Montcalm had assured would be "safe passage" to Fort Edward. However, Montcalm had underestimated the wrath of his Huron allies, who wished revenge against the English and ambushed the band of refugees. Historians are not certain just how many were massacred. The delay in storming Fort William Henry ultimately cost the French the war, putting an end to 100 years of fighting.

Only as recently as 1953 was Fort William Henry exhumed and examined. Montcalm, on his retreat, had burned what was left and covered the ashes in sand. Nothing but a fanciful replica of the fort remains today as a tourist attraction.

After returning to the trailhead, as a final touch (and only if you don't have children with you, since the traffic can be very heavy) ride your bike through the village and along Million Dollar Beach Road, where you can marvel at the hard-won, scenic landscapes of Lake George.

TRIP 35
SHELVING ROCK BAY

Rating: Strenuous

Distance: 10.0 miles

Elevation Gain: 1,000 feet

Estimated Time: 2.0 hours

Maps: USGS Shelving Rock 7.5; National Geographic Adirondack
Park: *Lake George/Great Sacandaga*; Adirondack Maps, Inc.:
The Adirondacks Lake George Region

This advanced mountain-bike trip takes you to a day-use area on the water's edge, where you can enjoy swimming and picnicking along with the excellent scenery over Lake George.

Directions

See Trip 25 for directions to the Hogtown trailhead. *GPS coordinates:* 43° 31.888' N, 73° 33.930' W.

Trip Description

Shelving Rock Bay is located in the wildest region of Lake George that is accessible by car and open to public use. This area of the Lake George Wild Forest is very popular with hikers, backpackers, campers, cyclists, snowshoers, backcountry skiers, hunters, trappers, and anglers. It is one of the few areas on the lake where public access is still free.

This area's popularity endures for several reasons. Twelve drive-up and carry-in campsites are along Shelving Rock Road and Dacy Clearing Road, at which a relatively high degree of seclusion can be enjoyed. Located on or near hiking trails to prominent peaks such as Buck and Sleeping Beauty mountains, these sites make excellent staging points for day hikes. Other attractions are the scenic picnic area along the lake's edge at the end of Shelving Rock Road, and the island campsite complex just offshore in Lake George Islands state park. In addition to camping at the islands, the boating public anchors here for swimming and cookouts in the day-use area. Of course, Lake George itself is the main highlight. Rarely will you find such pellucid, clean, and inviting water.

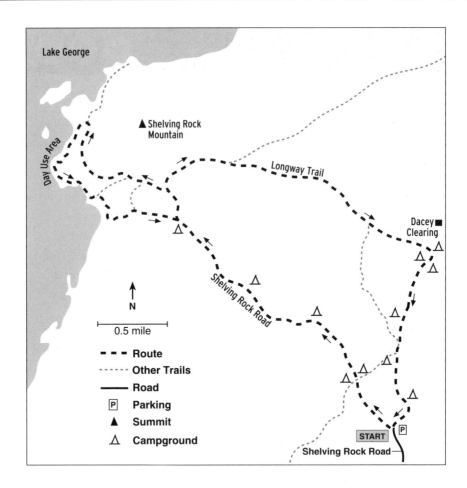

The most limiting factor to increased public use here is the steepness of the terrain. From the Hogtown parking area to the lake is an elevation drop of 1,000 feet. While this provides for a great deal of fun, it demands a serious aerobic effort. To get the benefit of the full workout, start and finish at either the top or bottom of Shelving Rock Road. This tour is described from the top of Shelving Rock Road.

Double-check your brakes—this is a long hill. Go out of the parking area and turn right, heading downhill on Shelving Rock Road. It's fast—feather your brakes. You'll pass a few trailheads and designated campsites. You'll also pass a few small pull-off areas, as well as the closed Pines day-use area on the left side of the road. At 3.2 miles, pass the large parking area on your left and continue to a point that's almost at the end of the public road.

Shelving Rock Bay on Lake George is an ideal spot for a picnic.

If you reach a private gate, you've gone just a little too far. On the left side of Shelving Rock Road, just before the road turns private, a small, unmarked trail goes left toward the lake. If you have an odometer on your bike, set to zero here. Follow this short trail to the lake's edge and turn left.

From this point the trail is magnificent. You will pass several little rocks and points. The views open up toward Tongue Mountain across the lake and Pilot's Knob to the south. This section of the trail is flat and wide, offering easy riding with few or no obstructions. The lake is on your right. You will pass several secluded peninsulas with informal foot trails leading to private spots on the lake's edge. If it's a nice day, you'll encounter lots of people here—especially families with kids. Keep bearing right, soon crossing a wooden bridge over Shelving Rock Brook. Leave a trail that heads uphill to the day-use area parking lot to your left. At a Y intersection 1.5 miles from the point at which you left Shelving Rock Road, bear left and go uphill on an old carriage road. (The trail to the right ends at the border of the day-use area—you can go no farther.) Go uphill on a rougher surface now, and pass the dam above Shelving Rock Falls. At 2.4 miles, get back on Shelving Rock Road and turn left, crossing a bridge (you covered the same distance earlier).

In less than a tenth of a mile, bear right onto the horse trail and go around the barrier gate. You will see blue horse trail markers and yellow snowmobile markers on this trail (though the colors have been known to vary). At 3.0 miles, you will cross a bridge and follow a brook. Soon, you will cross the brook and arrive at a T intersection. Go right here. The climbing begins.

You will cross a couple of plank bridges and arrive at a Y at 4.5 miles. Both trails lead to Dacy Clearing from this point, but Longway Trail is generally the better of the two. Go left here, toward the Upper Hogtown parking area. At 5.0 miles, you will arrive at Dacy Clearing, having regained almost all the elevation you previously enjoyed losing on the way down Shelving Rock Road. Nothing of interest is at Dacy Clearing except a foundation dating from the old Dacy farmstead. (Dacy Clearing parking and camping area is to the left.) Turn right, following Dacy Clearing Road through an area with several designated campsites. At 6.5 miles, you're back at the Upper Hogtown parking area.

With the conclusion of this ride, you've been introduced to only a small piece of the Lake George Wild Forest's Shelving Rock section—where a world of outdoor adventure remains to be discovered.

TRIP 36
SCHROON RIVER

Rating: Moderate (depending on water levels)

Distance: 10.0 miles

Elevation Drop: 28 feet

Estimated Time: 4.0 to 5.0 hours

Maps: USGS Bolton Landing 7.5; USGS The Glen 7.5; National
Geographic Adirondack Park: *Lake George/Great Sacandaga;*
Adirondack Maps, Inc.: *The Adirondacks Lake George Region*

**An easy and scenic section of recreational river with a few
Class I riffles and rapids is ideal for open canoes and kayaks.**

Directions to Put-in

From the Bolton Landing, take Exit 24 of the Adirondack Northway (I-87)
and go east off the ramp, following CR 11 for 0.2 mile. Cross the Schroon
River and turn left onto East Schroon River Road. At 0.2 mile, park on the
left at the Warren County canoe access site (room for eight to ten cars;
roadside parking also available). *GPS coordinates (put-in):* 43° 36.443' N, 73°
43.815' W.

Directions to Take-out

From Warrensburg, take Exit 23 of the Adirondack Northway (I-87) and turn
west off the ramp. Go 0.6 mile north on NY 9 (which becomes Main Street)
into Warrensburg and turn right at the traffic light onto Horicon Avenue
(CR10), which becomes Schroon River Road. Go 1.7 miles from the traffic
light to County Home Bridge Road and turn right, crossing the bridge. Park
at the Warren County canoe access site (room for ten cars). *GPS coordinates
(take-out):* 43° 30.705' N, 73° 44.805' W.

Trip Description

The 10-mile stretch of water from Riverbank to Warrensburg is the easiest and
most gratifying section of the Schroon River for beginner-to-intermediate
paddlers. The river drops only 28 feet in 10 miles, making it essentially a
flatwater paddle, yet there is always an obliging current.

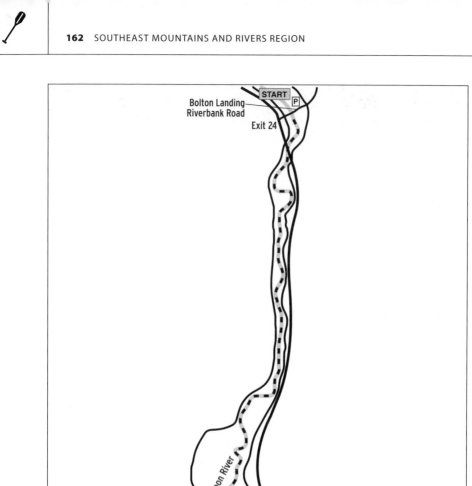

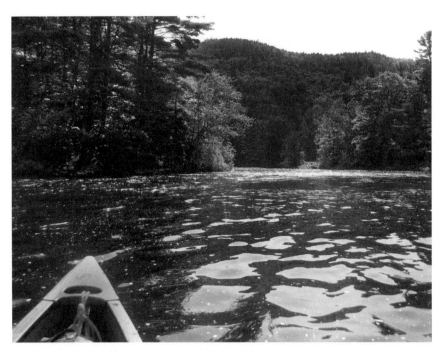

The Schroon River's flatwater is popular with paddlers and anglers.

Be advised that you will encounter a few short, easy rapids, which under normal conditions—neither flooding nor extreme low water—can be rated as Class I or below on the scale of river difficulty (flat or moving water that may have occasional or no obstructions). Avoid the river during flood conditions. Some familiarity with moving water will be useful, though it is not essential. If you have paddled only on flat water, this trip will move your skill set nearer to the Class I range without the need for a covered boat, specialized equipment, or tight and precise maneuvering. Remember, however, that any fast-moving water requires vigilance, as rocks and flotsam or even tree trunks and strainers (fallen trees and limbs) may present hazardous obstacles. A bow paddler should be versed in the draw and sweep strokes; a complement of strokes, along with a strong J stroke in the stern, is a necessity for the full enjoyment and efficiency of paddling a canoe on any type of water, moving or still. This section of the river is open and wide, providing little protection from the sun from midmorning to late afternoon. Sunglasses and sun protection are essential. Opportunities for swimming are plentiful.

The canoe and fishing access site at Riverbank is not as well developed as others maintained by the county, and the launching area is small. At higher levels of water you may be launching into moving water, so secure your canoe accordingly. Paddle downriver through a little fast water under the CR 11 bridge, heading south. Immediately a long, easy rapid begins, creating a large and slowly circulating eddy on the right before passing an RV park. This delightful and easy rapid curves around to the east and enters a long section of still water.

Sound from the highway, which roughly follows the river to Warrensburg, is distracting, but soon moderates as you pass beneath the road and swing west. As you travel easily downriver amid the thick hardwood vegetation, you will pass a pair of evenly spaced, overgrown rock piles in midstream—the remnants of a log boom. Here, logs were held until the spring freshets could carry them south into the Hudson River and beyond. If you look closely at the mound on the east side of the river, you can still see bits and pieces of the old chain links that held the booms. This boom was most likely in service between 1850 and 1900, when pine, then spruce, and ultimately hemlock (for use in the area's tanneries) were floated to the mills. Little or no market for hardwood logs existed until the early 1900s; hardwood logs cannot easily be shipped and don't float well enough to transport by river driving. This accounts for today's predominance of hardwood forests around the upper reaches of the Schroon River and its tributaries. The forges, mills, and tanneries of the era were profitable—like those of the Hudson Valley farther south, because of demand for iron and leather during the Civil War. Hides were brought to the tanneries by the tens of thousands in ships from as far away as South America.

Following the log boom abutments, you will pass beneath a power line. Be alert, as just past this point is a Class I drop, which is simply a V in midstream followed by a long, flat pool. Follow directly down the center of the V to avoid the rocks around it. Continue downstream. A series of lazy oxbows is ahead, with open sand aprons and shallows. Here the river has the appearance of a lowland creek, shadowed by large silver maples, with large white pines overhead. Driftwood tends to ground in the shallows against the sandy shores, where songbirds hunt and forage among the red osiers and alders.

Soon the bridge at the take-out comes into view. This is a popular spot for swimming, and people sometimes jump from this bridge into the water, though this is prohibited. To retrieve your put-in vehicle, navigate your way north on either the west side of the river (Schroon River Road) or the east side (East Schroon River Road) for an interesting alternative route to the Northway.

You can extend this trip by 2.5 miles by placing your shuttle car at the town park in Warrensburg. To reach the park, take NY 9 off the Northway into Warrensburg and turn left at the light at the intersection of Main Street and Water Street (CR 45). Turn left on Richards Avenue. Cross the Schroon River. Turn left on Milton Street and go 0.2 mile to the park (hours: 9 A.M. to 9 P.M.; no overnight parking).

TRIP 37
LAKE GEORGE ISLANDS

Rating: Moderate (depending on weather conditions)
Distance: 12.0 miles
Estimated Time: 6.0 hours (overnight suggested)
Maps: USGS Bolton Landing 7.5; USGS Shelving Rock 7.5; National
Geographic Adirondack Park: *Lake George/Great Sacandaga*;
Adirondack Maps, Inc.: *The Adirondacks Lake George Region*

This adventure paddling trip features numerous opportunities for swimming, picnicking, and island camping.

Directions
From Exit 24 of the Adirondack Northway (I-87), go east 4.8 miles on CR
11 to NY 9N in Bolton and turn left (north). Drive 4.2 miles to the boat
launch on the right side of NY 9N (immediately before crossing Northwest
Bay Brook). Unload at the water's edge first, then park in the lot (room for
twenty cars). *GPS coordinates:* 43° 37.541′ N, 73° 36.484′ W.

Trip Description
Many people who are unfamiliar with the scenic splendor of Lake George's
looming hills, uninhabited islands, and extensive state wild forest lands may
think of it as a kitschy tourist destination, an image that the spirited and
fun-loving village can do little to dispel. Paddlers who time their visits for
weekdays and off-season weekends, however, can avoid much of the din and
clamor of ski boats and parasailors, and will be rewarded with the quiet and
majestic grandeur of the lake the Abenaki called *An-Di-A-Ta-Roc-Te,* or "the
lake that shuts itself in." Enveloped by the eastern Adirondack foothills, the
lake gives you the feeling of paddling in a wide, deep river valley, shut out
from the rest of the world. Combined with the remote marshes of Northwest
Bay and the remarkably clean, clear waters of the lake itself, a midweek or
off-season day or overnight trip to the Narrows and its islands is something
you'll quickly add to your inventory of special places—especially if you have
children who love the water.

Prepare carefully for a day or overnight trip. Wait for fair weather with a

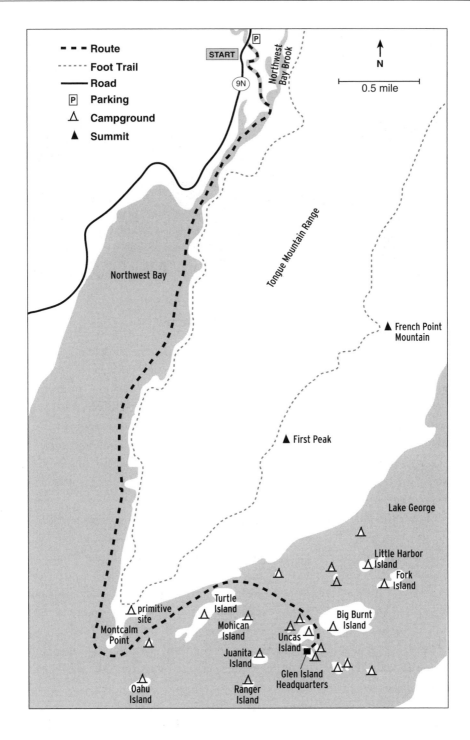

A kayaker rounds Lake George's Montcalm Point.

good forecast and, if possible, plan your trip to coincide with a rising moon, which makes camp life more enjoyable and offers the possibility of moonlight paddling. Be mindful of strong winds. Even when high-powered watercraft are not creating tumultuous conditions, the lake can develop conditions you'll have to reckon with. Northwest Bay is sheltered from all but southerly and strong westerly winds, but the open lake can develop dangerous winds and waves from any direction. You can paddle close to shore at any point in the trip; in the event of an emergency, take the foot trail that follows the shore for the full length of the Tongue to Montcalm Point, where you will round the peninsula and enter the Narrows.

From the boat launch, bear straight out from the sandy area and then go left (the first channel to the hard left of the put-in dead-ends). The first twenty minutes of paddling on Northwest Bay Brook is sheltered and narrow. This is one of the three largest wetlands in the Lake George Wild Forest, featuring a variety of wet meadows, forested swamps, and both deep water and emergent wetlands. Paddle south toward the bay, where herons will lift off ahead of you as ospreys soar overhead. Red wings and owls sound off in the rushes and woodlands, and in the dead waters, pond lilies and pickerelweed color and congest the shallows, blooming in bright-white, yellow, and purple.

At 1.3 miles, you will enter Northwest Bay, and the lake opens up ahead. Clear Bear Point is to your left. The prominent landmark of Cat Mountain

with its rocky easterly face comes into view ahead in the southwest. Passing several small bays on your left, you will cover the distance to Montcalm Point in an hour or so. Just before rounding Montcalm Point, a good rock landing is ideal for swimming. (No such place exists at the tip of the point or after you round it until you reach the islands.) You're nearly abreast of Cat Mountain now, which rises nearly due west. Few people realize that an established, legal, and free primitive campsite (a cleared space and informal fire ring) is on Montcalm Point, a few hundred feet from this rock landing. The campsite is reached via an evident, unmarked herd trail. No camping is allowed on the point within 150 feet of shore. Most paddlers prefer to camp closer to the water, in the more developed pay sites of the Narrows, just ahead.

Rounding Montcalm Point, bear left (northeast) into the Narrows islands group. In large bodies of water such as Lake George, small boats are often subject to challenging or even overwhelming conditions. During such times, rounding the point can be the most difficult segment of this trip. By all means, turn back if you feel you cannot round the point or continue safely. Here you will be exposed to whatever north, east, and south winds may be blowing, but if these winds are strong (the Tongue will tend to moderate strong westerlies), the islands will offer considerable protection. Stay between the Tongue and Turtle Island, and then bear east in the shelter of Mohican and Uncas islands, keeping close to the lee (downwind) shore. If you don't already have a campsite reservation, go directly to the state campground headquarters at Glen Island to register, where you'll find a well-stocked general store and a ranger headquarters. Paddle to the site and set up your camp.

Nearly endless opportunities for exploring, camping, fishing, hiking, and sightseeing exist here and in other areas of the lake that are within easy paddling distance of the Glen Island headquarters. Fall camping is especially enjoyable on a body of water as large as Lake George, since the lake tends to moderate temperatures late into the season. This effect can be seen in the vegetative communities of the Tongue Range, where moderate temperatures and exposure to direct sunlight have created a microclimate that encourages the growth of vegetative communities more common to the South. Hikers on the eastern mountains (such as Buck) will note the relative lack of snow present on the eastern side of the Tongue Mountain Range in early spring, when climbing Buck Mountain still requires snowshoes.

To return to the boat launch, paddle back to Northwest Bay and retrace your route.

TRIP 38
HUDSON RIVER

Rating: Moderate

Distance: 14.0 miles

Elevation Drop: 40 feet

Estimated Time: 5.0–7.0 hours

Maps: USGS Warrensburg 7.5; USGS Stony Creek 7.5; USGS Lake Luzerne 7.5; National Geographic Adirondack Park: *Lake George/ Great Sacandaga*; Adirondack Maps, Inc.: *The Adirondacks Lake George Region*

An easy, scenic downriver paddle with no portages follows along a wild section of the Hudson River.

Directions to Put-in

From Exit 23 of the Adirondack Northway (I-87), take US 9 north into Warrensburg. At 0.6 mile, bear left at the light onto CR 45. Go 0.2 mile and bear left across the Schroon River bridge. Turn right onto NY 418. From this point, it is 3.0 miles to the Warren County canoe access site (room for fifteen cars), which is obvious on your left just across the bridge spanning the Hudson River. *GPS coordinates (put-in):* 43° 28.824′ N, 73° 49.158′ W.

Directions to Take-out

If you chose to spot a car rather than use the Beaverbrook Outfitter's shuttle, drive to the Hadley Canoe take-out on Woodard Avenue. From the south, take Exit 18 of the Adirondack Northway (I-87); turn left (west) on Corinth Road (CR 28). At 9.0 miles, go north on NY 9N; the drive is 5.0 miles to Lake Luzerne. From the north, take Exit 21 of the Adirondack Northway (I-87), and head south 10.5 miles on NY 9N to Lake Luzerne. From Lake Luzerne's only stoplight, go west (CR 1/CR 4), crossing the Hudson River into Hadley. Within 0.2 mile, turn right onto Woodard Avenue where a street sign reads Hadley Canoe Take Out. Go 0.1 mile and bear right opposite Maple Street into the parking area (room for twenty cars). *GPS coordinates (take-out):* 43° 19.219′ N, 73° 50.778′ W.

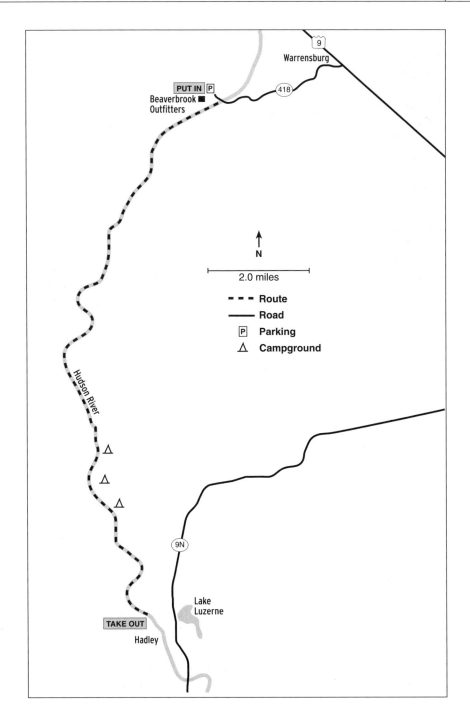

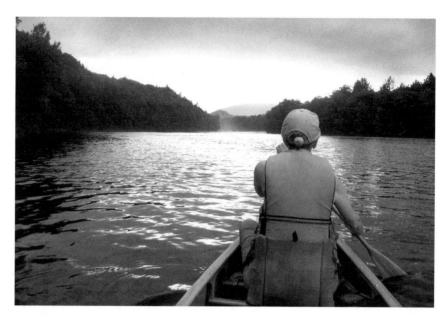
This scenic section of the Hudson River is an ideal introduction to river tripping.

To return to the put-in from Hadley, take CR 1 north through Stony Creek, and CR 2 to NY 418. At 16.0 miles, bear right on NY 418 to the Warren County canoe access point on the left.

Trip Description

Following its youthful origins from the high alpine slopes of Mount Marcy, the Hudson River becomes a raging maelstrom by the time it reaches the famous Blue Ledges. Below its confluence with the Indian River, thousands of people raft the gorge on guided trips every summer. More rapids follow, through North River and North Creek, into the realm of the expert paddler, where the Hudson River Whitewater Derby is held annually. Below the Glen, things begin to settle down, though a few more challenging drops remain. After the confluence of the Hudson with the Schroon River at Thurman Station, quick water moves just fast enough to make this 14-mile trip to Lake Luzerne nearly effortless. The river settles down, and the water is flat. Battered prows of islands, heaped with spring flood debris, jut into the current. Eagles soar over the narrow valley, and ospreys plunge into the river from high overhead. Foxes, deer, bears, and maybe even a moose are

among the animals present, and they will often be unaware of your stealthy approach in your silent canoe. Hills and cliffs rise to either side of you. Little channels of riffling fastwater curl around the low islands and shoals, offering themselves to exploration.

This amenable section of the Hudson—unimpeded by dams or rapids— is an ideal setting for an introduction to moving water. Families and young children in all kinds of watercraft often paddle it. A road follows along most of the west bank of the river, which is lightly developed. Most of the east bank remains wild, much of it state-owned wild forest and parkland with an unimproved, restricted dirt road. To avoid going through the trouble of spotting a car, you can reserve a spot on the Beaverbrook shuttle back upriver for a reasonable fee. You can also rent a canoe or kayak at Beaverbrook's outfitting station, which includes the shuttling fee—a choice that will greatly simplify the logistics of this trip.

While this is an "easy" section of river as far as paddling skills are concerned, both water levels and headwinds will influence your progress. From the access site, put in just below the bridge and paddle easily as the current pulls you south. You'll soon pass under an old, abandoned bridge. Channels are several feet deep and offer alternate routes around islands and shoals; fear not, for they all join up again ahead. Stay alert, as sleepers (large rocks lying invisible just below the surface) and shallows will require some easy maneuvering to avoid getting hung up. Low hills rise in every direction, with the Deer Leap Mountains rising ahead to the southwest. The bank vegetation varies from dominant hardwoods to hemlock and white pines.

You'll pass a golf course and some open meadows on river right. The road comes into view. At about 6.0 miles, opposite a white house on the west (right) bank, you will see a low set of log steps that rise into a day-use area on river left. Beyond is a series of designated, free campsites (landing is easier just ahead). This is the Lake George Wild Forest Hudson River Forest Preserve (HRFP), sections of which have been closed because of severe overuse. Camping is non-permitted and is on a first-come, first-served basis, with a three-day maximum stay. If you are interested in camping before, during or after the trip, be advised that on weekends, large and often loud groups will take most of these sites. Four sites on Buttermilk Road are most accessible to canoe groups, each requiring a short carry from the river. Camping is no longer permitted between Buttermilk Road and the river. The usual rules for

camping apply to the large inholdings of undeveloped state wild forest areas upriver of this point: Camp 150 feet away from any road, trail, water body, or stream.

Continuing downriver, keep to the left of the large island, where a convenient gravel beach leads up to a day-use area. This is a good place to stretch your legs. For the next 8.0 miles, the river is flat and wide, though still very wild and beautiful. Stony Creek comes into the river on the right, a short distance past the island. More residences appear, and both the ambient noises of civilization and the number of people launching from the day-use area in tubes and inflatable kayaks increase dramatically.

As you approach the take-out, you will hear the falls ahead. Keep to the right (west) shore and take out at the sign that reads "Attention: Caution! Waterfalls ahead." The take-out requires a short lift over a low jumble of riprap and a flat carry through the picnic area to the parking lot, where the Beaverbrook shuttle picks up.

Section 4

Southwest Lakes and Mountains Region

THIS QUADRANT OF ADIRONDACK PARK EXTENDS FROM the Black River Wild Forest in the far southwest through the Canada Lakes wilderness near the geographic center of the park around Newcomb in the northwest. Often referred to as the west-central mountain region, the northerly section of this area contains several scenic peaks. The hikes included here are Wakely, Blue, and Goodnow mountains—each rated as moderate or strenuous. The relief tapers off into the southwest, where an easy hike up Bald Mountain provides an overview of the surrounding lowlands to the west. All of the hikes in the southwest region feature fire towers, which provide distant, sweeping views of the High Peaks to the northeast.

The main travel corridor through the region is NY 28, which roughly bisects it in a southwest-to-northeast diagonal. Access from the southwest is in Old Forge. Several large lakes (Long, Blue Mountain, Indian, Raquette, and the Cedar River Flow) exist in the area. Blue Mountain is at the height-of-land marking the St. Lawrence and Hudson River watershed divide. Farther southwest is the Fulton Chain of Lakes on the Moose River-Black River watershed, where the first designated canoe route in the state was developed in the early 1900s. Historically, the route was used as an important travel, trade, and hunting corridor by American Indians, who preferred the protection of the interior Adirondack lakes and rivers to windy and tempestuous Lake Champlain.

As in other areas of the Adirondacks, logging here was followed by recreational hunting and fishing, which overlapped with leisure tourism. Thomas Clark Durant (manager of the Union Pacific Railroad), who owned hundreds of thousands of acres in the area—including all of Raquette Lake—developed the rail, water, and coach lines into this part of the Adirondacks with his son, William West Durant. William, who had spent his youth in Europe, observed firsthand the ornate building styles of many rustic retreats and hunting camps of the wealthy there. He is credited with originating the Great Camp style of architecture on Raquette Lake. Among his most noted achievements are Camp Pine Knot (1876), Camp Uncas (1893), and Sagamore Lodge (1897). Although the Durant influence lives on in the surviving Great Camps, the family's riches disappeared in William's lifetime.

Today's recreational paddlers, hikers, and cyclists follow these original river routes, stage roads, and footpaths. The Northern Forest Canoe Trail (NFCT), with its southern trailhead in Old Forge, crosses the Northeast to its northern trailhead in Fort Kent, Maine, following what is believed to be the ancient trade route of the Mohawk and Wabanaki. Some of the paddling trips in this book—the Marion River, Raquette River, and Lower Saranac Lake to Weller Pond trips—follow sections of the NFCT. The bike trips from Thendara and Inlet follow old rail beds. Paddlers on the Marion River use a canoe carry that was once the site of Durant's Marion River Carry Railroad—the world's shortest standard gauge railroad. Today, its locomotive can be seen in the Adirondack Museum.

There is no doubt that William West Durant saw something very special in this part of the Adirondacks. As early as 1866 he remarked to the *New York Daily Tribune*, "I firmly believe that the Adirondacks are the resort of the future."

TRIP 39
BLUE MOUNTAIN

Rating: Strenuous

Distance: 4.0 miles

Elevation Gain: 1,550 feet

Estimated Time: 3.5 hours

Maps: USGS Blue Mountain Lake 7.5; National Geographic
Adirondack Park: *Northville/Raquette Lake*; Adirondack Maps,
Inc.: *The Adirondacks West-Central Wilderness, The Adirondacks
Central Mountains*

**This popular climb, with its striking views into the
High Peaks, is complemented by a visit to the nearby
Adirondack Museum and Blue Mountain Lake.**

Directions

From the intersection of NY 28, NY 28N, and NY 30 in the hamlet of
Blue Mountain Lake, travel north on NY 28N for 1.0 mile, passing the
Adirondack Museum on the left. Continue on NY 28N/NY 30 for another
0.3 mile to the Blue Mountain trailhead parking area on the right (room for
50 cars). *GPS coordinates: 43° 52.485′ N, 74° 25.872′ W.*

Trip Description

Blue Mountain's distinctive, stetson-shaped peak is easily seen and identified
from great distances, making it one of the most familiar Adirondack
landmarks. A keystone in the seemingly endless wall of the western
mountains, this popular peak was an important summit for topographical
engineer Verplanck Colvin's 1870s survey work. Although it falls below the
lofty rank of the 4,000-footers—failing to qualify by a mere 241 feet as an
Adirondack High Peak—its usefulness to Colvin (and its attraction for hikers)
lay in the fact that it is considerably higher than most of its neighbors for
many miles.

Some observers have suggested that the mountain nearly always appears
in some shade of blue from a distance, a statement that seems apocryphal
until you hike to its summit and witness the expanse of open sky reflected
in the area's countless indigo lakes. The entire mountain can appear blue,

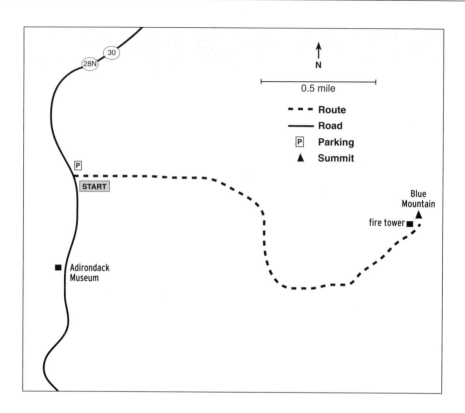

especially in the soft and radiant haze that is so common on late-summer afternoons. For many hikers, Blue Mountain is attractive because of its accessible fire tower, and its close proximity to Blue Mountain Lake and the Adirondack Museum. These combined features serve as an Adirondack primer, allowing you the opportunity to survey the lands below; paddle, hike, and swim in the lake; and study the natural and human history of the area, all in a single day. Or, ideally, to stay in one of the many public campgrounds or private lodgings nearby, and spend a day at each place.

Be advised that Blue Mountain is not a good choice when the trail is wet or icy. The smooth bedrock on the upper section of the trail can create very hazardous conditions, especially as you descend.

From the trailhead parking area, look for the trailhead and register near the middle of the lot. Sign in and set out through the dense northern hardwood forest following red markers. The heavily impacted trail climbs easily at first, crossing small bridges and puncheons. As elevation is gained, the footway is slick bedrock here and there, with roots and informal rock steps.

The High Peaks are visible from Blue Mountain's fire tower.

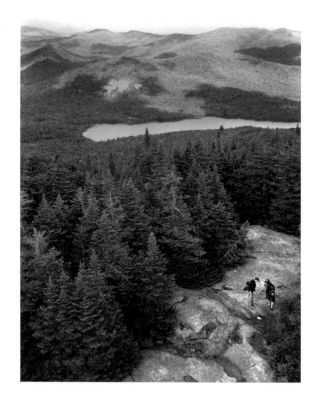

The first two-thirds of the trail is fairly easy, but the last third is very steep.

At around 2,700 feet, the trail begins to climb steeply as it curves into the south. Upon heading east again, and still climbing steeply, the trail assumes a parklike character, with pure stands of balsam fir over moss. This boreal atmosphere continues as the trail relaxes and gains the summit, which is enclosed in spruce-fir. Only a climb up the tower gives you the 360-degree view Blue Mountain is so well known for.

Looking northwest left to right you will see Debar, Ampersand, St. Regis, Seward, Sawteeth, Whiteface, Couchsacraga, Algonquin, Phelps, Mount Colden, Mount Marcy, Haystack, Nippletop, Dix, Boreas, and finally, Vanderwhacker, with its fire tower to the east–northeast. You can see as far east as the Green Mountains of Vermont, including Killington Peak. You'll be able to spot Sleeping Beauty in the Lake George Wild Forest. Gore, Crane, and Chimney mountains are visible, and you can identify Rock Lake below, just south of east in the foreground.

To the southeast you can see Sawyer, Kunjumuk (in the Siamese Ponds

wilderness), and the Copper Mountains, as well as Squaw, Snowy, Panther, Lewey, Pillsbury, and Wakely mountains to the south. To the west is Raquette Lake. Castle Rock is the low scarp just above Blue Mountain Lake's north shore. You can spot the fire tower marking the summit of Owl's Head. In the west–northwest is the Five Ponds wilderness, and Bear Mountain can be seen in the Cranberry Lake Wild Forest. Mount Arab, Mount Morris, and Floodwood Mountain can be spotted. Below and east is Tirrell Pond, which lies along the route of the Northville–Lake Placid Trail. Below to the west, you can see the Adirondack Museum.

Blue Mountain was popularized in the Great Camp and hotel heydays of the late 1800s. The Blue Mountain Lake House was built in 1871, followed by the Prospect House in 1881. With the help of Thomas Edison, the Prospect House became the first hotel in the world with an electric light in every room. Built by Frederick Durant (the nephew of the Union Pacific Railroad tycoon Thomas C. Durant), the Prospect House, with its 300 rooms, steam elevators, billiards room, restaurant, pharmacy, orchestra, library, and bowling alley, quickly became the most prestigious hotel in the Northeast. Until 1915, the hotel was the conduit by which the Tiffanys, Vanderbilts, Macys, Harrimans, Fords, Edisons, Firestones, Roosevelts, Whitneys, and their ilk would come from far away to enjoy the Adirondack forest primeval in splendor and luxury. They came partway on Durant's Adirondack Railroad, and the rest of the way by stage and steamboat.

You can learn more about Adirondack hotels, camps, and clubs at the Adirondack Museum, which also has permanent exhibits dealing with both the working and recreational history of the area.

Blue Mountain's wilderness appeal is compromised somewhat by the existence of a radio and cell tower on its summit, the latter of which provides limited-range cell and relay service for local emergency use. The trail heading north from the summit enters the private lands of Finch, Pruyn and Company, then descends to the highway on a rough service road. This trail is closed to the public.

Return the way you came.

TRIP 40
GOODNOW MOUNTAIN

Rating: Moderate

Distance: 3.9 miles

Elevation Gain: 1,100 feet

Estimated Time: 3.5 hours

Maps: USGS Newcomb 7.5; National Geographic Adirondack Park:
Lake Placid/High Peaks; Adirondack Maps, Inc.: *The Adirondacks
High Peaks Region, The Adirondacks Central Mountains*

**This is a moderate climb with unusually dramatic and sweep-
ing scenery of the High Peaks and the surrounding region.**

Directions

From Newcomb, go west on NY 28N for 1.5 miles past the Adirondack
Visitor Interpretive Center and turn left into the trailhead parking area,
which is marked with a white trailhead sign.

From Long Lake, go east on NY 28N for 11.6 miles, bearing right into the
trailhead parking area. *GPS coordinates:* 43° 58.192' N, 74° 12.882' W.

Trip Description

Goodnow Mountain lies just south of the High Peaks wilderness boundary
in the town of Newcomb. At 2,690 feet, Goodnow is not an especially large
mountain, and coupled with the moderate vertical rise required to reach its
summit, it is considered by most experienced hikers to be an "easy" peak.
But while the literature concerning Goodnow accurately calls the mountain
a "true gem" and a "rare find," it never fails to point out that Goodnow is
an easy climb only in relation to the vast scenic payoff you'll enjoy from
its summit. Realistically, this is a fairly demanding hike, and shouldn't be
mistaken for a cakewalk. Wear sturdy shoes and prepare for some aerobic
exercise. While many consider Goodnow the peak that provides the best view
in the Adirondacks for the least amount of effort expended, such statements
are purely subjective and depend on many variables. Regardless of the effort,
the views are unimaginably vast and engrossing. Once a state-of-the-art
interpretive trail that was seeded with grant money, the trail now offers

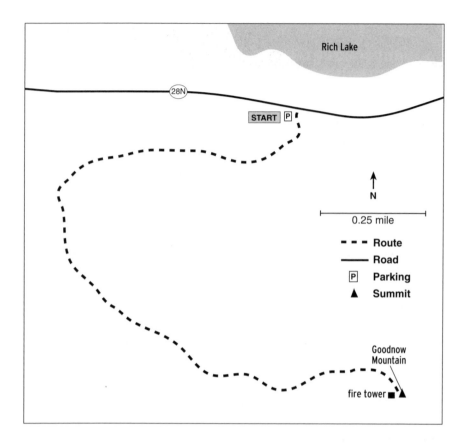

aging interpretive stations and its supporting brochure is no longer available and may be discontinued. Considerable work has been done to install and maintain the trail's water bars, boardwalks, puncheons, and signage.

Sign the trail register and climb a small set of wooden stairs, following the red trail markers with black arrows into the woods. The trail rises easily and then flattens out as it walks along the northwest face of a gentle slope. The forest type is generally northern hardwood, interspersed with isolated young hemlock stands. You will see some very large specimens of yellow birch and sugar maple. The trail crosses a stream and curves into the south, soon climbing moderately. This section of trail follows the old carriage road that Archer Huntington (see below) used to reach his cabin below Goodnow's summit. The trail turns east and ascends more steeply. At 1.6 miles, the foundation of a former state police radio repeater is on the right side of the trail. You will soon pass an open ledge, and the first views to the right.

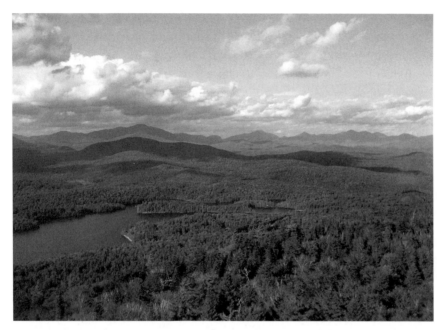

Goodnow Mountain's fire tower offers remarkable views of the High Peaks wilderness.

The ascent eases up as you pass the old barn, near a spring where Huntington kept his horses. A 150-foot boardwalk follows. As you continue, the forest type makes a slow transition from beech and witch-hobble to spruce-fir. A view toward Vanderwhacker Mountain appears on the right. The trail rises sharply now, the footway becoming a combination of roots and bedrock. Isolated stands of white birch appear. Step up on a low ledge and you've gained the summit, where the fire tower stands in the midst of a small clearing. The 60-foot tower was erected in 1922, staffed until 1970, and was restored in the 1990s. The cab is open and accessible, though unstaffed. The adjacent cabin, appointed with some original equipment and gear, remains as one of the best examples of the rugged simplicity the early tower observers experienced during their prolonged stays on the mountain.

The view from Goodnow's fire tower is extraordinary and complex. A topographic map is in place on the table, which will provide only limited help with peak identification. Your binoculars will prove indispensable, since the best orientation can be established by means of identifying individual fire towers (at one time, nine towers were visible from this spot). You can spot a small piece of Blue Mountain with its fire tower over the top of

Goodnow Pond, as well as Wakely Mountain's fire tower. To the southeast, Vanderwhacker is unmistakable, easily identified by its fire tower. By far the most interesting views are to the northeast, toward the High Peaks. You see Indian Pass and Wallface to the far left of the array of the eastern High Peaks. Caribou Pass is to the left of Algonquin, then Avalanche Pass, Colden, Mount Marcy, Skylight, and Haystack. The Sawteeth and several peaks in the Great Range follow, with Gothics prominent among them. Giant is far off though identifiable, as are Colvin, Nippletop, and Dix. Snowy Mountain (also with a fire tower) is seen to the south.

Mount Adams can be found below looming Algonquin Peak. With patience (and binoculars) you can identify it by its fire tower. Farther west are Santanoni and then Couchsacraga, with the Sewards in the north. Kempshall Mountain is in the west, on the eastern shore of Long Lake. Innumerable ponds and streams (including Goodnow Flow and the Fishing Brook Range in the Blue Mountain Wild Forest to the south) can be seen in the near foreground.

Goodnow Mountain's 15,000 acres constitute the Huntington Wildlife Forest, donated in 1932 to the State University of New York's College of Environmental Science and Forestry (SUNY-ESF) by Archer and Anna Huntington. Archer Huntington was the only heir to the founder of the Southern Pacific Railway, and his mother, Anna Hyatt Huntington, was a world-renowned sculptor. The Huntingtons were avid conservationists who donated these lands for the purpose of research into management and propagation of wildlife. In 1932, ESF initiated the first biological survey plots on the property, and in 1971 established the Adirondack Ecological Center, dedicated to developing a greater understanding of the Adirondack ecosystem through the monitoring of long-term ecological patterns.

After enjoying the view from atop the fire tower, return the way you came.

Acid Rain

Acid deposition, more commonly known by its ominous synonym, acid rain, is the top source of air pollution in the Adirondacks. The Adirondack Council refers candidly to the acidification of the Adirondacks (and elsewhere) as a "continuing national tragedy." Even a superficial inquiry into this insidious form of pollution will support the statement, for it is not simply the lakes and ponds of the Adirondacks that are being slowly killed off—it is the forest, as well.

In the United States, the major pollutants in acid rain—sulfuric and nitric acids and mercury—are the by-products of coal-fired electric generating plants located in the highly industrialized midwestern states of Ohio, Illinois, Pennsylvania, and Indiana. Regional weather patterns sweep these airborne pollutants across the Adirondacks, where they condense and fall as rain that contains 200 times the acid levels of natural rainfall. The acid is stored in snow and released in spring, causing sudden high concentrations of chemical pollutants, or "acid shock."

Acid rain decreases and ultimately ends the biological productivity of lakes and ponds; surveys have shown that 700 of the Adirondacks' nearly 3,000 bodies of water (most of them at higher elevations) no longer support indigenous plants or aquatic life. This means fewer breeding and feeding habitats for loons and other migratory and indigenous waterfowl, and it has resulted in the eradication of the native brook trout. Of course, acid rain is an issue elsewhere, but the anorthosite bedrock of the Adirondacks has few alkaline minerals and accordingly less buffering capacity than lime-bearing sedimentary geology.

Acid rain depletes the soil of minerals and damages the root systems of trees, most notably the red spruce, large kill zones of which have been identified in the fragile High Peaks eco-region. Trees weakened by acid deposition are more susceptible to drought, extreme cold, and insect and disease infestation. Excess nitrogen attracts the hemlock woolly adelgid, an insect that can kill mature hemlocks in just a few years. Sugar maples, already weakened by a warming climate, are further threatened by the leeching of calcium and magnesium in the soil.

The Adirondack Lakes Survey Corporation, which monitors acid rain and its effects, supports the EPA's estimates that without more stringent controls on air pollution, 43 percent of the Adirondack's lakes and ponds will reach a critical point by the year 2040. As luck would have it, the only species that appears to thrive in an acidic environment is the persistent blackfly (see page 206).

TRIP 41
BALD MOUNTAIN

Rating: Easy
Distance: 2.0 miles
Elevation Gain: 440 feet
Estimated Time: 2.0 hours
Maps: USGS Big Moose 7.5; National Geographic Adirondack Park: *Old Forge/Oswegatchie*; Adirondack Maps, Inc.: *The Adirondacks West-Central Wilderness*

This easy and scenic hike climbs to a fire tower overlooking the Fulton Chain of Lakes.

Directions

From the Old Forge Tourist Information Office, drive north on NY 28 for 4.5 miles, turning left onto Rondaxe Road where an NYS DEC sign marks the turn. Go another 0.2 mile to the parking area on the left.

From Eagle Bay, drive south from the junction of Big Moose Road and NY 28 for 4.5 miles. Turn right onto Rondaxe Road and go 0.2 mile to the parking area (room for 40 cars). Arrive early, as the lot fills quickly. *GPS coordinates:* 43° 44.742' N, 74° 53.973' W.

Trip Description

Bald Mountain (a.k.a. Rondaxe, 2,350 feet) is among those rare hikes on which the scenic payoff far outweighs the effort required to attain it. This is true, although it wouldn't quite be the case without the fire tower, for the summit is open only to the southeast through southwest at ground level. What makes this trail so attractive is that it's short, very pretty, and provides the second-quickest trip to a fire tower of any trail in the Adirondacks (Trip 13, Mount Arab, offers the quickest) Thus, it's a forgiving as well as inspiring first hiking experience for children and (it is hoped) conservationists of the future. What you can't reasonably expect to get here is solitude—Bald's summit is an immensely popular destination with young families and their dogs. Plan this hike for a warm, sunny day when you can linger on the grassy summit, and what you will get is an unforgettable tramping experience that you will want to undertake again and again as your children grow up.

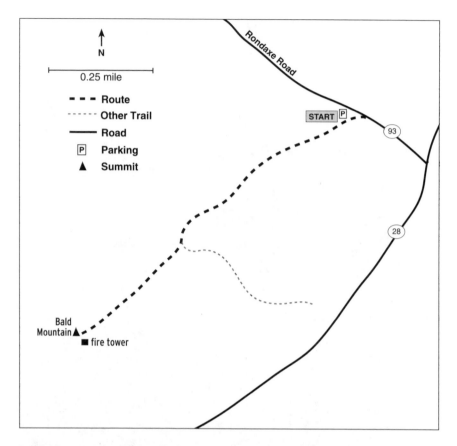

Bald Mountain is also called Rondaxe in order to differentiate it from another Bald Mountain lying 23 miles away in Lewis County. The Rondaxe reference arbitrarily derived from Rondaxe Lake, which sits just to the north. The distinction was made to avoid confusion in identifying forest fires, so the term Rondaxe is most often heard in regard to the tower rather than the mountain itself.

Another amenity the little mountain enjoys is the easily accessed trailhead between Old Forge and Inlet. The trail leaves from the northwest corner of the parking area, where you'll find the trail register. Follow the old truck trail on red markers through a youngish hardwood forest. The trail is mildly rocky and rooty. At first it ascends gently. After 15 minutes or so, the trail walks over a bedrock surface and soon levels out. From the left of the trail, views appear over Fourth Lake. Three such viewpoints are on the climb, positioned over the glacially scoured ledges of the escarpment. Tilted bedrock slabs with very thin footways follow, and these spiny ridges

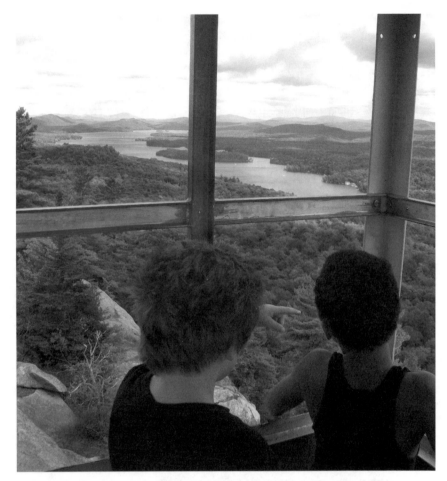

Bald Mountain's fire tower is a popular destination for families with young children.

can be extremely slippery when wet or icy. Herd trails that dodge into the woods have developed here, created by hikers to avoid the narrow slabs.

Before you realize it, you're on the sharp spine of the summit ridge. Beware of the steep, dangerous drop in front of the fire tower. The vantage looks across the Fulton Chain Wild Forest. The most prominent landmark is Fourth Lake, largest of the Fulton Chain of Lakes. The lakes form the headwaters of the middle branch of the Moose River. The state's first designated canoe route was in this area. For the better part of the twentieth century, the 16-mile-long chain was the classic Adirondack canoe trip, which included two carries to Sixth and Eighth lakes, where a state campground

is located. From there, the adventurous paddler can today continue into Brown's Tract to Raquette Lake and the Raquette River. The route has been rediscovered and promoted as a far-reaching system of revived hunter/trapper/guide routes, stretching into Tupper Lake or through the Saranacs or the St. Regis Ponds, crossing watersheds again at Paul Smiths to reach as far north as Lake Kushaqua. First Lake in Old Forge is the trailhead of the Northern Forest Canoe Trail, which follows the ancient route of the Mohawk and the Wabanaki for 740 miles across the Adirondacks, Lake Champlain, Vermont, New Hampshire, and Maine. In Maine, it follows the Allagash River to its terminus of Fort Kent on the St. John River.

Bald Mountain's fire tower is part of the Adirondack Mountain Club's (ADK) Fire Tower Challenge. To complete the challenge and get an official full-color patch, hikers must document ascents of at least 23 fire tower summits—eighteen in the Adirondacks and five in the Catskills.

The first tower on Bald Mountain, built in 1912, was made of wood. It was replaced in 1917 by a 35-foot steel Aeromotor LS-40 tower, which closed in 1990. In 2002, ADK's Genesee Valley Chapter organized a volunteer committee to save the tower. In cooperation with the Department of Environmental Conservation through the Adopt-a-Natural-Resource program, the Friends of Bald Mountain formed and began the restoration of the tower. It is notable as the last operating fire tower in New York State, and is on the National Historic Lookout Register and the National Register of Historic Places.

The state's first female observer, Harriet Rega, staffed the Bald Mountain fire tower. She served on Mount Electra in the former Nehasane Park from 1924 to 1930, and on Bald Mountain from 1933 to 1936.

In addition to views over the Fulton Chain of Lakes, Blue Mountain and the Sewards are also visible from the tower. Mount Marcy can be seen 56 miles away, to the left of which is Mount Colden. Also, Bottle, West, Couchsacraga, Santanoni, Vanderwhacker, Wakely, Lewey, West Canada, Ice Cave, and Woodhull mountains can be seen. Far more wait to be identified, which you must do with only your map and binoculars, since no alidade is in place and your compass won't work in or even close to the tower.

TRIP 42
WAKELY MOUNTAIN

Rating: Strenuous

Distance: 6.2 miles

Elevation Gain: 1,650 feet

Estimated Time: 5.0 hours

Maps: USGS Wakely Mountain 7.5; USGS Snowy Mountain 7.5;
National Geographic Adirondack Park: *Northville/Raquette Lake*;
Adirondack Maps, Inc.: *The Adirondacks West-Central Wilderness,
The Adirondacks Central Mountains*

A steep climb to the highest fire tower in the Adirondacks offers views over the Moose River Plains and Cedar River Flow.

Directions

From Indian Lake, travel north on NY 28/NY 30 for 2.0 miles, and bear left onto Cedar River Road (CR 12). The road turns to dirt after 8.0 miles from NY 30. Find the Wakely Mountain trailhead on the right at 11.7 miles.

From Inlet, go east on NY 28 for 1.2 miles and turn right onto Limekiln Road. Go 1.8 miles to the Moose River Plains Limekiln entrance and bear left. Sign in at the register. At 4.6 miles from the entrance, turn left at the T intersection as you enter the camping area. At 8.4 miles, turn left. At 21.5 miles, sign out at the gate as you arrive at the Cedar River boat launch and camping area. Continue straight for another 0.3 mile to the Wakely Mountain trailhead parking area on the left (room for five or six cars). *GPS coordinates:* 43° 43.868' N, 74° 28.380' W.

Trip Description

The trip to the trailhead of Wakely Mountain (3,744 feet) and the view from its fire tower will familiarize you with the wild Moose River Plains recreation area, with its many free campsites and ponds, and the popular Cedar River Flow canoe area. This is a remote wild forest with rough roads, yet it is easily accessible from two entry points: Indian Lake in the north and Inlet to the south. Anyone entering the Plains is required to register at one of the two entry gates. Registering helps to ensure your safety, and helps to justify expenditures that will keep this area open in the future.

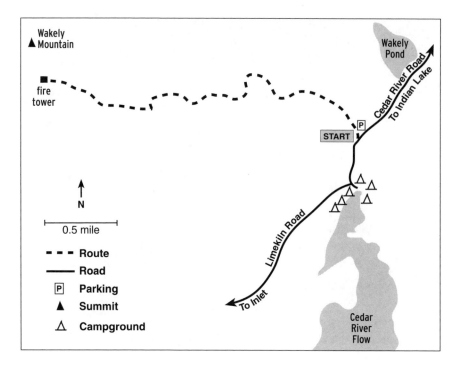

The road conditions between Inlet and the Wakely Mountain trailhead are generally poor; if this concerns you, come in from Indian Lake on Cedar River Road. More adventurous motorists, equipped with four-wheel-drive vehicles and interested in exploring the interior plains, come north from the Limekiln entrance in Inlet. The roads are passable, but can be extremely rocky, rutted, and potholed. The state may close the road at any time for any reason. The Wakely Mountain trailhead lies 0.3 mile outside the northern gate. If you're planning on traveling through either gate, be advised that after October 1, all two-wheel-drive vehicles must carry tire chains that fit the vehicle. No motorcycles, motorized bicycles, or all-terrain vehicles are allowed. Snowmobiles are permitted. Bicycles and pedestrians are permitted at any time of year. Excellent free camping exists close to the trailhead at the Wakely Dam camping area. You can park your car there or drive 0.3 mile to the trailhead parking area.

From the parking area and trail register, the trail heads west into the woods over a rough dirt road. Marking (red foot trail disks) is inconsistent, but the road is self-guiding and kept clear of obstacles. This area was heavily logged 50 years ago, and though the forest is recovering, some skid trails and open decking areas (places where logs were piled for shipping) remain.

Members of the Student Conservation Association take a break from working to refurbish the Wakely Mountain fire tower.

At 0.7 mile, a wetland is seen through the woods to the right. At 1.0 mile, a pair of boulders blocks the road before a stream crossing. The trail ascends easily alongside a creek, through a forest of thin maple, beech, and birch. At 1.8 miles, a signed junction is reached, where an unmarked trail to the left goes along the edge of a nameless pond. Bear right here. The trail ascends steeply from this point on. The forest type becomes more coniferous as the trail rises over low rock ledges and exposed roots. There are a few switchbacks—most of the time you are heading nearly directly up the fall line of the mountain. Although in the leafless seasons you may get glimpses of the fire tower from lower elevations, the tower is well hidden in the upper elevations until you arrive at the summit. Note the helipad to the right of the trail just before the tower is reached.

At 92 feet high, the Wakely fire tower is the tallest in the Adirondacks. Those who have difficulty with heights will appreciate the fact that it is not necessary to climb as far as the tower's cab in order to enjoy 360-degree

views. The tower's steps, landings, and guard wire were repaired in 2011 by members of the Student Conservation Association (SCA). The SCA, an AmeriCorps organization that works throughout the Adirondacks on various conservation and maintenance projects, also refurbished the observer's cabin, which stands next to the tower.

A broad swath of Adirondack country is seen from the tower. The first easily identified landmark is Blue Mountain, which rises to the north beyond the helipad. Moving to the right, far to the north in the haze are Whiteface Mountain, and then the nearer MacIntyre Range. Algonquin (58 degrees, 38.6 miles distant), Colden, and Marcy (63 degrees, 39.3 miles distant) are the three major peaks appearing to be equidistant from one another. Gothics is easily identified, as is Giant beyond it. Snowy Mountain with its fire tower lies nearly due east, and moving right, Lewey, Cellar, and Blue Ridge are followed by Pillsbury Mountain, which rises to the south.

Fourth Lake appears in the west, with Raquette Lake to the northwest. Owl's Head Mountain is identifiable by its fire tower to the north. Little Cellar Pond is the closest body of water south of Wakely's summit. The elongated body of water directly to the east is Cedar River Flow.

Descend the mountain the way you came, and if you've come in from the north, go the additional 0.3 mile down to Wakely Dam for a look at the campsite and the view across the flow of Lewey Mountain. Even better, plan a weekend of trout fishing and camping in the Moose River recreation area, which has many primitive campsites.

TRIP 43
CASTLE ROCK

Rating: Easy

Distance: 2.0 miles (with option to add 1.0-mile loop)

Elevation Gain: 530 feet

Estimated Time: 1.5 hours

Maps: USGS Blue Mountain 7.5; USGS Deerland 7.5; National
Geographic Adirondack Park: *Northville/Raquette Lake*;
Adirondack Maps, Inc.: *The Adirondacks Central Mountains*

**Castle Rock offers the most scenic family-friendly hike in the
southwestern Adirondacks, with views over Blue Mountain
Lake and the Blue Ridge wilderness.**

Directions

From the intersection of NY 28 and NY 30 in Blue Mountain Lake, go north
on NY 30 (toward the Adirondack Museum) for 0.5 mile and take a left onto
Maple Lodge Road. Go 1.2 miles to the end of the road at the location of the
Minnowbrook Conference Center. Two separate lots accommodate ten to
fifteen vehicles. *GPS coordinates:* 43° 52.360′ N, 74° 27.082′ W.

Trip Description

Castle Rock (2,430 feet) is a partially bald, low-elevation hill rising between
Blue Mountain Lake and Little Blue and Peaked mountains, Castle Rock's
taller neighbors to the west. It has been a popular hiking destination from
the late 1800s, when the Prospect House on Prospect Point was the newest
and fanciest hotel in the East. Guests had only a 0.6-mile climb and 600
feet in elevation to reach Castle Rock's ledges from the lake. With the
disappearance of the gilded-age hotels at the onset of the twentieth century,
this trail, like many others, fell into obscurity. Even today it is not widely
known outside the immediate area. Overshadowed by Blue Mountain, which
gets most of the attention from the visiting hiking community, Castle Rock
seems destined to retain its quiet reputation in a little-used section of the
Sargent Ponds Wild Forest.

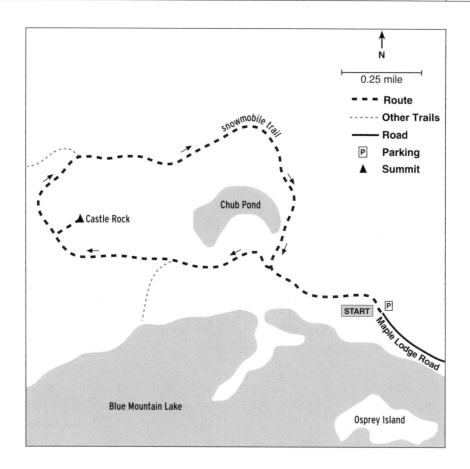

The trail begins beyond the main entrance of the private Minnowbrook Conference Center, where the map and register are located. Continue on foot along the road, following red trail markers. Follow the trail to the right as it leaves the road and enters the woods. Turn left at the first junction. (The trail to the right, which at this point is a part of the snowmobile trail to the Sargent Ponds Wild Forest, completes a loop if you should choose to return on it.) The forest consists of beech, birch, and maple, the most familiar northern hardwoods.

At a junction, avoid the trail to the boat-accessible trailhead on Blue Mountain Lake, which goes downhill to the left. Bear right here. The trail ascends at a moderate pitch, making a long switchback at a point where it levels out. It switches back again at the base of Castle Rock, where the ledge

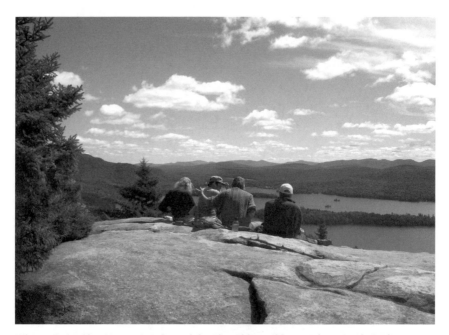

Hikers admire Blue Mountain Lake and the Blue Ridge wilderness from Castle Rock.

has fractured and huge talus blocks have created an intricate system of crevices and caverns. This system of natural buttresses, parapets, and rampartlike rock formations probably provided the inspiration for Castle Rock's romanticized place-name. Many people have explored this cavernous matrix of stone, evidenced by the surrounding herd trails.

At a junction, the yellow trail branches off to the left, which is the loop trail back to the snowmobile route that passes Chub Pond. (For those who would like a slightly longer hike than the up-and-back trip to Castle Rock, more distance can be added by closing the loop around lonely and attractive Chub Pond, adding 1.0 mile to the outing.) Go right and continue adjacent to the ledges on the right as you climb toward Castle Rock. The trail is eroded and not well marked as it approaches the top. The little shelf facing east provides a dramatic view of the lake below. (Use caution with children. Several dangerous vertical ledges are in this area.) You are poised immediately above Blue Mountain Lake, with views of Lake Durant, Blue Mountain, and the Blue Ridge Wilderness Area, including Buck and Squirrel Top mountains. Pieces of Raquette Lake are seen to the southwest. From the other side of the ridge you can see Owl's Head to the north. This is as fine a place as any to

spend an hour or an afternoon—come with your lunch and a book.

Return to the previous junction. Hike back out the way you came in if you're not doing the loop. To hike the loop, bear right, going downhill and around the north side of Castle Rock. Cross a stream and head east to join the Sargent Ponds snowmobile trail. At a junction, turn right, and follow downhill easily. The trail curves around into the south over flat terrain where hardwoods tunnel over the trail. Walk along the eastern edge of scenic Chub Pond, over which you can see Castle Rock. Trail signage is consistent. Continue to the first junction, bearing left. Turn left as you reach the road and return to the trailhead parking area.

Don't leave Blue Mountain Lake without visiting the Adirondack Museum, which *The New York Times* has called "the best of its kind in the world." The Castle Rock trailhead is only 1.5 miles from the museum. Although the Prospect House is long gone, Miles Tyler Merwin's famous Blue Mountain House log hotel (which he built as an extension of his home) still exists and can be seen on the museum grounds. A museum visit will give you an idea of what it was like to live in the Adirondacks in a time when the lakes and streams were the only highways, and the transportation was by stage, train, and steamboat.

TRIP 44
CARTER STATION

Rating: Easy
Distance: 14.0 miles (with 6.0 miles by train)
Estimated Time: 3.0 hours
Maps: USGS Old Forge 7.5; National Geographic Adirondack Park:
Old Forge/Oswegatchie; Northwoods Sno-Travelers Club:
Sno-Mobile Map of Old Forge and the Adirondacks; Adirondack
Maps, Inc.: *The Adirondacks West-Central Wilderness*

This is the ultimate family bike trip, beginning with a train ride through the woods to Carter Station and followed by a dirt- and paved-road trip through the villages of Old Forge and Thendara on the TOBIE Trail.

Directions

To reach Thendara Station from Old Forge, travel south on NY 28 for 1.0 mile, cross the Moose River, and bear left onto Forge Street. Continue two blocks.

From the New York State Thruway (I-90), take Exit 30 at Herkimer or Exit 31 at Utica. Take NY 28 north to Thendara. The station is on the right side of NY 28 as you enter the village. *GPS coordinates:* 43° 41.929' N, 75° 00.321' W.

Trip Description

One of the major attractions for mountain bikers visiting the Old Forge region is the Adirondack Scenic Railroad, which runs between Utica and Thendara. The train carries not only passengers, but also canoes and bicycles. The Adirondack Railway Preservation Society operates 70 miles of restored track in the Adirondacks. Its goal is to reestablish service on the tracks between Carter Station and Saranac Lake, and then to Lake Placid.

For additional information about the Town of Webb trail system and the TOBIE Trail, see Trip 46. If you wish to leave the described route to explore more of these exciting trails, the Northwoods Sno-Travelers map is essential for accurate wayfinding.

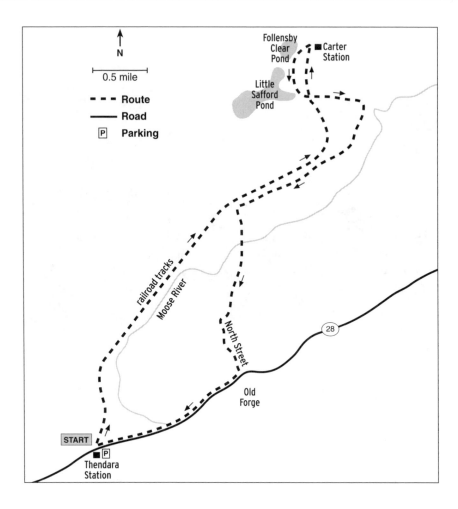

Children will love this slow-paced trip along the north branch of the Moose River—no homes or other structures can be seen after the train enters the Town of Webb lands east of the Ha-De-Ron-Dah Wilderness Area. The train from Thendara to Carter Station leaves at 10 A.M., and you must arrive at least fifteen minutes early to get tickets and load your bikes into the freight car. Half fares are provided for those who are riding their bikes back to the station. The trip to Carter Station takes about 45 minutes on this full-scale, diesel-powered passenger train. Interpretive information on the history and development of railroading in the Adirondacks plays on the coach's sound system.

Upon your arrival at the former site of Carter Station, your bikes will be

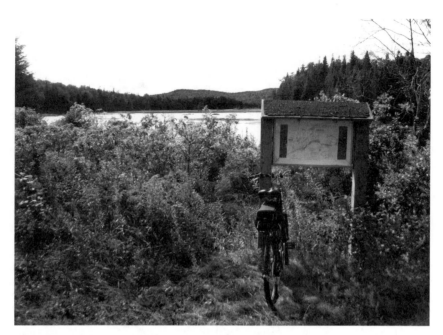

The bike-friendly trails of Old Forge are scenic and well marked.

handed down to you from the freight car. Within a few minutes the train will depart, backing its way to Thendara, and you will be left alone. Cycle back across the tracks, following Trail 9 as it heads southwest away from the station. Soon you will pass Follensby Clear Pond on the right. You will see Town of Webb postings here and there, which are meant to deter trespassing with automobiles. The trails are well groomed and easily managed by hybrids as well as mountain bikes.

Go 0.4 mile to an intersection, posted as Junction 24, and turn left toward Trail 8. (Junctions and trails are numbered on the Sno-Travelers map as well as in the field.) Cross the outlet of Little Safford Pond, continue a short distance to Junction 23, and turn left onto Trail 8. Climb an easy hill (the only uphill section of the entire trip), level out, and descend to Junction 22. Turn right, joining the TOBIE Trail (Trail 3), which you will follow all the way back to Thendara. You've ridden 1.5 miles to this point. Look for the yellow letters on a brown background that mark the TOBIE Trail.

The main numbered routes of the trail system are clear, graded, and drivable, even by two-wheeled vehicles. You will pass several marked loops

and some unmarked trails as you travel along Trail 3. These loops are not in the same good condition as Trail 3, but therein lies their attraction for some riders. The loops are often rutted, muddy, and sometimes obstructed by blowdowns. As you draw near to the railroad tracks, the Wheeler Pond loop is on the left. Soon you will arrive at Junction 3. The tracks can be seen to the right. Arrows here point straight across the four-way intersection of Junction 3 toward Thendara—but only experienced cyclists should choose to ride that trail. Young children will quickly become frustrated with the rocky ascent and deteriorating road surfaces. Instead, turn left here, heading for Old Forge. This is Trail 1. It will bring you downhill and across the Moose River, where you will likely see kayakers pulling their boats out of the stream. A large trailhead parking area follows. This is the parking area at the terminus of North Street. Those who prefer to use the Town of Webb trails without riding the train should enter the trail system here (3.7 miles from the start).

Ride along paved North Street, leaving the airport and the town recreation center to your right. Cross NY 28 in Old Forge at 5.7 miles. Follow the TOBIE Trail signs across NY 28, and ride across the covered bridge over the spillway of the middle branch of the Moose River. Note that this is the southern trailhead of Northern Forest Canoe Trail, the 740-mile water route that ends in Fort Kent, Maine. A kiosk describes the traditional Adirondack canoe routes, including the Fulton Chain of Lakes route, which also begins here. Follow the TOBIE Trail as it goes along the edge of First Lake and crosses South Shore Road, heading south through a quiet neighborhood. The TOBIE Trail takes you through the residential streets of Old Forge, then turns right to join NY 28. Turn left and follow the trail all the way back to Thendara Station and your starting point.

TRIP 45
BLACK FLY CHALLENGE

Rating: Strenuous

Distance: 40.0 miles, one way

Elevation Gain: 1,700 feet

Estimated Time: 4.0 to 6.0 hours

Maps: USGS Big Moose 7.5; USGS Limekiln Lake 7.5; USGS Mount Tom 7.5; USGS Wakely Mountain 7.5; USGS Snowy Mountain 7.5; USGS Blue Mountain Lake 7.5; USGS Rock Lake 7.5; National Geographic Adirondack Park: *Old Forge/Oswegatchie*; *Northville/ Raquette Lake*; Adirondack Maps, Inc.: *The Adirondacks West-Central Wilderness*; *Central Mountains*

Following the route of the longest National Off-Road Bicycle Association–sanctioned mountain-bike race in the Northeast, this tour takes riders through the scenic backcountry of the Moose River Plains.

Directions

From Raquette Lake, take NY 28 for 11.0 miles south to the village of Inlet. From Old Forge, take NY 28 for 11.0 miles north to Inlet. Begin at Arrowhead Park, where parking for 50 cars is available. *GPS coordinates:* 43° 45.111' N, 74° 47.698' W.

To spot a car in Indian Lake, drive east from Blue Mountain Lake for 11.0 miles on NY 28/NY 30 to the center of Indian Lake village. Park in the large municipal lot just west of the intersection on NY 28 where NY 28 and NY 30 come together. *GPS coordinates:* 43° 46.968' N, 74° 15.931' W.

Trip Description

The Black Fly Challenge is a 40-mile mountain-bike race, held every year on the second Saturday in June. The race is run between the villages of Inlet and Indian Lake, through the rugged territory of the Moose River Plains. Although the winning times for this grueling event are around two hours, the rest of the pack generally takes up to four hours. This colorful event attracts many competitive cyclists.

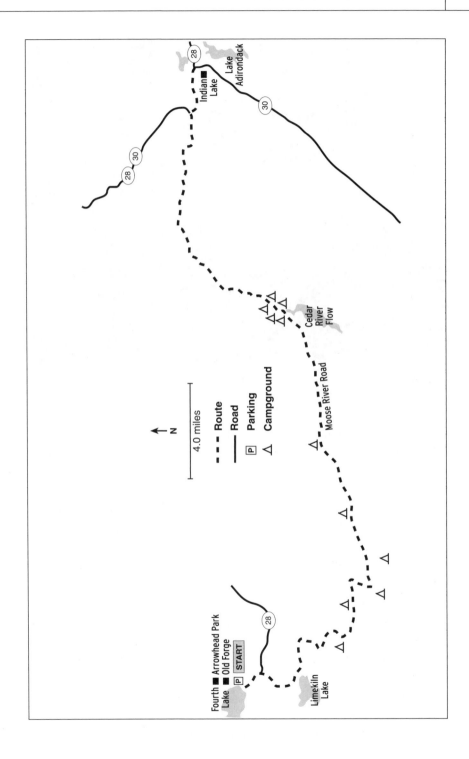

N

4.0 miles

- - Route
— Road
P Parking
△ Campground

Indian Lake

28

Lake Adirondack

30

30

28

Cedar River Flow

Moose River Road

Fourth Lake

Arrowhead Park

Old Forge

P START

28

Limekiln Lake

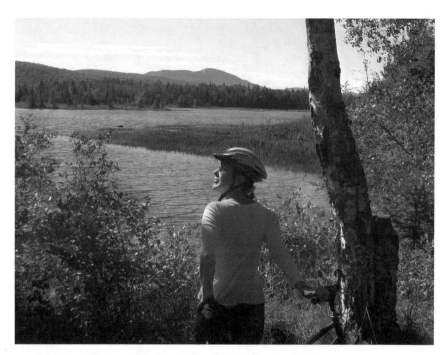

A cyclist enjoys the view from the camping area at Cedar River Flow.

Of course, you don't have to enter the Black Fly Challenge to experience the vastness and solitude of the Plains. The route is, in fact, one of the best recreational, off-road bike tours in the Northeast, suitable for riders of every ability level. Perhaps you want to shake down your gear for a longer ride; try out a new mountain, hybrid, or cross bike; or stage a weekend bikepacking getaway in an area with fewer cars and fewer people than anywhere else you can ride a bike this far in the Adirondacks. Finally, you can pick a better time than mid-June—which on some years coincides with the height of blackfly season in the Adirondacks (see page 206)—to enjoy this beautiful ride at a pace that doesn't have to be fast enough to outrun the flies.

The Black Fly Challenge route introduces the intrepid cyclist to the Plains area via Moose River Road, the main road through the Moose River Recreation Area. Other, even more remote roads stem from it, heading south and dead-ending on the border of the West Canada Wilderness Area. Major intersections are few and well marked. Ponds and hiking trails are signed. The 160 campsites are numbered and each site has a privy, picnic table, and fire ring. It will soon become apparent to you that within the core of this

50,000-acre wild forest, a lifetime of adventure possibilities exists.

The best way to stage a tour in the area is to ride with a friend, placing one vehicle in Inlet and the other in Indian Lake. Otherwise, the lone rider will be faced with doing a round-trip of 80 miles, or selecting a shorter tour from within the Plains. This is easily accomplished by camping at the Limekiln Lake public campground in Inlet and accessing the Plains from the Limekiln gate, or by cycling or driving into the Plains through the Limekiln gate and selecting a primitive campsite from which a tour can be staged.

The official race course begins and ends (on alternating years) in Inlet's Fern Park, but loaded touring cyclists who want to avoid this section of single-track can ride the road. To undertake the tour from Inlet to Indian Lake, begin at Arrowhead Park in Inlet. Turn right out of the park onto NY 28. At 0.8 mile, turn right onto Limekiln Road (CR 14) and follow it to a point just past the Limekiln state campground entrance at 2.7 miles. Go left and stop at the gate to sign the trail register. This is a rough dirt road that cyclists will love. Traffic is extremely light, though present, and the speed limit is 15 MPH. The road is slightly hilly as it winds through a hardwood forest. At 7.5 miles, turn left at a major, marked intersection where you enter Camping Area 1 and cross the Red River. At 11.2 miles, bear left and enter the ancient floodplain of the Moose River's south branch, where several small streams converge. In 2.0 miles you will leave the flat Plains, and the road becomes hilly again. You will pass many trailheads and campsites before you arrive at Wakely Gate and the Cedar River flow camping area at 25 miles. This is the best place to camp and the last camping area in the Plains.

In the late 1800s, this area was the site of a hotel and sawmill owned and operated by William D. Wakeley (transcribed on maps to Wakely), who built the original dam to aid in floating logs down the Cedar River. Wolves were so rampant in the area that bonfires were sometimes necessary to keep them away from the teams of oxen.

Sign out at the trail register (the two state cabins here are no longer staffed). Take a ride across Wakely Dam for a limited view of Cedar River Flow. Return to Moose River Road and head north toward Indian Lake. You'll see the Wakely Mountain trailhead on the left, and soon afterward, you will cross the scenic Wakely Pond Outlet. The road, which has been steadily improving, turns to pavement at 30.0 miles. Residences and hunting camps appear, and here and there you get a view of the Cedar River on your right. At 37.5 miles, turn right onto NY 28, cross the Cedar River, and arrive in Indian Lake at 40.0 miles.

Blackflies

Blackflies, the most notorious of the Adirondacks' biting fly species, are voracious, demoralizing, and persistent. They are born in moving water, which is almost everywhere in the Adirondacks. Relative distance from water, however, does not promise diminished concentrations of flies: They can travel 30 to 50 miles from their hatching areas. Their incisions can take weeks to heal, remaining itchy and painful, or even becoming infected. Of course they have also prevented or curtailed many an Adirondack trip. Indeed, seasoned Adirondack locals plan their outings for either before or after blackfly season. Infestation peaks from mid-May to late June, although blackflies are generally still present throughout the summer. They are most active on humid and cloudy days. Fortunately, they do not appear at night. Populations of all the Adirondack flies diminish substantially by mid-August.

Unlike mosquitoes, which puncture the skin and suck the blood through a tube (the proboscis), blackflies cut the skin and drink the blood off the surface of your flesh. The result is a slashed hole that usually requires time to heal. Repellents are only marginally effective and rarely long-lasting, but there are steps you can take to diminish your discomfort.

While organic repellents work well for some people, N,N-diethyl-meta-toluamide (DEET) is considered the most effective repellent. It comes in various concentrations, but studies have demonstrated that stronger concentrations (100 percent) have the same effect as weaker ones (20 percent). This is a significant detail, since DEET is a suspected carcinogen when applied directly to the skin. Rather than applying it directly to your skin or clothing (it has been known to cause nausea and seizures, and also melts some synthetic materials, such as plastic), apply it to a bandanna, which you can wear around your hat or neck, while also using a less caustic repellent on your skin. Since blackflies will crawl up your pant legs and shirtsleeves, tie them off with elastics. In the thick of blackfly season, wear a head net or bug jacket. You can also spray your clothing with an aerosol repellent. Wear light-colored clothes and avoid the color blue.

In camp, a smoky wood fire (a "smudge") is helpful. It also seems that the popular mosquito coils work on blackflies. Fogging your campsite with a heavy-duty spray may be of some help. A screen tent will provide the only reliable relief during the idle hours spent in camp.

TRIP 46
THE TOBIE TRAIL

Rating: Moderate
Distance: 21.5 miles
Elevation Gain: 1,000 feet
Estimated Time: 4.0 to 5.0 hours
Maps: USGS Big Moose 7.5; National Geographic Adirondack Park:
Old Forge/Oswegatchie; Northwoods Sno-Travelers Club: *Sno-Mobile Map of Old Forge and the Adirondacks*; Adirondack Maps,
Inc.: *The Adirondacks West-Central Wilderness*

This is an easy and scenic dirt-road and rail-trail ride through forest and lake country, with well-marked intersections and little or no shared road traffic.

Directions
See Trip 45 for directions to Arrowhead Park. (If this lot is full, park 1.0 mile south on NY 28 at the Black Bear Mountain/Rocky Mountain trailhead on the right.) *GPS coordinates:* 43° 45.111' N, 74° 47.698' W.

Trip Description
The acronym TOBIE stands for Thendara-Old Forge-Big Moose-Inlet-Eagle Bay and represents the villages that the TOBIE bicycle and pedestrian trail connects. This string of towns and hamlets stretches north from Old Forge to Inlet. The beauty of the TOBIE Trail is that it never follows the shoulder of any state highway or busy secondary roads. Instead it uses woodland trails, old carriage roads, disused town roads, back roads, and a piece of the Adirondack Railway bed. It penetrates the backcountry, crosses the Moose River, and rides past loop after loop of side trails and single-tracks. The result is the largest contiguous designated off-road trail network in Adirondack Park.

Off-road bicyclists are the TOBIE Trail's largest user group. Hybrids and cyclocross riders are right at home on the graded surfaces, and joggers and walkers use the trail for exercise. But the biggest advantage of having a well-managed and maintained trail system with a main trunk trail like the TOBIE is its tremendous appeal to families with young children. Few other trails provide the opportunity to ride as a group in peaceful surroundings without

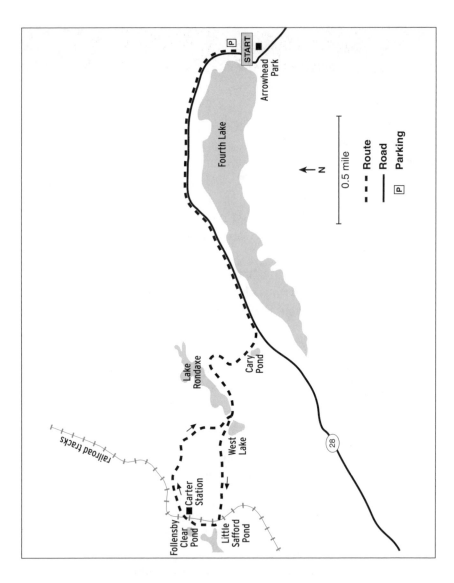

having to worry about vehicular traffic and the kinds of obstacles common to more serious mountain-biking trails. If you're planning a ride with children, you can shorten this trip by beginning anywhere in Eagle Bay, parking next to or across the street from the Big M market at the junction of NY 28 and Big Moose Road. The Sis and Bubb Lakes trailhead (room for five cars) is also a good starting point when traveling with small children.

The best map to the Town of Webb trail system is the Northwoods Sno-Travelers map. Get one at the Inlet tourist information center, the Town of

The TOBIE Trail crosses the rural countryside around the town of Inlet.

Webb offices, or the Old Forge tourist information center. Be forewarned that no other current map is accurate enough for use in the Town of Webb trail system, through which the TOBIE Trail runs. Every major trail and trail junction is numbered both in the field and on the map.

Access the TOBIE trailhead at Inlet's Arrowhead Park. The trail markers are yellow letters on a brown background. Head south (left) out of the park and follow uphill on the left side of the road along the sidewalk. As the trail pulls away from town, it becomes a paved bikeway for the next 2.0 miles into Eagle Bay.

At this point in Eagle Bay, the marked TOBIE Trail is also snowmobile trail number 5 on the Northwoods map. It follows the old railway bed, turns to dirt, and heads south along the north side of NY 28. At 3.5 miles, you will pass the Sis and Bubb Lakes trailhead parking area on the right. The most pleasant and peaceful section of the ride follows. Threading in and out of the woods, the trail draws near to the highway but is never on or near its shoulder. Pass the old Bald Mountain station site, once a stop on the Adirondack Railway.

At 5.7 miles (from Inlet), about midway down Fourth Lake (which is hidden by trees to the south), the trail veers off into the woods and you'll see beautiful Carey Pond on the left. Soon you join South Rondaxe Road (dirt,

vehicles permitted). At 7.7 miles, go right on the dirt road and cross between Lake Rondaxe and West Lake. Join dirt Carter Road. North Rondaxe Road (a.k.a. Rondaxe North Shore Road), forks to the left. Continue 0.4 mile on the TOBIE Trail, watching carefully just ahead as it turns left into the woods. Follow it, and turn right in 500 feet at the end of this short spur. Soon you will come to an open field at Junction 19, where Trail 5 goes left to Old Forge and the TOBIE Trail goes right on Trail 8. Follow the TOBIE Trail across the Moose River on the steel footbridge. Follow uphill to Junction 22. Go straight ahead now, leaving the TOBIE Trail (which goes left on Trail 3). Head uphill on Trail 8, and level out, descend, and cross the railroad tracks at 9.7 miles. Turn right at Junction 23, toward Trail 9. Cross the outlet of scenic Little Safford Pond. This is a good place for a break.

Continue on this flat section and turn right at Junction 24 onto Trail 9. Pass Follensby Clear Pond on your left. The Town of Webb posted signs are not meant to keep you from riding on this short path along the lake's shore, but are in place to enforce legal use. Cross the railroad tracks at 10.3 miles, and you will see a residence at the former site of another bygone Adirondack Railway stop, Carter Station, of which nothing remains but a foundation. Bear left and follow the wide dirt road now, passing another residence. The road from this point is open to vehicular traffic, though few drivers use the road because it leads into the restricted trail system. This area is also open to hunting, in season. Second-growth, logged forests like these no longer contain much high-quality timber, but they do provide a great deal of under-story growth, which attracts wildlife, including deer and bear. Local warming trends have enabled turkeys to proliferate in the Adirondacks. The nearby Moose River provides habitat for waterfowl and birds of prey, which also reside in the area's many small ponds and lakes. Coyotes and bobcats are common here.

Pass Trail 3 on the right. Continue straight ahead now, until at 12.8 miles you will recognize the junction where you joined Carter Road at Rondaxe Lake, and will have joined the TOBIE Trail once again. Retrace the route now, back to your starting point.

TRIP 47
MOOSE RIVER

Rating: Easy

Distance: 11.0 miles

Estimated Time: 4.0 hours

Maps: USGS Big Moose 7.5; USGS Old Forge 7.5; National Geographic Adirondack Park: *Old Forge/Oswegatchie*; Adirondack Maps, Inc.: *The Adirondacks West-Central Wilderness*

This easy and scenic river trip is great for paddlers of all skill levels, with livery service convenient to the put-in and take-out points.

Directions to Put-in

From the tourist information center next to the covered bridge in Old Forge, take NY 28 north for 4.5 miles to Rondaxe Road (CR 93). Turn left and go 2.0 miles on Rondaxe Road to the bridge spanning the Moose River. Rondaxe Road is 4.6 miles south of the junction of NY 28 and Big Moose Road in Eagle Bay. *GPS coordinates (put-in)*: 43° 45.789' N, 74° 55.226' W.

Directions to Take-out

From the tourist information center in Old Forge, drive 1.1 miles south on NY 28, to Mountainman Outdoor Supply Company on the right. *GPS coordinates (take-out)*: 43° 42.198' N, 74° 59.220' W.

Trip Description

The North Branch of the Moose River is an easy trip for paddlers young and old—and of any skill level. The water is shallow and slow. The trip can be undertaken in any sort of canoe or kayak, but because of the river's many narrow twists and turns, a boat that maneuvers easily will be appreciated more than a hard-tracking sea kayak or tripping canoe. A proficient J stroke or a double paddle is recommended. Added to the ease of paddling the Moose are the relatively straightforward logistics involved in getting in and out. Because the put-in and take-out points are both close to NY 28, it is easy enough to design your own trip using a two-car shuttle. But those

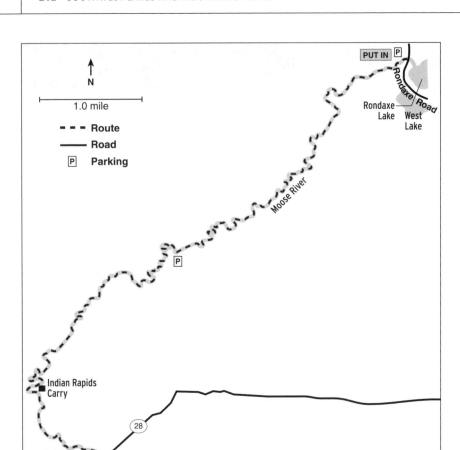

who research the possibilities thoroughly will ultimately conclude that it is far simpler to hire the livery service at Mountainman Outdoor Supply in Old Forge. For a reasonable cost they will take you to the put-in and you can take out at their dock, which is located at the store in Old Forge. (The more paddlers that participate, the cheaper the price becomes per paddler.) You can also rent boats here. Finally, the staff at Mountainman is a group of knowledgeable paddlers who can tell you all you need to know about the Moose River, the most popular paddling trip in the immediate area.

The Moose's extraordinary popularity is indeed an issue you should consider before planning a trip. While the wild character of the river is high, the number of paddlers you will encounter is also high. If it is your goal to enjoy the quiet atmosphere of this solitary river and to see the maximum amount of its wildlife, by all means avoid it on weekends. Not

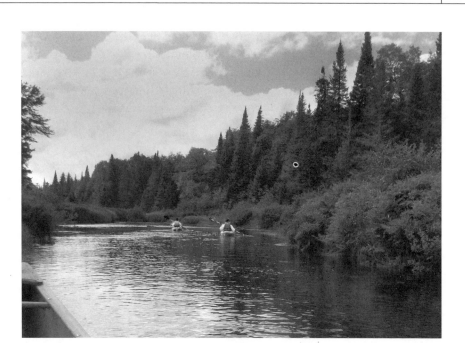

The languid Moose River is ideal for paddlers of any ability level.

even a rainy day will assure your solitude; put in very early in the morning using your own vehicle, after arranging livery service at Mountainman to bring you back upriver. Check with them a day ahead of time for scheduling and availability.

Carry your boat down the short lift and put in just above the bridge at the Lake Rondaxe outlet. The river moves at about 1 MPH. The magic of the experience begins at once, with the quiet river casting its spell as it summons you downstream. Although you will be passing through private lands for most of the distance, and will hear the noises of civilization (mostly to the east), the west-lying Ha-De-Ron-Dah Wilderness Area is an omnipresent reminder that you are in fact on the fringe of a very remote section of Adirondack Park. The water is shallow and your paddle will touch bottom often. There is a discernable channel here and there. You'll pass low sandy bluffs, rocky shorelines, and sometimes a blowdown or two that might reach halfway across the river. Because of the river's intensive use, any blowdowns are normally cut away very quickly.

At 0.8 mile, pass beneath the steel footbridge of the TOBIE Trail, and soon afterward, pass a private lean-to on river left. The river bottom is sand

and grass. Tall spruce trees and white pines stand over the dense forest. To the east you see the low ridges of Sugarloaf Mountain.

One of the challenges with paddling the Moose is the lack of landmarks by which you can gauge your progress. At 4.8 miles, however, you can't miss the bridge at the end of North Street, which you'll have to pass beneath. Paddlers both take out and put in here for up- or downstream excursions. A large parking area is to the left, across the bridge, which provides access to the Town of Webb snowmobile and multi-use trail system. (No services are here.) Old Forge is 2.0 miles east on North Street.

You can place a shuttle car at this parking area if you're outfitting this trip on your own, but you'll miss roughly half the river as it is described. Continue downstream. Some deep holes and sand aprons are here and there. Where the river becomes very convoluted, a paddle with a directional arrow shows the way. Normally the current is strong enough that the weeds will point downriver. While it may be easy to get "turned around," it's hard to get lost here.

At 8.4 miles, you will reach the Indian Rapids Carry. Take out on river left for the short (1,000 feet) portage. It is not wheelable. The wide, wooden bridge is overbuilt to accommodate snowmobile traffic. Put in below the rapids and continue downriver. Soon you pass the golf course on the right. You'll have to pass the Mountainman pull-out area for some distance before reaching the channel to the dock. If you reach the NY 28 bridge, you've gone too far.

The section of the Moose below the bridge is also a popular short paddle. If you've got the time, you can continue downriver to the next bridge, adding another 3.0 miles to your trip. The river is wider and deeper here, but also closer to the road.

TRIP 48
MARION RIVER

Rating: Moderate (depending on weather conditions)

Distance: 12.0 miles

Estimated Time: 6.0 hours

Maps: USGS Blue Mountain Lake 7.5; USGS Sargent Ponds 7.5;
USGS Raquette Lake 7.5; National Geographic Adirondack Park:
Northville/Raquette Lake; Adirondack Maps, Inc.: *The Adirondacks
West-Central Wilderness, The Adirondacks Central Mountains*

**This scenic lake and river paddling adventure in the heart
of Adirondack canoe country offers outstanding camping,
exploring, and sightseeing.**

Directions to Put-in

From the intersection of NY 28, NY 28N, and NY 30 in Blue Mountain Lake,
go south on NY 28 for 0.2 mile. The boat launch and trail register appear on
the right, just north of the town beach. Roadside parking is available on both
sides of NY 28. *GPS coordinates (put-in):* 43° 51.280' N, 74° 26.066' W.

Directions to Take-out

Go south from Blue Mountain Lake for 13.0 miles to the intersection of
NY 28, Sagamore Road, and CR 2 and go right on CR 2 for 0.4 mile to the
Raquette Landing boat launch parking area. *GPS coordinates (take-out):* 43°
48.798' N, 74° 39.386' W.

Trip Description

This historical paddling trip on the Marion River will introduce you to
Blue Mountain, Eagle, Utowana, and Raquette lakes. The trip can easily be
accomplished in one moderate day's outing, but the opportunity for island
camping on both Blue Mountain and Raquette lakes will tempt you to spend
the weekend.

The languid Marion River drains the Eckford Chain of Lakes (Blue Moun-
tain, Eagle, and Utowana), into Raquette Lake's southerly basin. This trip is
described as a thru-paddling adventure, beginning at Blue Mountain Lake
and taking out at Raquette Landing, though since the river has a slow but

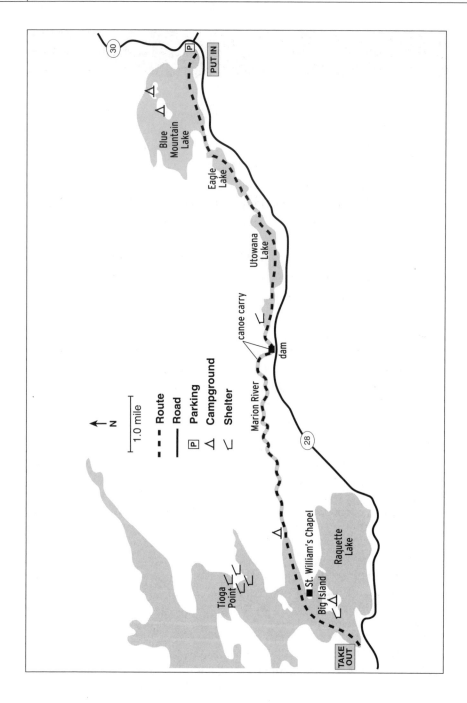

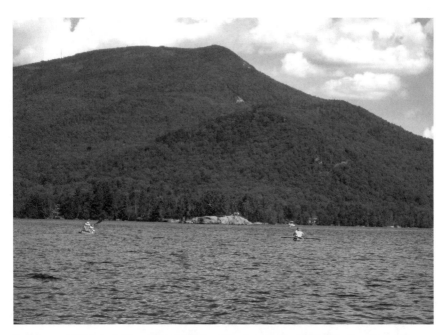

Kayakers paddle across Blue Mountain Lake at the headwaters of the Marion River.

definite current, paddling this trip in both directions is possible should you elect to use only one vehicle. Many paddlers with a single vehicle put in and take out at Blue Mountain Lake. However, high seasonal water levels will affect the speed of the current, and while the trip back upriver would be easy enough at low water levels, it may not be as pleasant at higher ones. Accordingly, using the single-car option, it is better to launch from Raquette Landing, heading upriver first, thereby giving yourself the choice of turning back at the location and pace of your own choosing.

Put in at the public canoe launch on Blue Mountain Lake and head your boat in a southwesterly direction, keeping the south shore to your left. The lake's shore is almost all privately owned, but its appearance is wild and the waters are clean and clear. This large lake may present a challenge in the event of strong north winds that could produce waves. In spite of the serpentine nature of the river itself, this is a popular trip with sea kayakers. On a placid day, you can explore the islands to the north of the lake, where several free, designated campsites are on the larger islands.

The lake narrows as you paddle into Eagle Lake through a short thoroughfare. Pass under the bridge, which was commissioned by William West Durant in honor of his father, Thomas C. Durant, who built the Adirondack Railway to North Creek and who joined the eastern and western United States by transcontinental railroad while serving as president of the Union Pacific.

Eagle Lake is narrow and protected from high winds. Like Utowana, it is not well developed, and has maintained a higher level of wilderness scenery and atmosphere than Blue Mountain Lake. Uphill to the north is the little hill known as Eagle Nest. The shores are thickly forested with a variety of trees, from mature white pines in the overstory and white cedars along the shores, to homogenous stands of northern hardwoods on the slopes.

The paddling is easy and pleasant as you pass into Utowana Lake. The few camps and boathouses you'll see are rustic and attractive. A lean-to is situated on a small intrusion of the Sargent Ponds Wild Forest on the right-hand shore, just before you enter the river. You will experience some road noise from NY 28 at this point, but as you enter the river and pull away into the west, the sounds of nature take over. In a short distance on river right, you will come to the hulking ruin of a steamboat landing at the head of the carry, next to the small dam that maintains Blue Mountain Lake's water level. The 0.5-mile carry is wheelable, as it follows the bed of the former Carry Railroad, which delivered passengers from incoming steamboats to the ones that took them to the Adirondacks' earliest resort hotels on Blue Mountain Lake.

Put in to the shallow at the west end of the carry, and half paddle, half drift along as you share the scene with herons, eagles, ospreys, and kingfishers who inhabit this boggy realm. Deer come out to drink, and it is not out of the question that a moose could appear. Purple pitcher plants and crimson sundews grow thick in the bogs. Little, soft red maples turn the colors of autumn early in the moist soils, while tamaracks, the only deciduous evergreens, turn golden. One low ridge after another enfolds the river between the Blue Ridge wilderness and the Sargent Ponds Wild Forest until finally, after so many twists and turns of the river, you pass a campsite on the right and enter the deep outlet at Raquette Lake between Long and Woods points. Favor the left bank so you can look at St. William's Chapel.

Very few places capture the atmosphere and mood of the Adirondack

lake country like Raquette Lake in the summertime. Poised on the edge of the wilderness, it is a paddler's paradise, with islands and bays leading to faraway places and nearby adventures. It is at the north end of the Fulton Chain, in the beginning miles of the Northern Forest Canoe Trail, and at the head of the Raquette River.

Paddle left (south) around Long Point. (Note that 1.3 miles to the north is Tioga Point state campground, with 15 lean-tos. Fees apply.) As you head south, Big Island, lying ahead, appears to be part of the mainland. You can paddle to either side of it, but going around the eastern shore of the island will take you past the campsites and the lean-to on the point. (Two more lean-tos are on the west side of the point.)

As you paddle away from the southern tip of Big Island, you will see Raquette Landing and the boat launch, 0.6 mile to the southwest.

Flesh-Eating Plants

Some flesh-eating, or carnivorous, plants ingest only insects. But others eat small mammals. Carnivorous plants grow in environments that are generally too nutrient-poor or acidic to provide sufficient minerals for their root systems. While bogs are organically rich environments, their high acid levels impair bacterial nitrification, the process through which plants absorb nitrogen and phosphorus through the soil, which is vital to plant life. Flesh-eating plants have evolved to obtain these elements from the insects they lure into their traplike leaf mechanisms. Some will ingest frogs and small mammals instead: there are two documented cases of a monkey-cup pitcher plant, common to Southeast Asia, devouring a bird.

Flesh-eating plants are generally grouped as either active or passive by the type of leaf traps they've evolved. Snap, pitfall, suction, flypaper, and lobster pot traps are the most common types. The Venus flytrap, a relative of the indigenous sundew, is the prime example of an active snap trap, which closes in a tenth of a second (it may not open again for a week after trapping prey). There are two passive carnivorous plants found in Adirondack bogs that are both prolific and easily identified. Most often encountered is the pitcher plant, a form of pitfall trap that draws insects into a deep, liquid-filled cavity using a combination of pigment and nectar bribes. A foraging insect cannot escape the slippery walls of the leaf and is drowned in a bacterial, rainwater soup, combined with the plant's secreted enzymes that convert the dissolved matter into mineral nutrition. The pitcher plant is easily recognized by its drooping, umbrellalike purple flowers and purple-streaked cylindrical pitchers.

The sundew (*Drosera*), often found in the company of pitcher plants, is a colorful flypaper trap. Sundews excrete visible, glistening mucilage from their glandular hairs, which renders caught insects helpless while the digestion process begins. Sundews, which can live for 50 years, are fast-growing and depend on their rapid growth to envelop an insect with their leaves. The carcass is then enzymatically digested and absorbed. Sundews will ignore raindrops, but will react to the stimulation of the tiniest midge fly, an adaptation that fascinated Charles Darwin, who found his first carnivorous plant (a sundew) on an English heath. Darwin commented, "I care more about *Drosera* than the origin of all the species in the world."

Rating: Moderate (depending on weather conditions)
Distance: 8.5 miles
Estimated Time: 5.0 hours
Maps: USGS Snowy Mountain 7.5; National Geographic Adirondack
Park: *Northville/Raquette Lake*; Adirondack Maps, Inc.:
The Adirondacks West-Central Wilderness, The Adirondacks Central Mountains

This sheltered lake and river trip takes paddlers into the marshy wetlands of the Cedar River, in the Canada Lakes Wilderness Area.

Directions

From Indian Lake, travel north on NY 28/NY 30 for 2.0 miles, and bear left onto Cedar River Road (CR 12). The road turns to dirt 8.0 miles from NY 30. Pass the Wakely Mountain trailhead at 11.7 miles and arrive at Wakely Dam at 12.0 miles.

From Inlet, go east on NY 28 for 1.2 miles to Limekiln Road and turn right. Go 1.8 miles to the Moose River Plains Limekiln entrance. Sign in at the register. At 4.6 miles from the entrance, turn left at the T intersection as you enter the camping area. At 8.4 miles, turn left. At 21.5 miles, arrive at the boat launch and camping area (room for 30 to 40 cars). *GPS coordinates:* 43° 43.589' N, 74° 28.371' W.

Trip Description

The great attraction of the Cedar River Flow is its isolated location in the heart of the Moose River Plains. Few wild forest areas in the Adirondacks are as isolated or as surrounded by such large adjoining wilderness areas. The launch is situated deep inside the central Moose River Wild Forest. This area meets the qualifications of a wilderness and would have been classified as one, but upon its sale to the state in 1963, the Gould Paper Company retained an easement for vehicular use so the territory would be readily accessible to its former employees, who fished and hunted the area, as well as to the public.

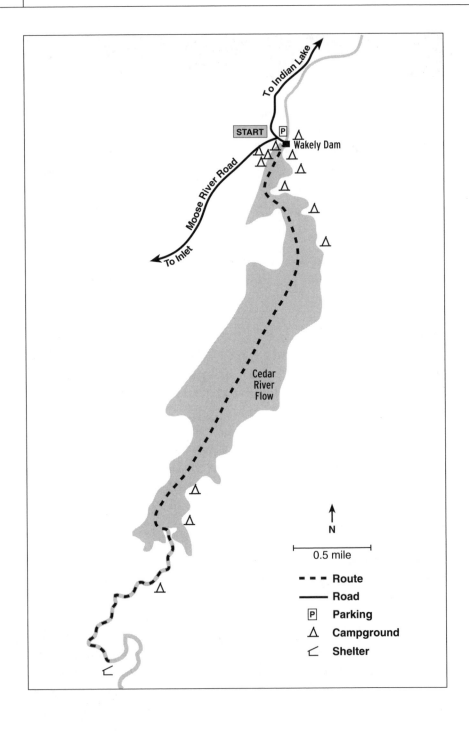

To Indian Lake

START

P

Wakely Dam

Moose River Road

To Inlet

Cedar
River
Flow

N

0.5 mile

- - - Route
——— Road
P Parking
△ Campground
⊂ Shelter

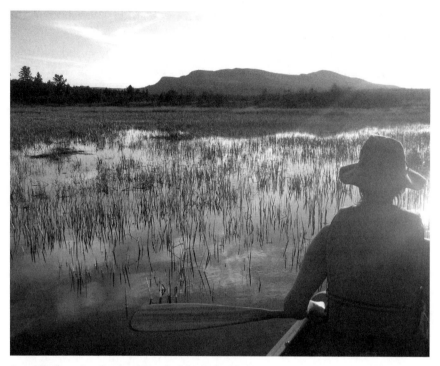

A paddler searches for the channel of the Cedar River.

Regardless of its land-use classification, this wild forest area feels like a wilderness and carries all of the caveats and requires all of the precautions of one. Venture into the Moose River Recreation Area prepared for any eventuality. The road is long, rough, and difficult, with many sharp rocks and potholes. Fill your gas tank before your trip and make sure you have the ability to reinflate or replace a flat tire. Carry extra food and water. Access from Indian Lake is shorter and the road is much better, so if possible, use the northern approach.

If you're coming from outside the park, consider camping close to the launch at one of the drive-up campsites. This is the largest concentration of designated, free campsites in the Adirondacks. Each site has a picnic table, fire ring, and privy. Eight or more sites are at the Wakely Dam camping area, which makes for an ideal staging ground. Several designated sites are on the flow itself, and a lean-to is at this trip's turnaround point.

Sign in at the trail register next to the put-in adjacent to Wakely Dam, on the west bank. Load your boat for big water—there can be high winds on the flow and the shallow water can produce a steep chop fairly quickly. Paddle into the flow and bear left (east) around the point. The lake opens up ahead of you. Choose the route that will best protect you from the wind, but if possible, follow along the eastern shoreline's hardwood forests, where several campsites are situated.

As you make progress to the southwest toward the river, you will note that the flow is surrounded on all sides by low hills and mountains. Ahead of you, the largest landmark seen from the lake is Lewey Mountain. To your right, about midway down the lake, you will see the fire tower on Wakely Mountain. The Sturge Hills lie to the west, and the bare rock face of (trailless) Sugarloaf Mountain stands out in the north, behind you.

Soon you will paddle through a marshland to reach the river. A slow-moving current pushes through a green, savannahlike maze of rushes and islands, widening into the flow somewhat left (east) of the marsh's center. Aim somewhere around the middle of this grassy wetland, favoring the left, and you will soon find the channel. (Do not follow hard to the eastern shore; this small bay dead-ends.) Variations in weather and water levels, as well as the work of beavers, have relocated the channel from time to time, and you may have to look around for it. Follow the strongest current upriver, watching the bottom grasses that point downriver, thus showing the way upstream. The channel is perhaps 10 to 15 feet wide and 4 to 6 feet deep here. Soon you enter the defined river channel, which is deeper, more easily followed, and enclosed in impenetrable alder growth.

Birdlife abounds here, particularly on the western, floristically diverse side of the flow. See if you can spot heron nests in a red spruce tree to the right of the channel's entrance. You will also see loons, mergansers, mallards, herring gulls, and ospreys. Ravens and hawks hunt the area and nest nearby.

Wind your way upriver, passing an idyllic campsite on a sandy pine bluff on river left. This traditional campsite, which provides some of the only hard ground in this part of the wetlands, has most likely been used for centuries by hunters and anglers. The Cedar River supports a healthy population of native brook trout, so you will see as many anglers in this area as sport paddlers. Be mindful of standing dead trees if you choose to camp here, and camp well back from the prow of the bluff if there's a chance of thunderstorms.

At periods of high water, the river becomes more serpentine, gains volume, and its current increases significantly. Stay to the inside eddies as you ascend, where the water is slowest. At 1.4 miles, the river makes a sharp curve to the left, where you will see the turnaround-point lean-to on river right, a hundred feet from shore. This shelter is known as the Carry Lean-to. It is situated on Northville–Lake Placid Trail in the West Canada Lake Wilderness Area, which abuts the Siamese Ponds Wilderness Area to the east and the Blue Ridge Wilderness Area to the north. Camping is legal in proximity to the lean-to, as well as 150 feet from the river or trail.

Upriver from this point is a short series of rapids. Another half-mile of paddling can be had if you're willing to line or warp your way upstream, but the chance for blowdowns and debris increases as the river narrows. When you've finished exploring the area, return the way you came.

TRIP 50
RAQUETTE RIVER

Rating: Strenuous (easy quick water in river; lake travel difficulty depends on weather conditions; includes a 1.3-mile carry)

Distance: 28.0 miles

Estimated Time: 15.0–20.0 hours (overnight suggested; up to three days)

Maps: USGS Deerland 7.5; USGS Kempshall Mountain 7.5; USGS Stony Creek Mountain 7.5; USGS Tupper Lake 7.5; National Geographic Adirondack Park: *Lake Placid/High Peaks*; Paddlesports Press: *Adirondack Paddler's Map*; Adirondack Maps, Inc.: *Adirondack Canoe Map, The Adirondacks Northwest Lakes*

This scenic section of wild river features easy quick water and sheltered wilderness canoe camping at many lean-tos and campsites.

Directions to Put-in

From the intersection of NY 28N and NY 30 in the village of Long Lake, go north on NY 30. In 0.4 mile, turn right onto Dock Lane. Go 0.3 mile to the parking area (room for 40 to 50 vehicles) on the right. *GPS coordinates (put-in):* 43° 58.714′ N, 74° 24.985′ W.

Directions to Take-out

From the intersection of NY 28N and NY 30 in the village of Long Lake, take NY 30 north for 22.0 miles to Tupper Lake. Here NY 30 joins NY 3. Follow NY 30 and NY 3 an additional 4.0 miles and turn right into the parking area (room for 40 to 50 vehicles in two lots). *GPS coordinates (take-out):* 44° 14.344′ N, 74° 23.311′ W.

Trip Description

This easily paddled section of the Raquette River abuts the western boundary of the High Peaks Wilderness Area, between Long Lake and Tupper Lake. The route is suitable for prepared paddlers of any ability level, provided the usual precautions are taken when traversing Long Lake, which

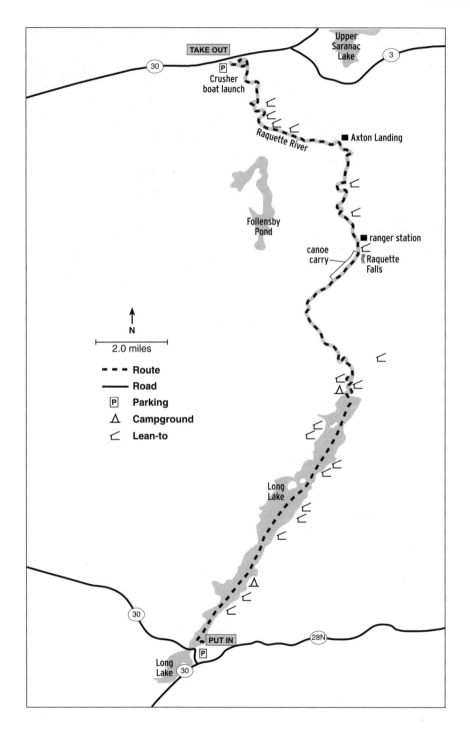

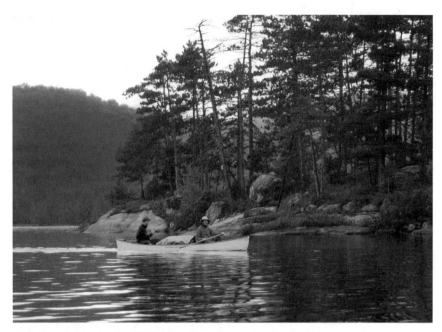

Canoeists explore the Camp Islands scattered across Long Lake.

can produce challenging conditions. Campsites and lean-tos are numerous and conveniently situated at the water's edge throughout the trip. Paddlers must spot a car at the Crusher boat launch in Tupper Lake, or arrange to be picked up.

The trip begins in the charming lakeside village of Long Lake. Long-term parking (more than 24 hours), including trailer parking, is available only at the boat launch, 0.4 mile east of the village. Motorboats of any horsepower are permitted in Long Lake.

Load at the dock or on the concrete launch. Once afloat, follow the eastern shore of Long Lake, round Oven Point, and enter Catlin Bay, where the wilderness area begins on the east side of the lake. Stay to the eastern shore if winds allow. While the lake lies in a fairly narrow valley and is protected from both east and west winds, a very strong westerly may require that you follow the western shoreline, which has the disadvantage of being privately owned all the way to the lean-to site at Camp Riverdale. In contrast, the eastern shore has dozens of campsites. Paddling north, leave the private Camp Islands to your left. Nearing the north end of the lake you will pass Island House Island (also private). With the exception of a few private

inholdings on the eastern shore toward the north end of the lake, designated tent and lean-to camping is provided all the way to the end of the lake at Turtle Beach, a pine bluff campsite above a white-sand beach, just west of the river's entrance. You can see Kempshall and Blueberry mountains back to the southeast.

Paddle into the river at the northeast end of the lake and you will soon feel the current. Upon passing a private camp on river right, the wilderness atmosphere takes over. Just downriver of a lean-to on river left, the Lost Channel, a dead end, appears to the right. Although at high water it may provide a connection to the Cold River, a more reliable shortcut exists downstream. The Cold River enters the Raquette from river right at its junction with Deep Hole, where a lean-to appears on Raquette River left. The Cold can be ascended for a mile or more at high water, and leads to the isolated Calkins Creek Lean-to.

The river meanders, leaving the Moose Creek swamp to the west, and brings paddlers to the carry on river right. The torn-off bow section of an aluminum canoe (part of the permanent signage here) offers the best advice against going any farther downriver. The carry is long (1.3 mile) and can prove arduous. It can be wheeled to some extent and with some extra effort, although it is not without roots, rocks, and hummocks, to the extent that those with light outfits may find it easier to use a traditional overhead carry.

Raquette Falls is a series of heavy rapids and two main cascades (in which boats as well as lives have been lost) dropping a total of 80 feet. Those who wish to see them can walk the marked river trail, which cannot be portaged. Past the lean-to, which is set at the head of a pine-fringed blueberry meadow, the carry is flat and leads to the river just beyond the interior ranger station (staffed in season). Several attractive designated camping sites are in the general area. A 4.5-mile-long foot trail connects the ranger station to Corey's Road just east of Stony Creek, near Axton.

Continuing downriver, the current assists you once again. More lean-tos and campsites are encountered, and many little marshes invite side trips, especially during periods of high water. In 6.0 miles, Stony Creek is reached. A pretty peninsula campsite just upriver from the creek's marked entrance is the location of the trail to a lean-to, situated up a hill on river right. Just downriver is Axton Landing (marked), the site of an early logging camp called Axe Town. If for some reason your party must pull out of the river

early, Axton is convenient to NY 3 on Corey's Road. Designated camping and long-term parking are available at Axton.

Continue downriver as the Raquette heads west through a long series of oxbows. Passing Trombleys Landing, where a high, flat bluff marks the entrance to a backwater with a lean-to, the river turns north once again. It is possible to continue on the Raquette River for another 6.0 miles to Tupper Lake (adding 2.0 miles to reach the public boat launch in Moody), but the sense of wilderness—and the number of campsites—diminishes beyond this point. Take out at the Crusher canoe access site and head south on NY 30/NY 3 to Tupper Lake, continuing to Long Lake and your vehicle.

Appendix A:
Helpful Information
and Contacts

**New York State Department of Environmental Conservation
Forest Rangers State Headquarters**

625 Broadway, 8th Floor
Albany, NY 12233-2560
518-402-8839

Region 5
Captain John Streiff,
Regional Forest Ranger
P.O. Box 296
1115 State Route 86
Ray Brook, NY 12977-0296
518-897-1303

State Police

Clinton, Essex, Franklin, Hamilton, and St. Lawrence counties
518-897-2000

Herkimer, Jefferson, and Lewis counties
315-366-6000

State Park and Tourist Information

To order travel literature:
New York State Division of Tourism Travel Information Center
800-225-5697; iloveny.com

To find information for all regions:
The Adirondack Regional Tourism Council
visitadirondacks.com

To find maps and geographic information:
The Adirondack Park Agency
518-891-4050; apa.state.ny.us/about_park

To read the Adirondacks camping guide:
New York State Office of Parks,
Recreation & Historic Preservation
Adirondack Region
nysparks.state.ny.us/regions/adirondack/default.aspx

To find a lodging and activities guide:
adirondack.net

Maps

Adirondack Forest Preserve map
NYS Department of Environmental Conservation
518-402-8013; dec.ny.gov

Adirondack Maps, Inc.
Large-format, multicolored topographic trail maps;
Adirondack Canoe Map
518-576-9861; adirondackmaps.com

Adirondack Mountain Club
Various guides to Adirondack trails and canoe routes, including the
Adirondack Trails series and the *Canoe and Kayak Guides* series
Maps available separately
518-449-3870; adk.org

Adirondack North Country Association
Regional map, *Bikeways of the Adirondack North Country Map*
Byways: Scenic Driving Tours of the Adirondack North Country
(self-guided tours of eleven auto trails highlighting attractions along the way)
518-891-6200 adirondack.org

Adirondack Park campground map
Department of Environmental Conservation
dec.ny.gov/outdoor/33154.html

Adirondack Regional Tourism Council
Adirondack Waterways Guide
518-846-8016; visitadirondacks.com

Appalachian Mountain Club
Various books and maps, including *Quiet Water New York*
and *Nature Guide to the Northern Forest*
800-262-4455; outdoors.org/amcstore

National Geographic
Trails Illustrated maps
Adirondack Map Pack
800-962-1643;
natgeomaps.com/trailsillustrated

New York State Department of Transportation
Topographic and county base maps with state land boundaries
518-457-3555; nyc.gov/dot

Paddlesports Press
Adirondack Paddler's Map
(a full-color shaded relief map showing portages and campsites)
888-775-2925; canoeoutfitters.com

Raquette River Outfitters
Paddlers and Hikers Map, Lows Lake and Bog River
518-359-3228;
Raquetteriveroutfitters.com

United States Geological Survey
Topographic maps
888-ASK-USGS; usgs.gov

Camping

To get detailed information or to make a reservation for any campground, contact Reserve America at 800-456-CAMP (800-456-2267) or online at newyorkstateparks.reserveamerica.com.

For more information about DEC-operated campgrounds and day-use areas, call DEC at 518-457-2500.

For State Land Camping and Hiking Rules (DEC), visit dec.ny.gov.

To read the NYS Summer Recreation Campground Summary, visit dec.ny.gov/docs/permits_ej_operations_pdf/2011facilityinfo.pdf.

Paddling

For information on shuttling and water levels in the Hudson River, call 1-888-454-8433 or visit beaverbrook.net.

For a map and information on camping in the Hudson River Special Management Area, visit dec.ny.gov/outdoor/65483.html.

Appendix B:
Free Camping

IF YOU COME WITH A TENT, A SLEEPING BAG, AND A CANOE OR KAYAK, you will be able to find free camping on pubic lands throughout the Adirondacks. You don't even necessarily need a boat—but having one will help you find more attractive campsites, away from the roads.

What follows is a list of roadside, walk-in, or otherwise easy-access designated campsites in areas of the Adirondack forest preserve that are near enough to the book's destinations to be of practical use. Note that not all of these camping areas are located at the trailheads of the trips described. Many will require considerable driving, hiking, paddling, or cycling to reach the trailhead.

At this time, no comprehensive lists, maps, or brochures identify free, designated camping sites in the Adirondacks. Since all of the hikes in this book are on New York State forest preserve lands, they offer free camping—both near the trailhead and along the full length of the trail, road, or river you're traveling on (see page xxviii for rules and regulations). In order to minimize impacts, however, campers should make every effort to use the established, designated campsites, which are marked by an NYS yellow camping disk. Designated campsites have been created only in areas where the terrain is not steep, poorly drained, easily eroded, or in proximity to sensitive natural communities. Many designated campsites have been closed or relocated because of site degradation and overuse of sanitary facilities, and this practice will continue. (Note that there is a three-day limit for camping in any site without a permit, which can be issued only by the local forest ranger.)

Section 1: High Peaks Region
Roaring Brook Falls, Giant Mountain Wilderness Area
Three walk-in campsites at the base of Roaring Brook Falls provide an excellent staging ground for hikes in the Giant Mountain, Dix Mountain, and High Peaks wilderness areas. Park at the Roaring Brook trailhead parking area (see Trip 7 for directions and details) and follow the marked trail 0.1 mile to the first fork. Follow another 0.1 mile to the designated camping area at the base of the falls.

South Meadows Road, Eastern High Peaks Wilderness Area
At this time, a half dozen roadside campsites are along South Meadows Road (signed as Meadow Road). They are very popular owing to the two High Peaks trailheads here. Because this road is not in conformance with wilderness guidelines, it will most likely not remain open indefinitely, in which case these will become walk-in sites. Many people park here and hike to Marcy Dam (en route to Mount Marcy and the High Peaks), where there is also free designated camping. For directions, see Trip 6.

Section 2: Northwest Lakes and Foothills Region
Floodwood Road, St. Regis Canoe Wilderness Area
More than a dozen sites are located along Floodwood Road. From Lake Clear (at the junction of NY 30 and NY 186), drive 5.5 miles to Floodwood Road and turn right (west). The campsites begin on the left side of the road and continue past Middle, Floodwood, and East Pine ponds. The canoe access site for Floodwood Pond's many free campsites is adjacent to St. Regis Canoe Outfitters. For details, see Trip 23.

Follensby Clear Pond, Saranac Lakes Wild Forest
From Lake Clear (at the junction of NY 30 and NY 186), take NY 30 approximately 8.0 miles to the Follensby Clear Pond boat launches. Several designated campsites are within a short paddling distance of either launch.

Corey's Road, Saranac Lakes Wild Forest/High Peaks Wilderness Area
Corey's Road is located approximately 12.0 miles southwest of Saranac Lake, and 8.0 miles east of Tupper Lake, off NY 3. Canoe-accessible campsites are off Corey's Road, where a small parking area is provided on

the left, adjacent to Stony Creek Ponds. Look for this parking pull-off 0.5 mile south of NY 3. The sites are located on peninsulas in the northerly section of the ponds, a short paddle from the put-in. At 2.0 miles from NY 3 on Corey's Road, a large site (drive-up) is located at Axton Landing. (Bear right at the small sign onto a single-lane dirt road and go a short distance to the canoe access area on the Raquette River.) More sites are found beyond the bridge over Stony Creek along the roadside, in the western High Peaks Wilderness Area. Where Corey's Road crosses a bog at 5.2 miles, a rough dirt road goes to the left, where a pretty campsite is located next to Ampersand Brook. Corey's Road is gated where it meets private property at 6.0 miles.

Lake Lila, William C. Whitney Wilderness Area
Two sites can be reached on foot from the Lake Lila canoe access parking area. They require a 0.3-mile walk to the end of the portage trail on Lake Lila. Many designated, canoe-access-only campsites are distributed throughout this region. Most of them are located on Little Tupper Lake and Lake Lila. For directions, see Trips 22 and 24.

Horseshoe Lake and Bog River Road, Horsehoe Lake Wilderness Area
Approximately 17 designated campsites are along the south and west shore of Horseshoe Lake on NY 421, 8.5 miles south of Tupper Lake on NY 30. One site is on the right side of Low's Lower Dam Road on the way into the Bog River canoe access site, and several readily accessible sites are along the Bog River, a short paddle (upstream) from the put-in at the Lower Dam. For directions see Trip 21.

Section 3: Southeast Mountains and Rivers Region
Shelving Rock Special Management Area (SRSMA)
Twelve campsites are in proximity to Lake George, Buck Mountain, Sleeping Beauty Mountain, and Shelving Rock Bay. The sites are on Shelving Rock and Dacy Clearing roads. The main public access to the SRSMA is from the south off NY 149. From NY 149, travel north on Buttermilk Falls Road to Sly Pond Road. Continue north to the Upper Hogtown parking area, where you can gain access to Shelving Rock Road and (dirt) Dacy Clearing Road. See Trips 25, 26, and 35 for detailed directions.

Hudson River Special Managment Area (HRSMA)

The HRSMA is also known as the Hudson River Recreation Area. The NYS DEC provides many accessible facilities for people with mobility disabilities in the HRSMA, including eight campsites and 1.5 miles of roadways open to people permitted through the DEC's Motorized Access Program for People with Disabilities (MAPPWD).

Many attractive campsites are near the Hudson River here. The area can be very busy on weekends throughout the summer. Campsites 1–5, 10, 17, and 18 are managed to provide access for campers with mobility disabilities.

From Exit 21 (Lake George) of the Adirondack Northway (I-87), take NY 9N west toward Lake Luzerne for approximately 9.7 miles. Turn right onto Mill Street after passing the Lake Luzerne Elementary School. Follow Mill Street to its end at the intersection with River Road, and turn right onto River Road. The designated campsites of the HRSMA can be accessed from River Road. This camping area is near Trips 32 and 38.

Tongue Mountain Trailheads

The Tongue Mountain area has no designated drive-in camping areas convenient to either the southerly Clay Meadow trailhead (a.k.a. The Quarry) or the northerly Deer Leap trailhead. However, there is evidence of sustained (legal) use by campers in the area directly across NY 9N from the Quarry parking area, between Northwest Bay Brook and NY 9N. This area is large enough to provide the required 150-foot distance from both the highway and the brook. However, some sites that have been "established" through repeat use by campers are too close to the brook, and therefore in violation of the rule. Another choice for camping is the pine plantation beyond the barrier gate in the Clay Meadow trailhead overflow parking area, which is just 200 feet north along NY 9N from the Quarry parking area. Beyond the barrier gate on the east edge of the parking area, a disused fire road leads into the woods. As with any forest preserve campsite, be careful to select an area where standing or leaning dead trees are not present—there are many in the old Civilian Conservation Corps plantations like the ones you'll see around the Tongue trailheads. For directions, see Trip 27.

Pharaoh Lake Wilderness
During early spring (or in any wet period) the designated campsites at the Pharaoh Mountain trailhead are difficult to reach by car.

From Exit 28 of the Adirondack Northway (I-87) take NY 9 for 0.6 mile south. Bear left onto Alder Meadow Road. Go 2.1 miles, bearing left onto Crane Pond Road. At 3.5 miles, all but high-clearance four-wheel-drive vehicles are better off parked at the large (ten to twelve cars) trailhead parking area at the point where the road bears right. Another 1.6 miles on this dirt road (which may be blocked by a beaver flow at 1.3 miles) brings you to the foot trail at Crane Pond and a designated camping area. For detailed directions and information, see Trip 30

Section 4: Southwest Lakes and Mountains Region

Moose River Recreation Area
This area has approximately 160 sites, the largest number of designated campsites in a single location in the Adirondacks. Spread out along (and radiating from) the 20-mile long Moose River Road between Indian Lake and Inlet, these drive-up sites provide a wildernesslike experience. The road is little-used and can present rough traveling conditions. Be prepared to repair flat tires, and carry extra food and water. For details and directions, see Trips 42, 45, and 49.

Moss Lake, Fulton Chain Wild Forest Area
Eagle Bay is 9.0 miles north of Old Forge on NY 28. Moss Lake is located 2.0 miles north of Eagle Bay on Big Moose Road. At the trailhead parking area, a map indicates the locations of several walk-in or bike-in sites, along with an island site. A hiking/biking path encircles the lake, providing access to several campsites. (The trail around the lake in a counterclockwise direction begins from the northwest corner of the parking area.) These sites are located in proximity to Trips 43, 44, 45, 47, and 48.

Big Island Raquette Lake

Big Island is one of the most accessible and attractive island camping sites in the southwestern Adirondacks. From Raquette Lake Landing, paddle 0.6 mile northeast to the southwesterly point of the island (the shore that is closest to Raquette Landing). Three lean-tos are on the point (one is immediately visible; two are around on the left side of the point in the woods) and some designated, lakeside campsites are along the south shore of the island. After Labor Day, the roadside campsites of Brown's Tract Pond state campground are free (find them along Brown's Tract Road, which leaves to the north out of the Raquette Landing boat launch parking area). The village of Raquette Lake is 0.4 mile north off NY 28, 22.0 miles north of Old Forge and 13.0 miles south of Blue Mountain Lake.

Index

About the Author

PETER KICK, a native of the Catskill Mountains region, is a New York State licensed guide who has led trips throughout the Adirondacks. The author of several hiking and mountain-biking guides, including AMC's *Catskill Mountain Guide* and AMC's *Best Day Hikes in the Catskills & Hudson Valley*, he has also written for *The Conservationist, Backpacker, Sailing, Cruising World,* and *Adirondack Life.*

Appalachian Mountain Club

Founded in 1876, AMC is the nation's oldest outdoor recreation and conservation organization. AMC promotes the protection, enjoyment, and understanding of the mountains, forests, waters, and trails of the Northeast outdoors.

People
We are more than 100,000 members, advocates, and supporters, including 12 local chapters, more than 16,000 volunteers, and over 450 full-time and seasonal staff. Our chapters reach from Maine to Washington, D.C.

Outdoor Adventure and Fun
We offer more than 8,000 trips each year, from local chapter activities to adventure travel worldwide, for every ability level and outdoor interest—from hiking and climbing to paddling, snowshoeing, and skiing.

Great Places to Stay
We host more than 150,000 guests each year at our AMC lodges, huts, camps, shelters, and campgrounds. Each AMC destination is a model for environmental education and stewardship.

Opportunities for Learning
We teach people skills to safely enjoy the outdoors and to care for the natural world around us through programs for children, teens, and adults, as well as outdoor leadership training.

Caring for Trails
We maintain more than 1,500 miles of trails throughout the Northeast, including nearly 350 miles of the Appalachian Trail in five states.

Protecting Wild Places
We advocate for land and riverway conservation, monitor air quality, research climate change, and work to protect alpine and forest ecosystems throughout the Northern Forest and Mid-Atlantic Highlands regions.

Engaging the Public
We seek to educate and inform our own members and an additional 2 million people annually through the media, AMC Books, our website, our White Mountain visitor centers, and AMC destinations.

Join Us!
Members meet other like-minded people and support our mission while enjoying great AMC programs, our award-winning *AMC Outdoors* magazine, and special discounts. Visit outdoors.org or call 800-372-1758 for more information.

APPALACHIAN MOUNTAIN CLUB
Recreation • Education • Conservation
outdoors.org

The AMC in New York

AMC has two active chapters in New York. The New York–North Jersey Chapter offers more than 2,000 trips per year, ranging from canoeing and kayaking to sailing, hiking, backpacking, and social events. The chapter is also active in trail work and conservation projects and maintains a cabin at Fire Island. The Mohawk Hudson Chapter serves residents of Albany, Columbia, Fulton, Greene, Montgomery, Rensselaer, Saratoga, Schenectady, Schoharie, Warren, and Washington counties. It offers a variety of outdoor activities for all levels of ability. You can learn more by visiting outdoors.org/chapters. To view a list of AMC activities in New York and other parts of the Northeast, visit activities.outdoors.org.

AMC Book Updates

AMC Books strives to keep our guidebooks as up-to-date as possible to help you plan safe and enjoyable adventures. If after publishing a book we learn that trails have been relocated or route or contact information has changed, we will post the updated information online. Before you hit the trail, check for updates at outdoors.org/bookupdates.

While hiking, biking, or paddling, if you notice discrepancies with the trip description or map, or if you find any other errors in the book, please let us know by submitting them to amcbookupdates@outdoors.org or in writing to Books Editor, c/o AMC, 5 Joy Street, Boston, MA 02108. We will verify all submissions and post key updates each month. AMC Books is dedicated to being a recognized leader in outdoor publishing. Thank you for your participation.

AMC BOOKS & MAPS

EXPLORE THE POSSIBILITIES

AMC's Best Day Hikes in the Catskills & Hudson Valley, 2nd edition

Peter W. Kick

With more than 600 miles of trails within just a few hours of New York City, the Catskills and Hudson Valley are a hiker's paradise, boasting varied and scenic terrain from Westchester County to Albany. The fully updated guide leads hikers of all ability levels along 60 of the region's most spectacular trails.

$18.95 • 978-1-934028-45-2

Quiet Water New York
2nd edition

John Hayes and Alex Wilson

From clear-flowing waterways to picturesque ponds, the trips in this guide allow paddlers to explore the great variety of water excursions New York has to offer. With 90 spectacular destinations to choose from, experts and beginners alike will enjoy this guide.

$19.95 • 978-1-929173-73-0

AMC's Best Day Hikes in the Berkshires

René Laubach

Discover 50 of the most impressive trails in the Berkshires, a region rich with waterfalls and mountains, serene ponds, and rocky cliffs. Each trip description includes a detailed map, trip time, distance, and difficulty rating.

$18.95 • 978-1-934028-21-6

Catskill Mountain Guide
2nd edition

Peter W. Kick

A must-have for every Catskills hiker, this revised and updated guide offers hikers comprehensive coverage of more than 300 miles of trails in the Catskill Mountains. Inside you'll find detailed descriptions of trails to suit every ability level — from an easy walk to Kaaterskill Falls to strenuous climbs in the Indian Head Wilderness Area, including Devil's Path.

$23.95 • 978-1-934028-19-3

AUG -- 2019